# TEMPLE SQUARE

## THE SPIRIT OF SALT LAKE CITY

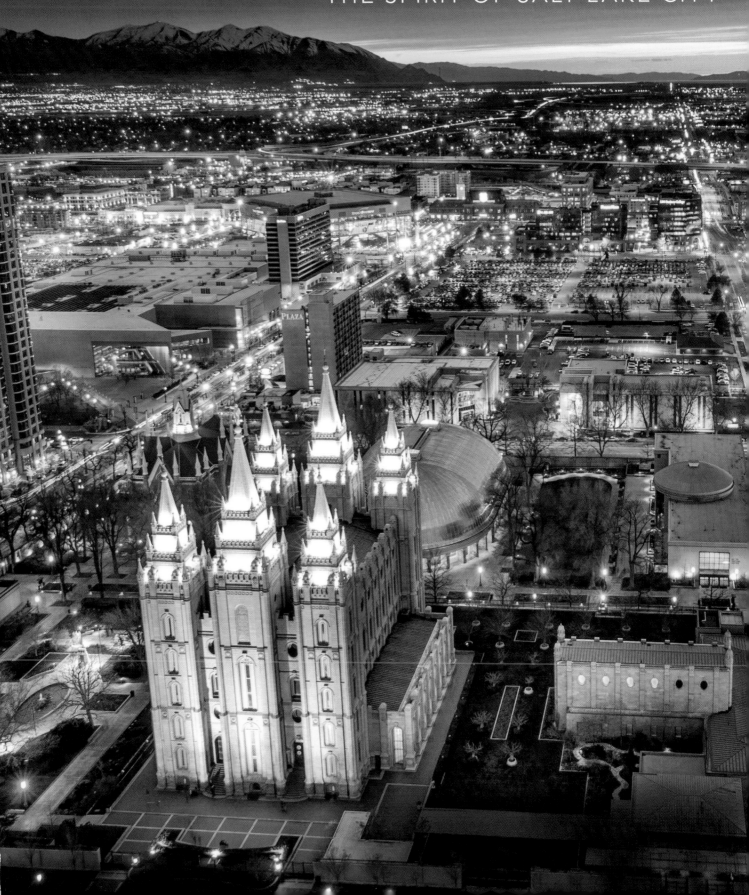

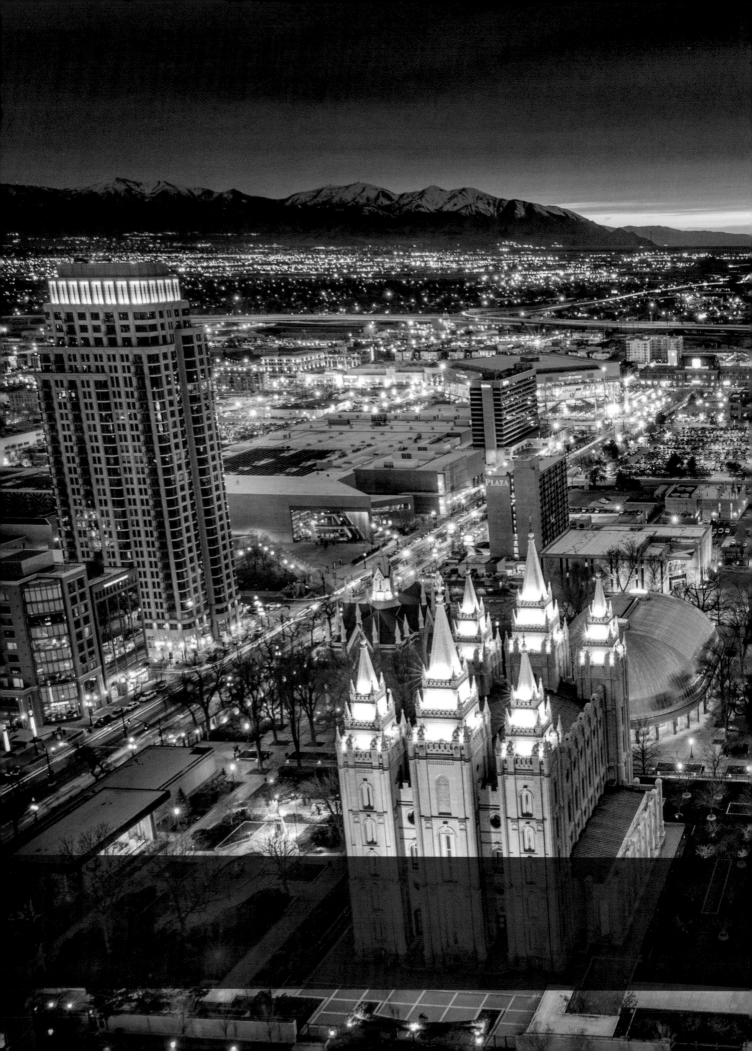

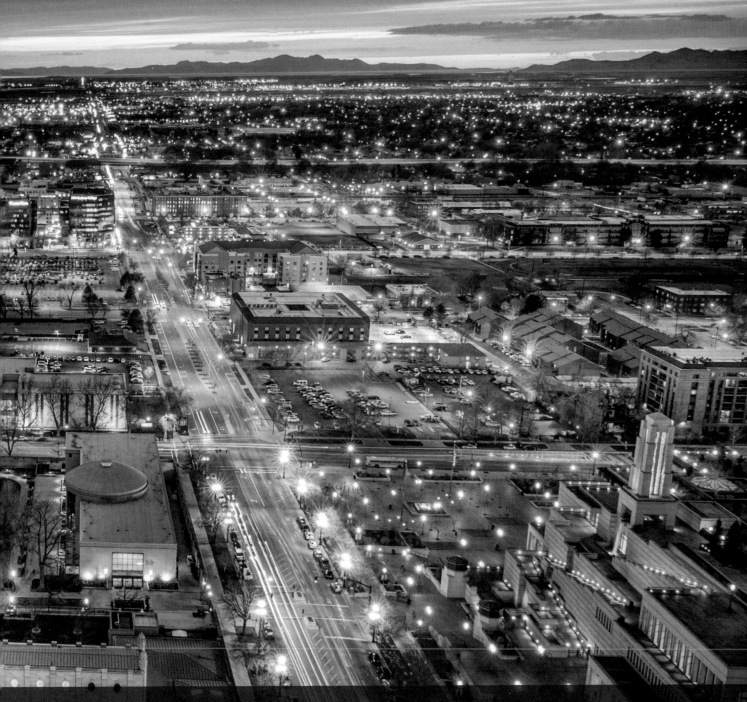

# TEMPLE SQUARE

## THE SPIRIT OF SALT LAKE CITY

A photographic exploration by

## SCOTT JARVIE

CFI  •  An imprint of Cedar Fort, Inc.  •  Springville, Utah

ISBN 13: 978-1-4621-2137-3

Published by CFI, an imprint of Cedar Fort, Inc.
2373 W. 700 S., Springville, UT 84663
Distributed by Cedar Fort, Inc., www.cedarfort.com

Library of Congress Control Number: 2017951073

Cover design by Shaun McMurdie & Shawnda T. Craig
Interior layout design by Shawnda T. Craig
Cover design © 2017 Cedar Fort, Inc.
Edited by Jessica Romrell

Printed in the United States of America

10 9 8 7 6 5 4 3 2 1

Printed on acid-free paper

To my father, whose last instructions he ever gave in
this life were the simple words "Go to church."

He was a wonderful example of a faith-centered father,
and I never once questioned where he stood on the
gospel, a gospel I love so dearly as well.

—Scott Jarvie

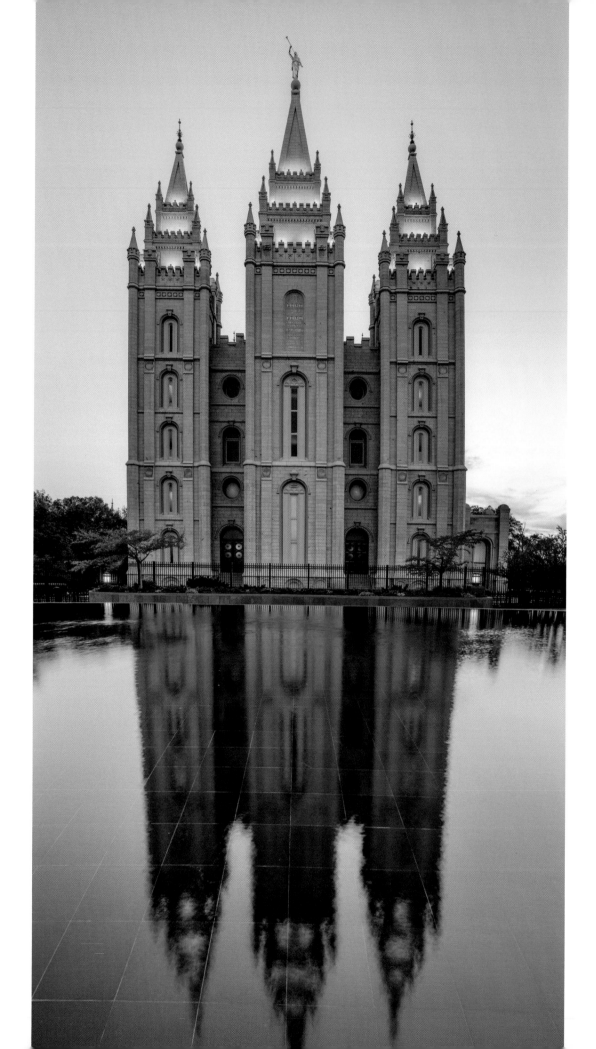

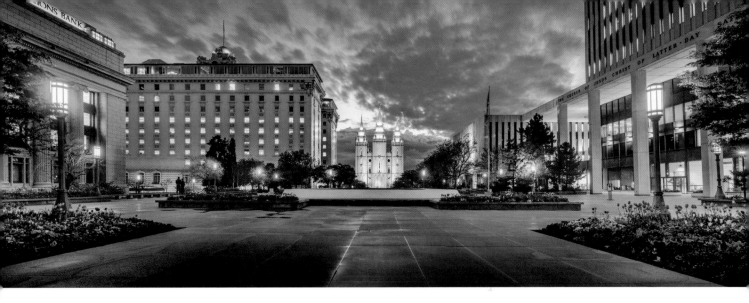

# TABLE OF CONTENTS

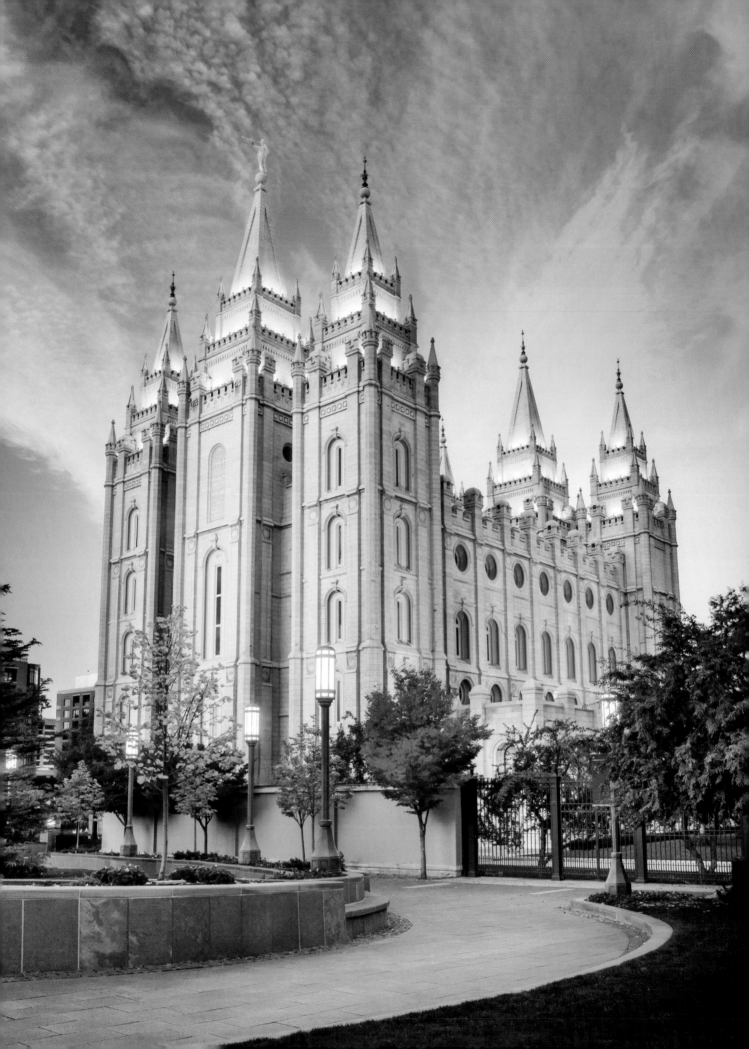

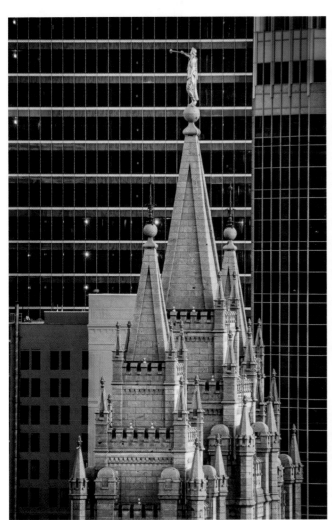

# SALT LAKE TEMPLE

## *Interesting Facts*

- On July 28, 1847, Wilford Woodruff drove a stake into the ground marking the site of the Salt Lake Temple after Brigham Young declared, "Here we will build a temple to our God." Not quite 46 years later, Woodruff would be the one to dedicate the temple on April 6, 1893.[1]

- The temple was carefully constructed over a period of 40 years. Each granite block was shaped by master stonemasons and lifted into place with cranes.[2] In Brigham Young's words, "I want to see the temple built in a manner that it will endure through the Millennium."[3]

- In 1847, Truman O. Angell was appointed the temple architect, with William Ward serving as his assistant. Sadly, Angell never got to see the finished building; he died in 1887.[3]

- The phrase "Holiness to the Lord. The House of the Lord" carved in the granite on the west side of the temple was engraved by John Rowe Moyle, a stonecutter who walked 22 miles to the temple site each week from his home in Alpine.[4]

- Although today there are more than 100 beautiful temples in all parts of the world, the Salt Lake Temple is considered the most iconic of them all.[3]

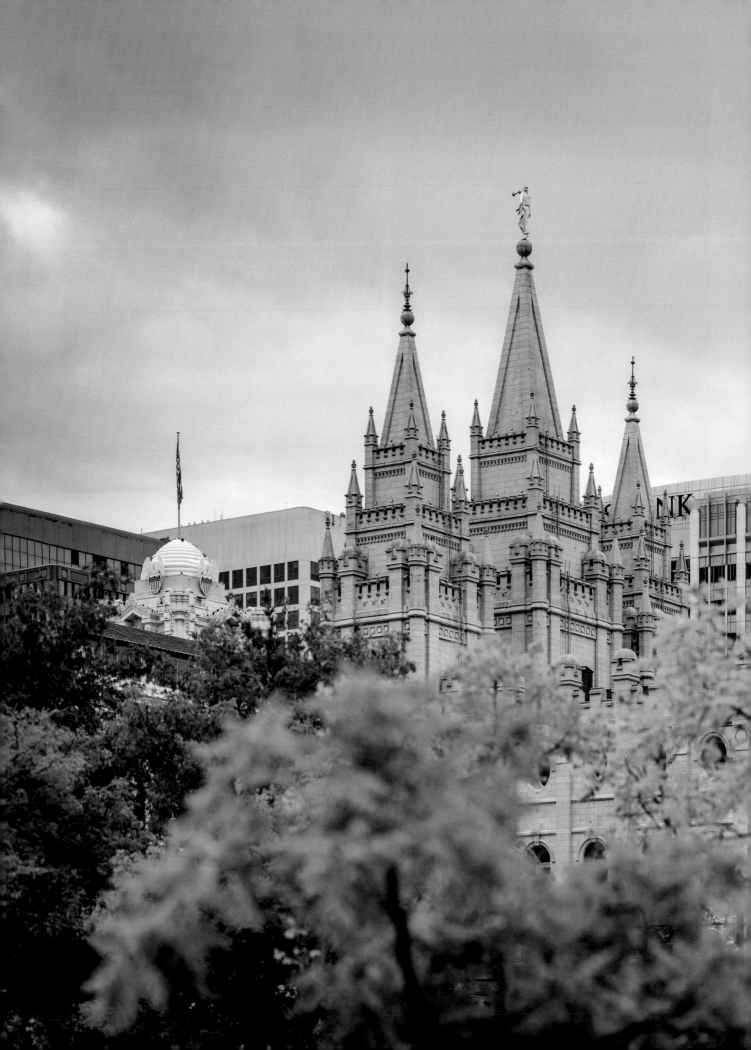

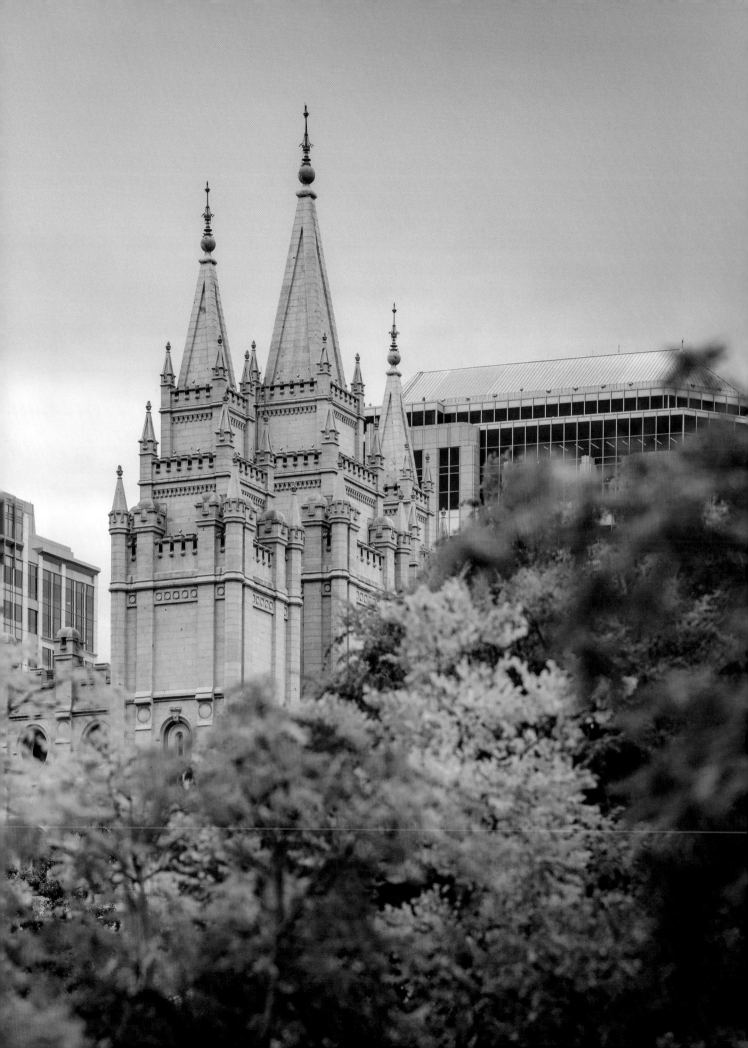

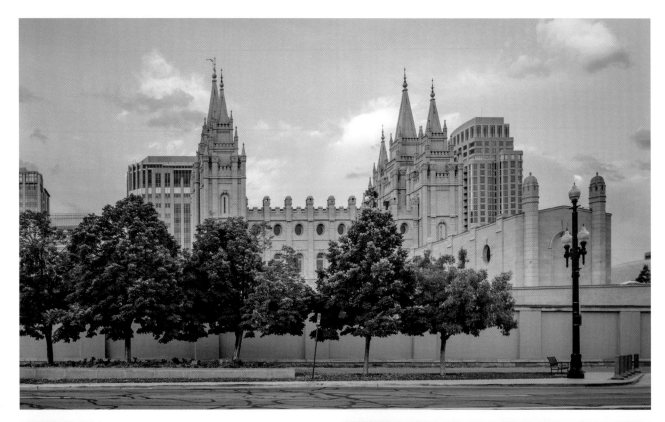

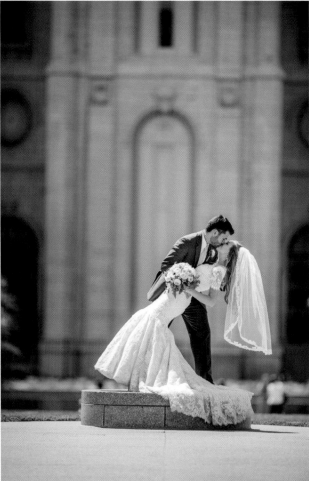

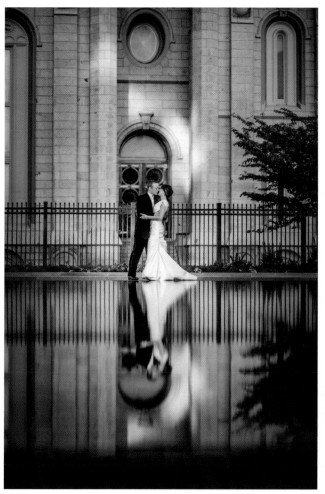

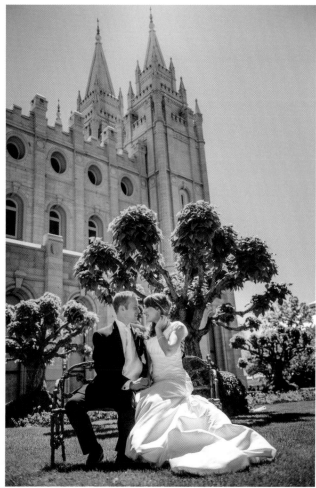

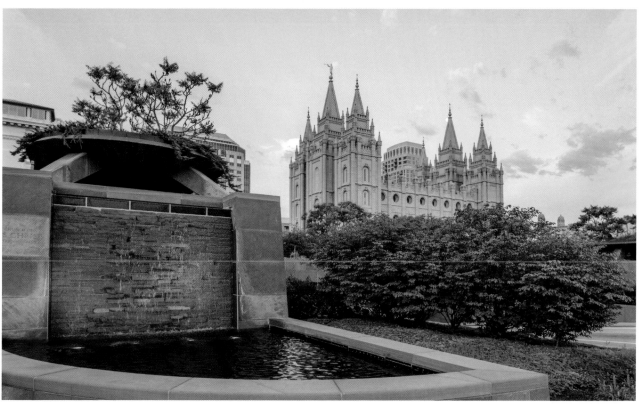

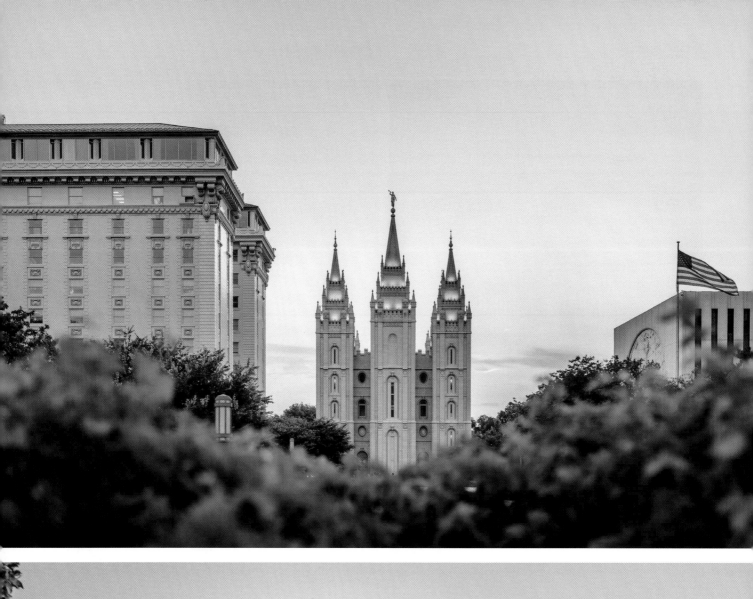

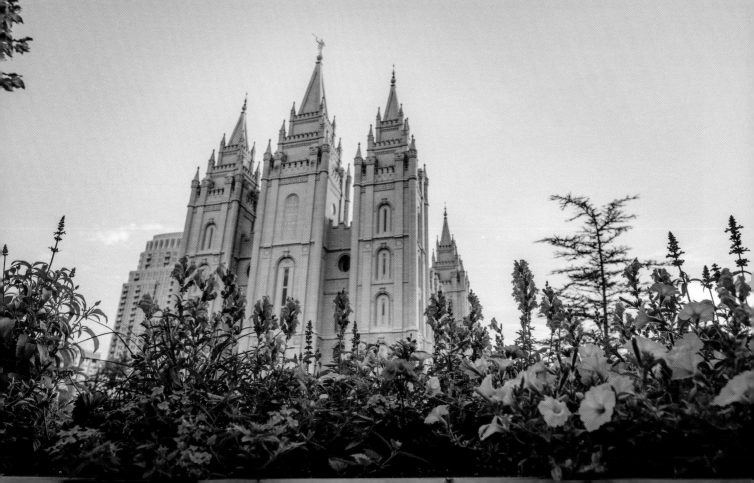

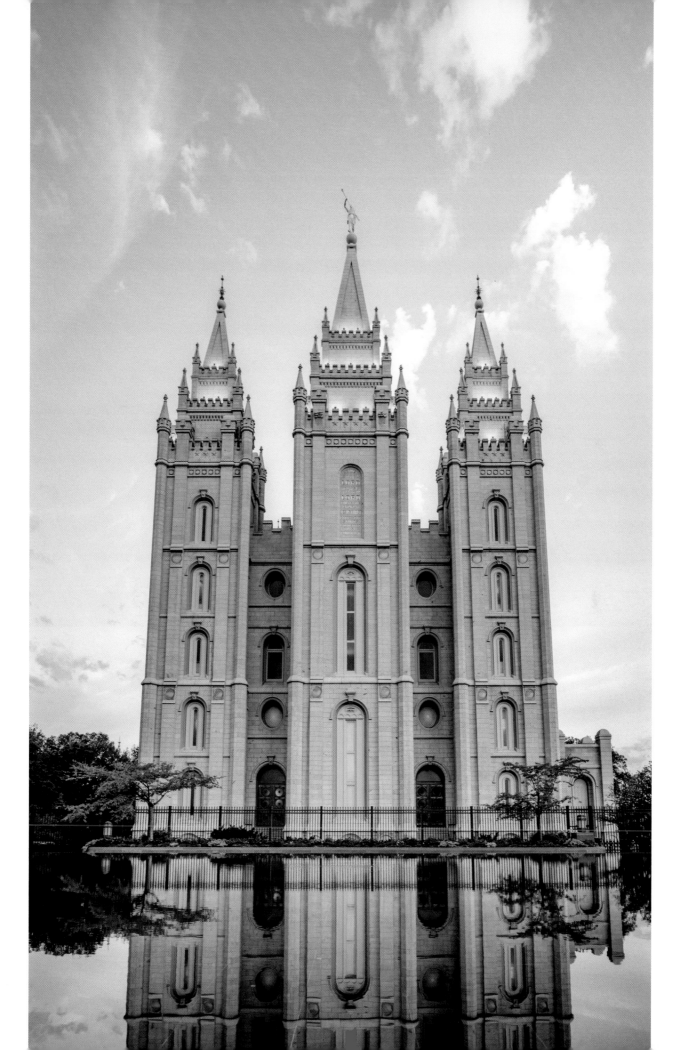

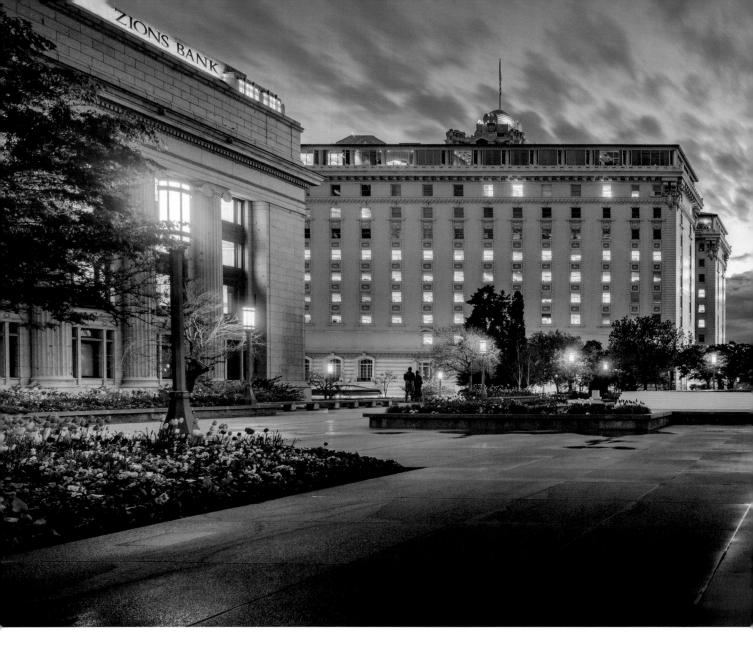

## Every Stone in the Temple Is a Testament

One hot summer day, my mission companion and I saw a young man walking out of the Tabernacle alone. I felt prompted to speak with him. We approached and asked what he thought of the tabernacle. He said he admired the building but didn't know much about it. We explained the purpose of the building and why it was important to listen to the counsel of God as revealed through His prophet. We then asked, "What is something in your life that you value?"

The young man, Hugo, began to tell us about his family back home in France. He was the oldest child in his family and was in Utah as an exchange student. He said he wasn't sure if he believed in God but he really missed his family.

As he spoke, I felt impressed to take him to the Salt Lake Temple. On our way there, he shared more about his family with us and we explained how important the family unit is in the church. We went right up to the

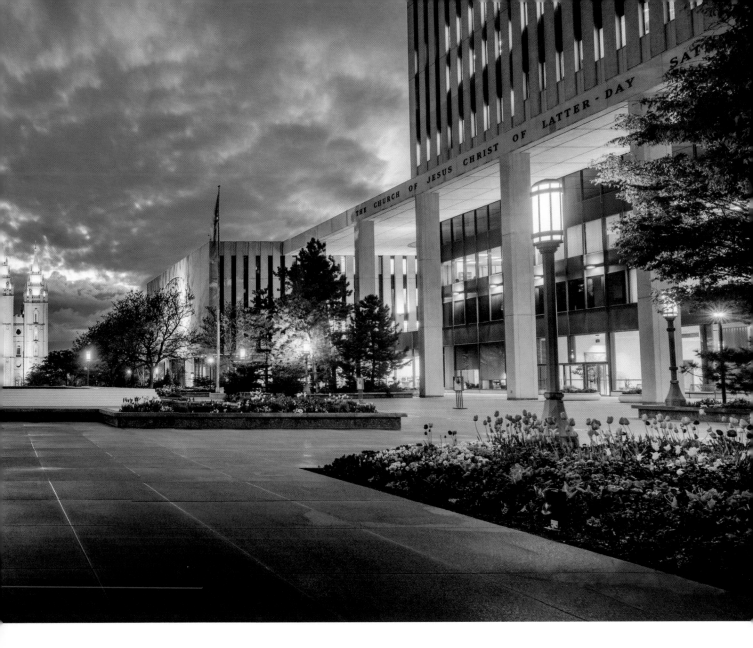

temple and shared some historical facts about it. Then I invited Hugo to touch the exterior of the temple. I testified to him that the pioneers who had suffered so much and lost family members along the trek west to Utah, started building this Temple because they knew and understood that it is through the Temple that they could be united eternally as a family and see their loved ones again. I told Hugo that every stone in the Salt Lake Temple was a testament to the faith of those pioneers who suffered and endured much but understood that death is not the end and that God intended families to be Eternal.

I noticed while I was testifying of these truths Hugo was fighting back tears. When I finished speaking he said to us through tears, "How did you know that's what I needed to hear? My little brother passed away last year and I have been thinking about him a lot lately. I now have hope that I can see him again."

–Rachel Matautia, Australia

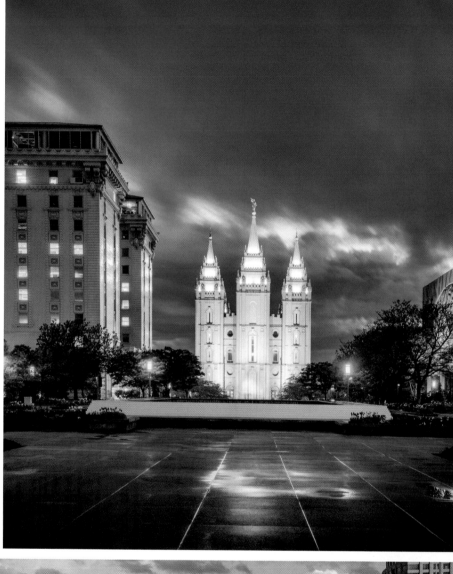

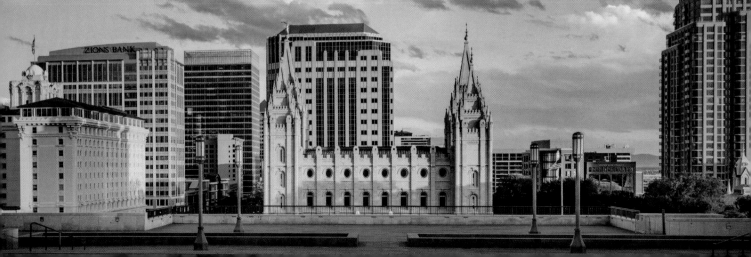

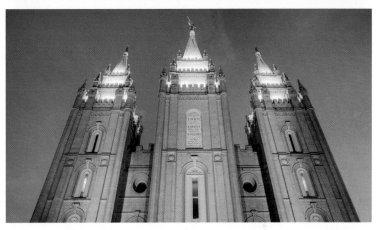

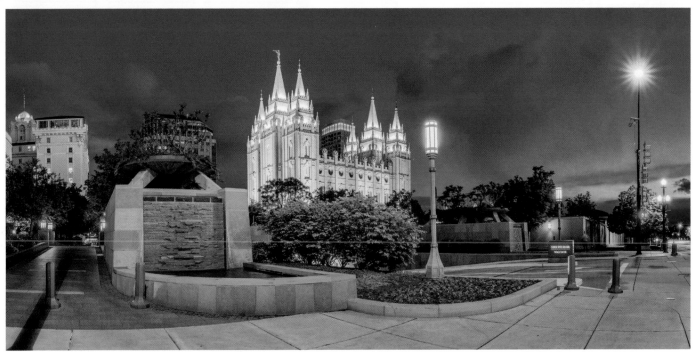

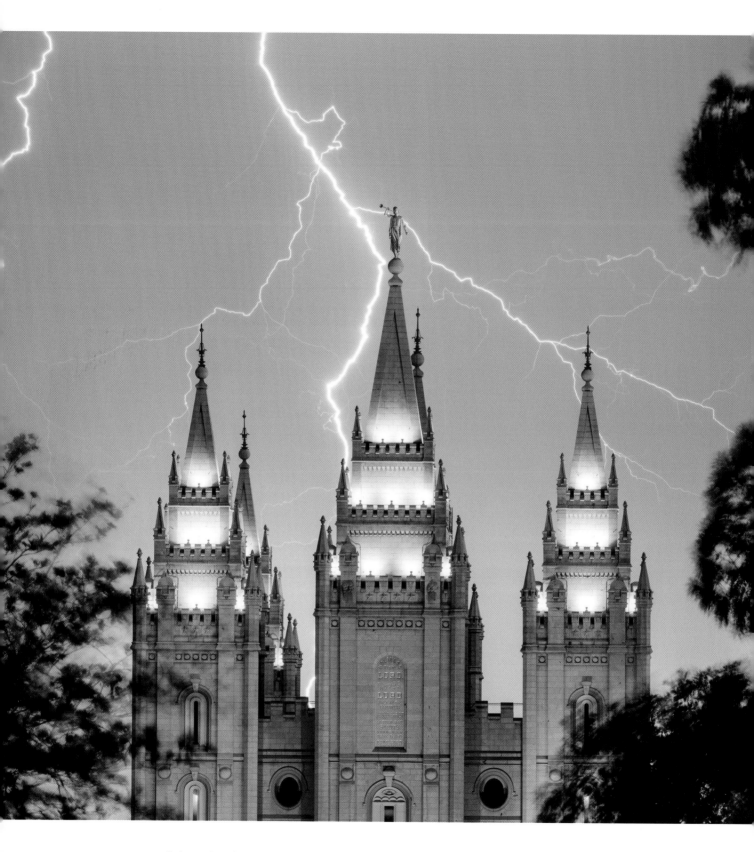

"[The Salt Lake Temple] is a creation of beauty—A symbol of strength; A haven of peace; A sanctuary of service; A school of instruction; A place of revelation; A fountain of truth; A house of covenants; A temple of God."

—Gordon B. Hinckley[1]

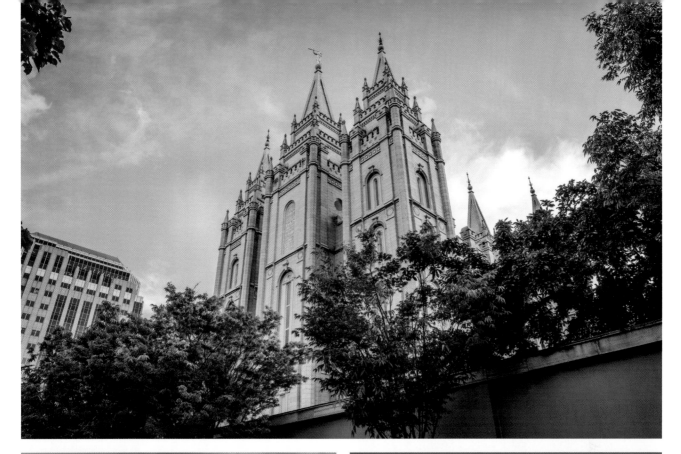

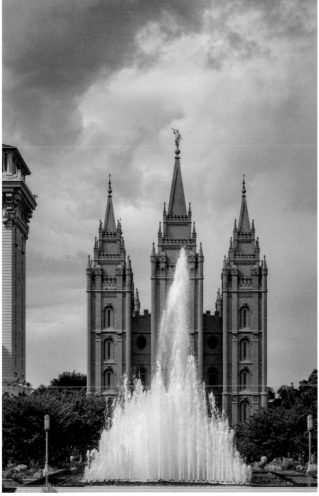

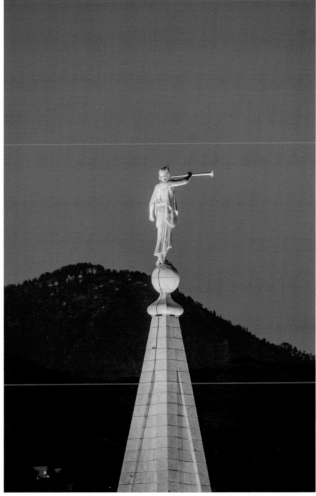

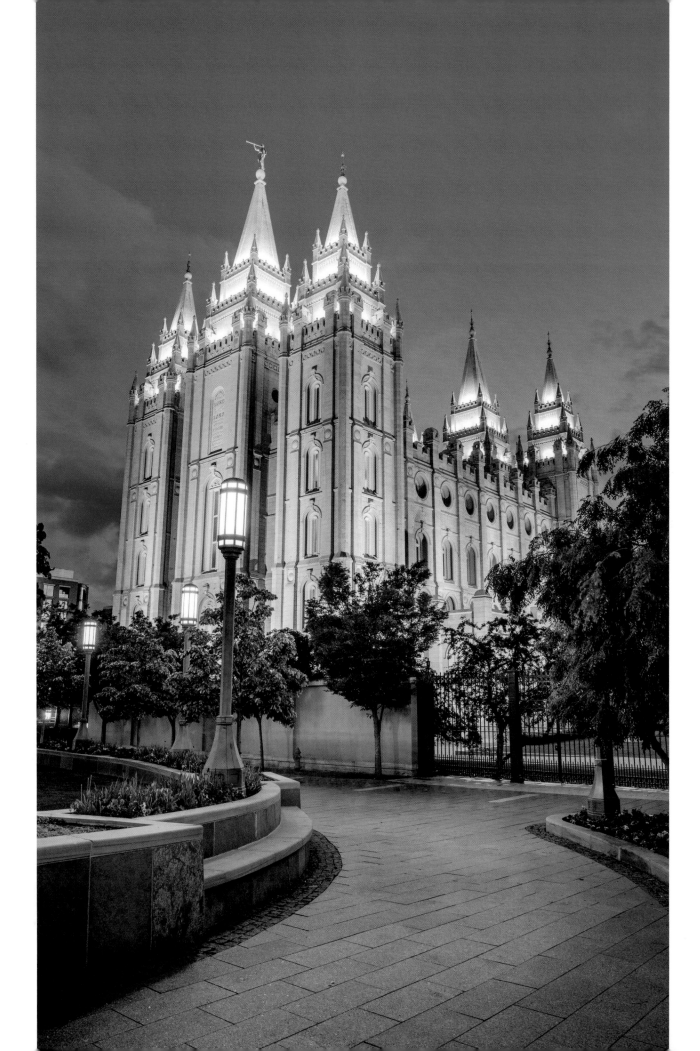

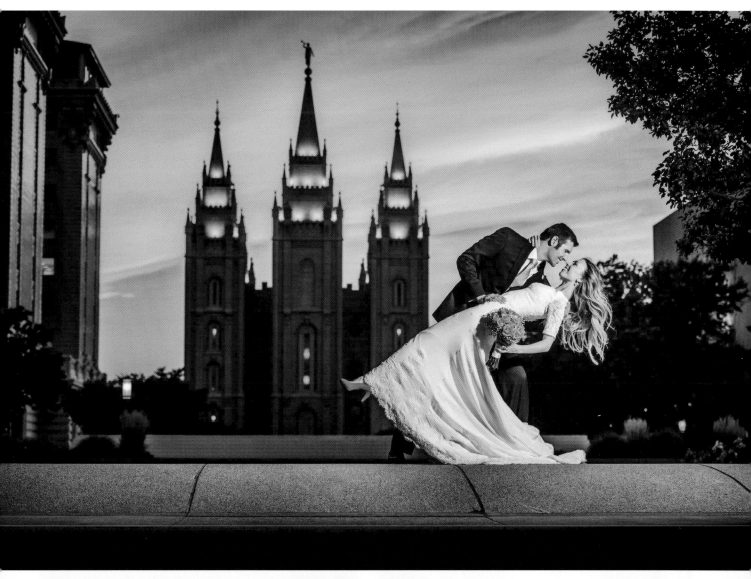

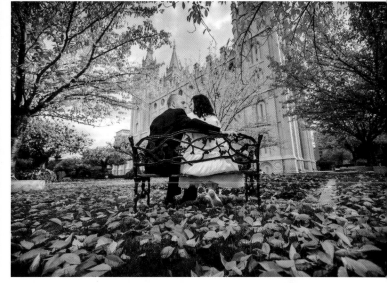

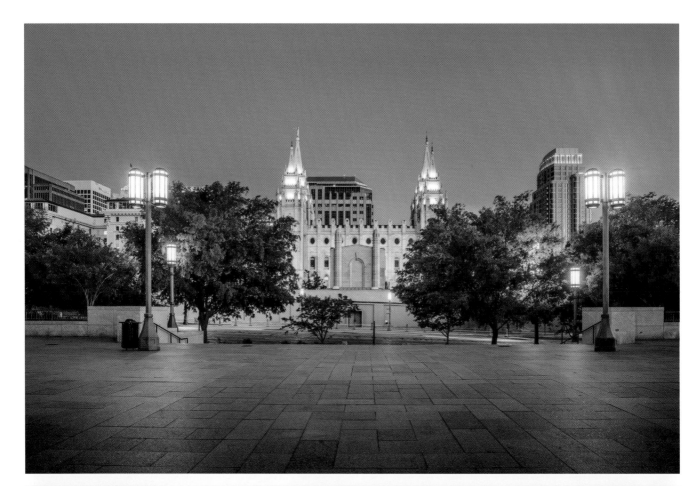

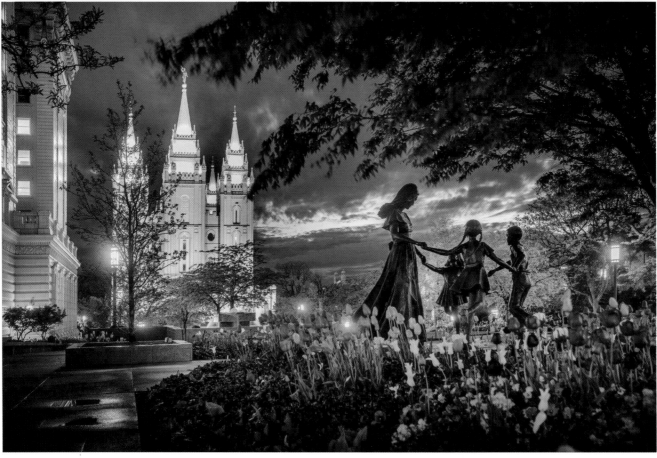

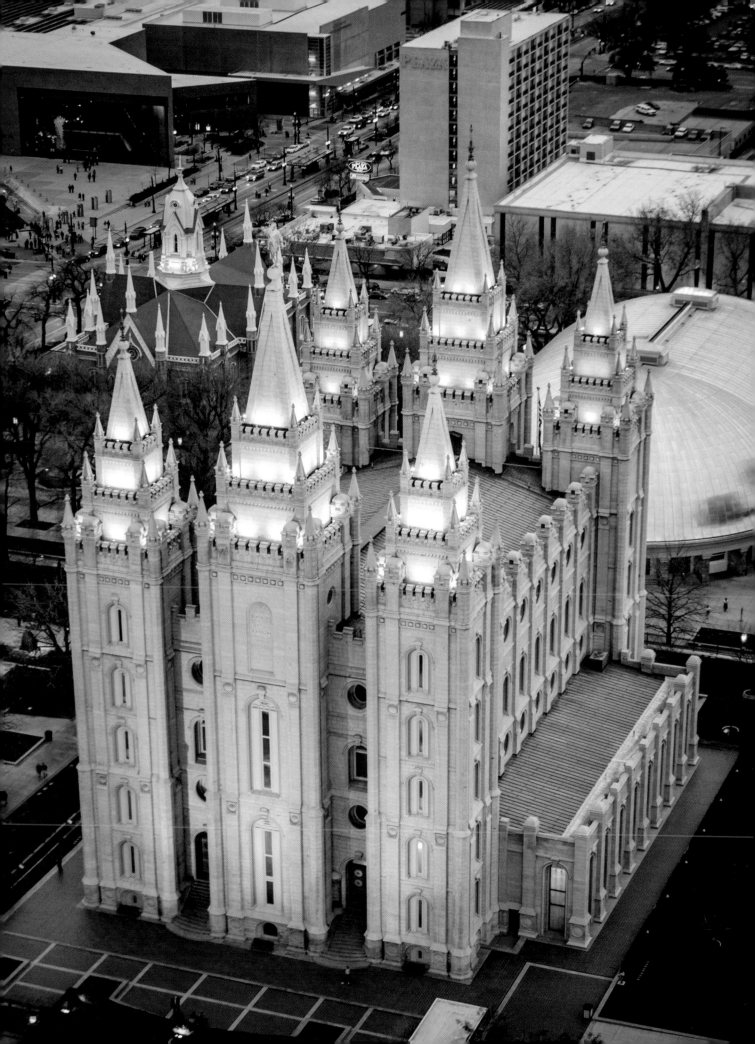

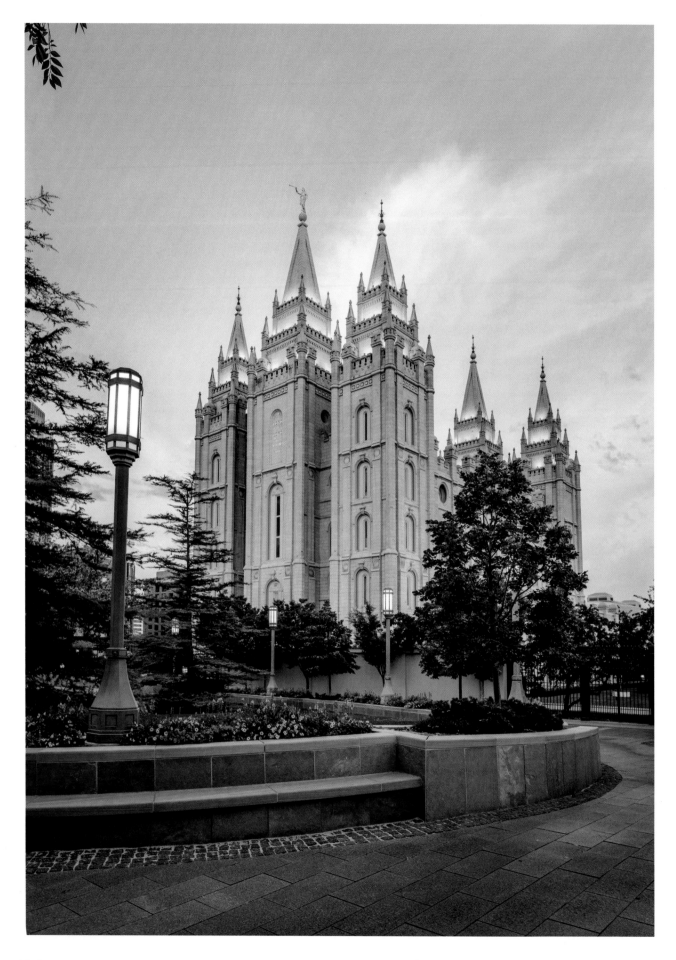

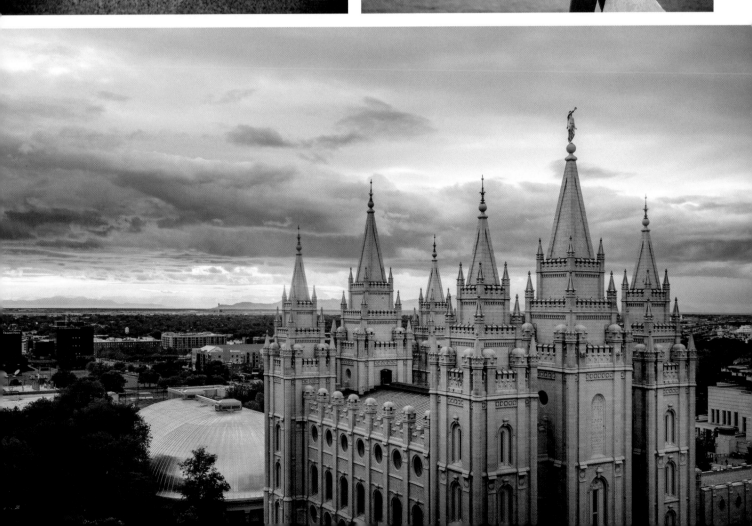

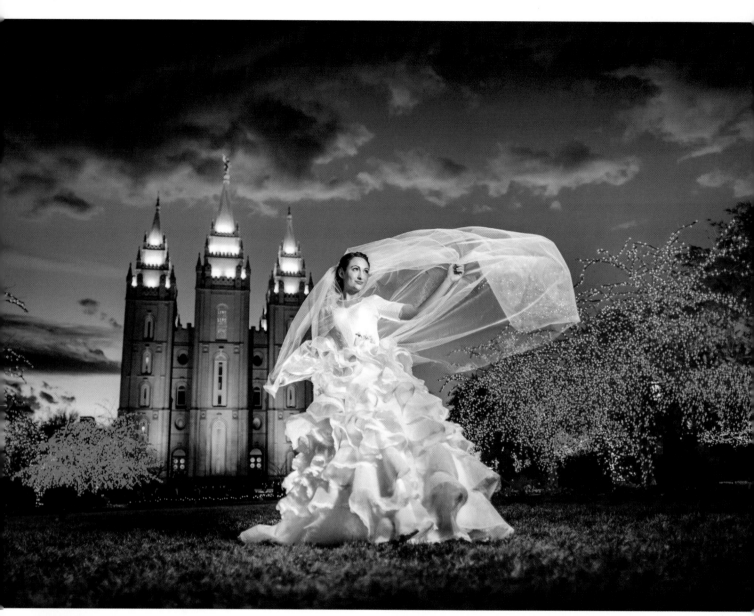

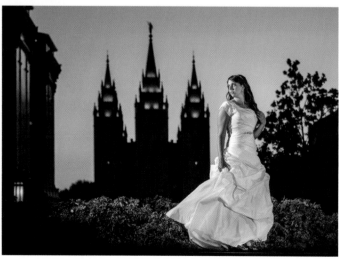

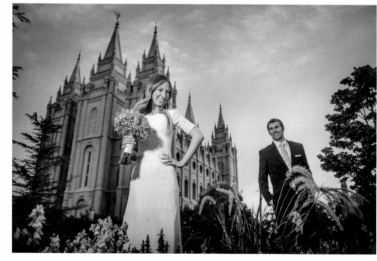

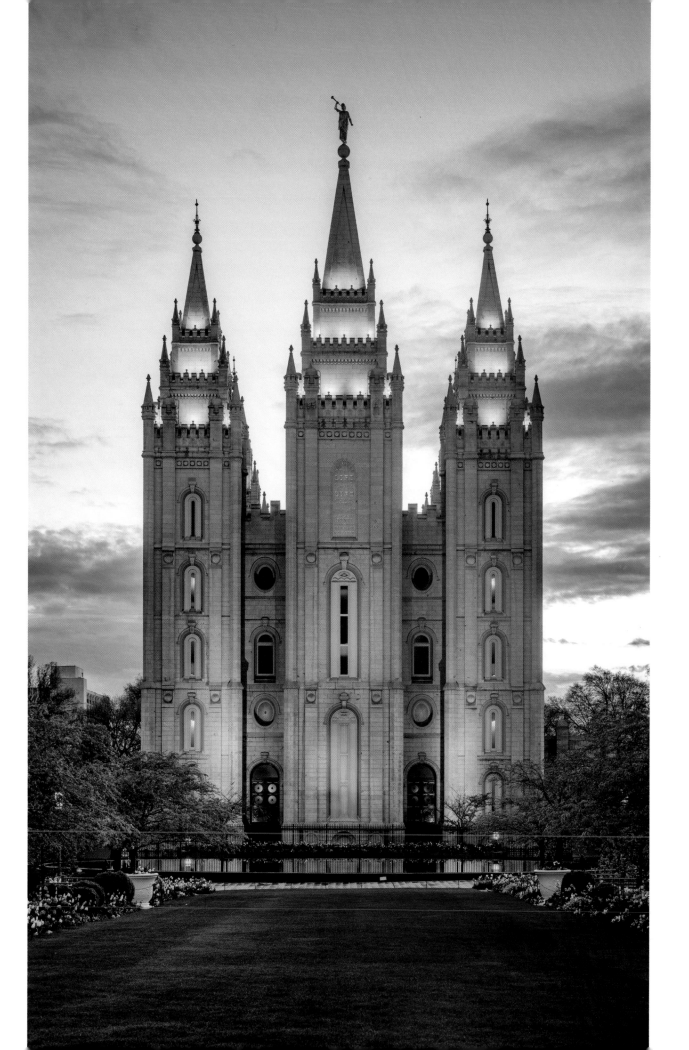

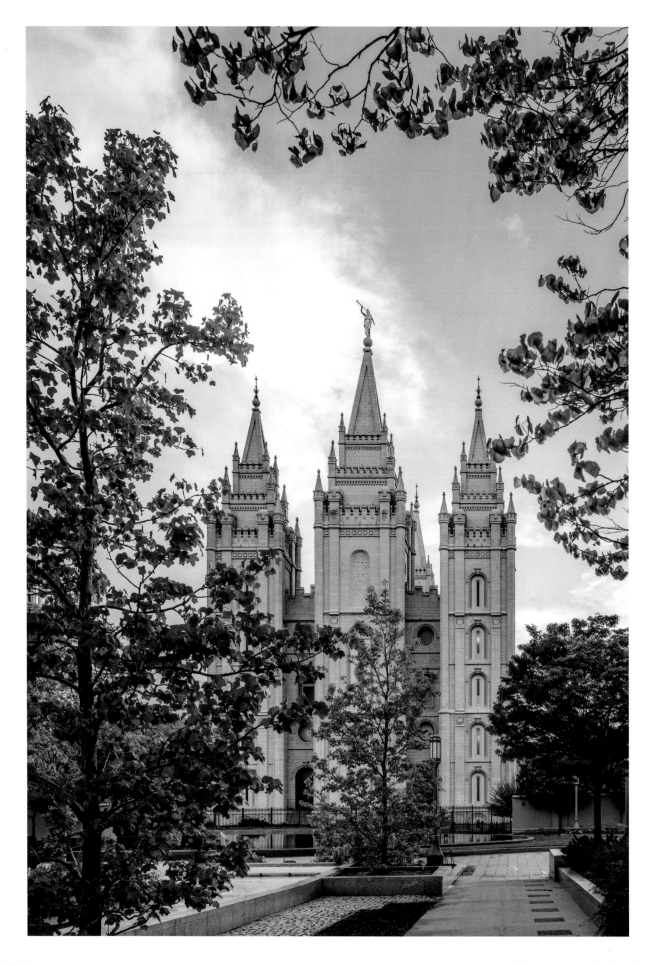

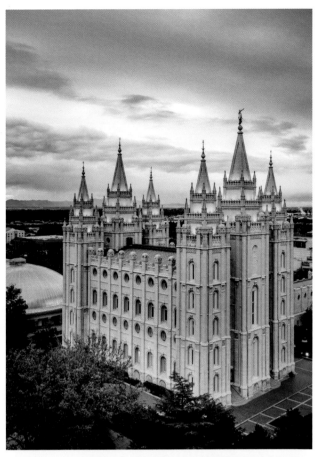

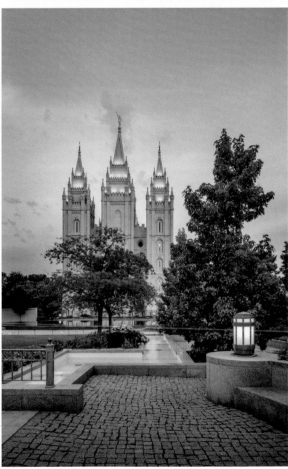

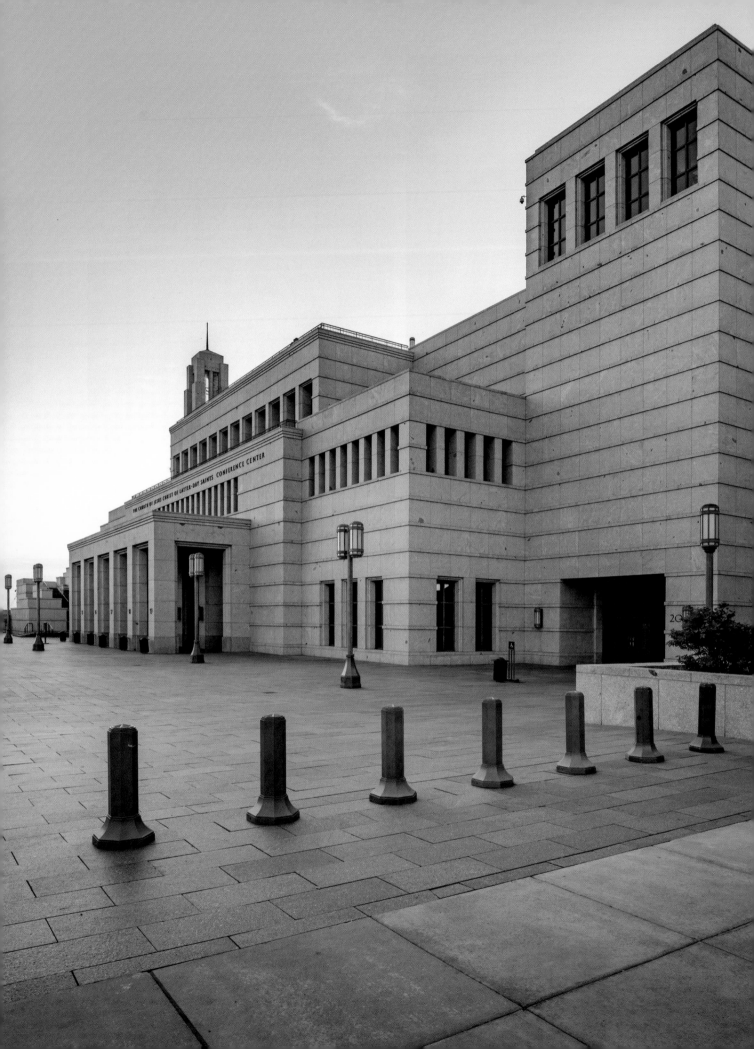

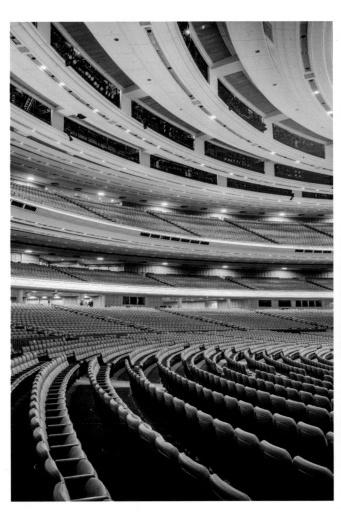

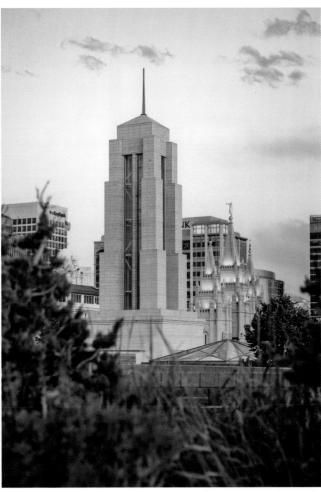

# CONFERENCE CENTER

## *Interesting Facts*

- The LDS Conference Center was dedicated on October 8, 2000. At 21,000 capacity, its auditorium is one of the biggest in the world, and every detail is designed to create the best acoustics possible.[5] The building is used for events such as concerts, church meetings, and civic gatherings.[6]

- Twice each year, the conference center is the site of a General Conference of The Church of Jesus Christ of Latter-day Saints. Conference addresses are translated into more than 90 languages and broadcast to all those who cannot attend in person.[6]

- More than 1,000 people from three different construction companies worked each day from 1996 to 2000 to construct the building.[5]

- One of Gordon B. Hinckley's desires for the building was that there be no columns in the auditorium, so that each seat could have an unobstructed view of the stage. To achieve this goal, engineers used 620-ton king trusses.

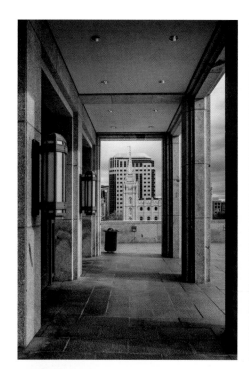

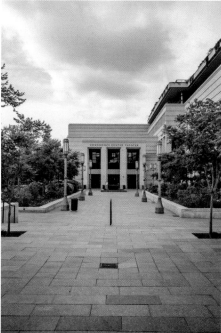

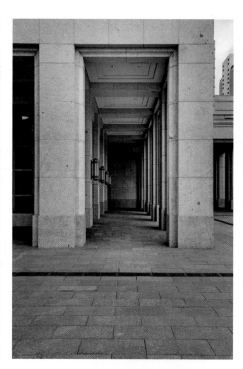

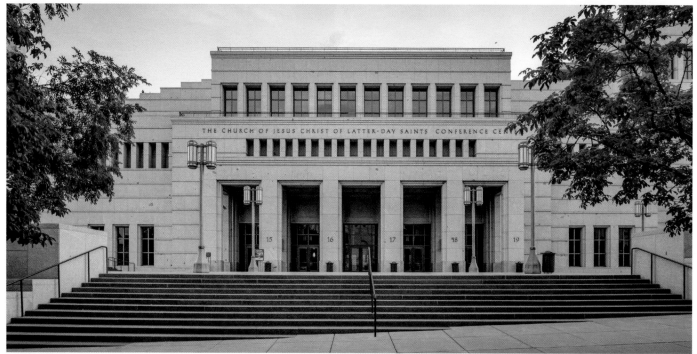

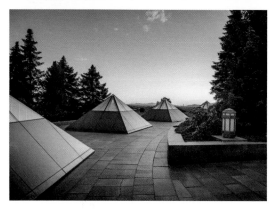

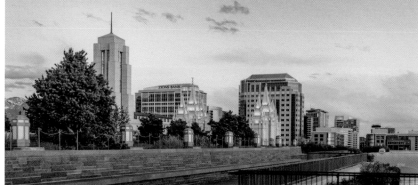

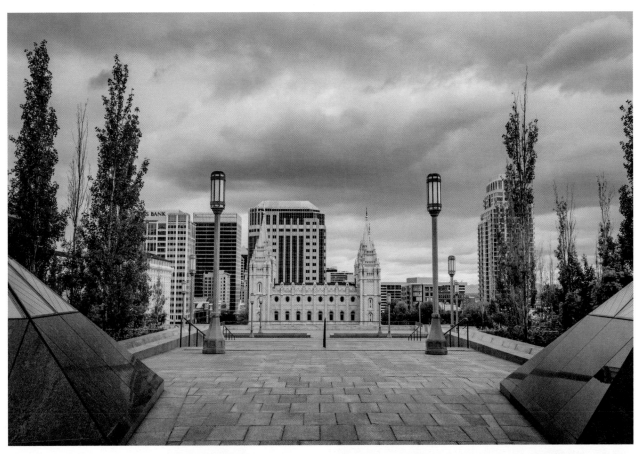

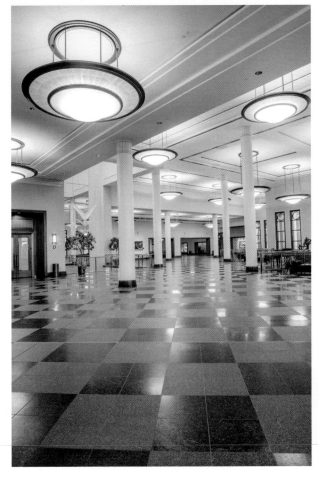

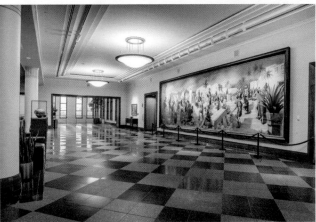

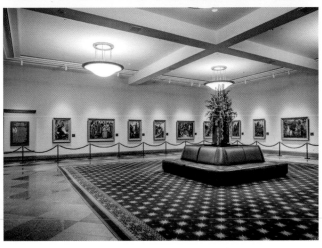

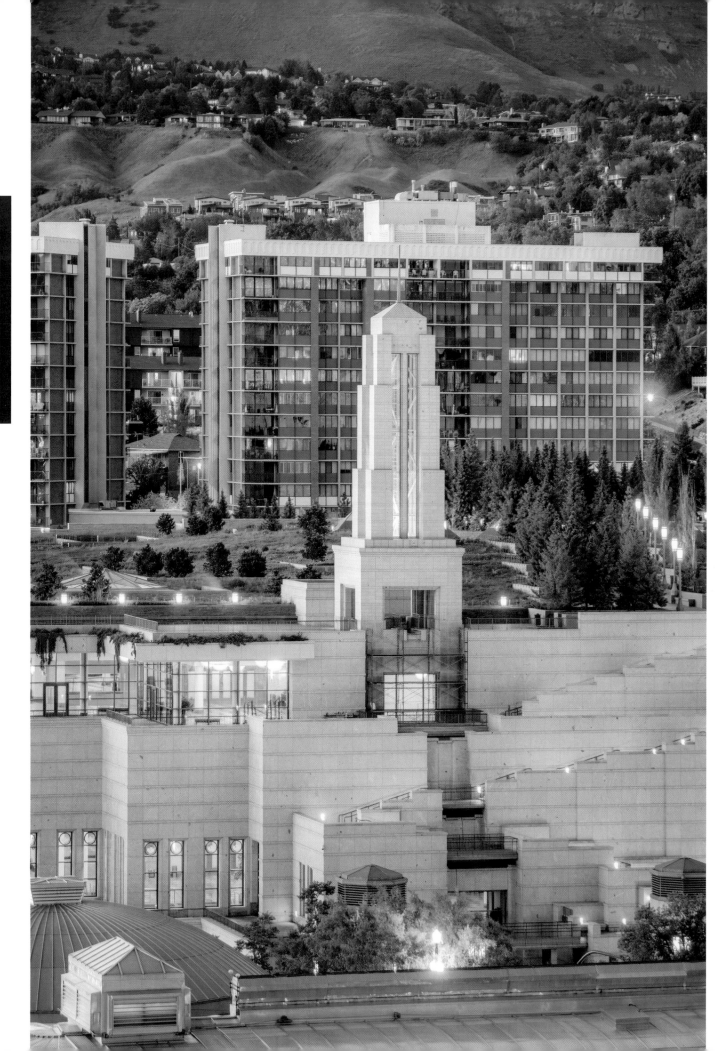

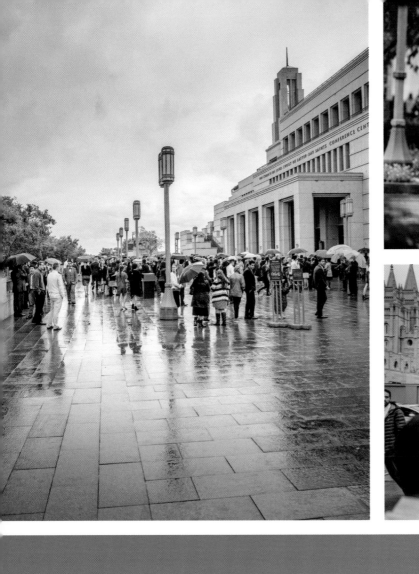

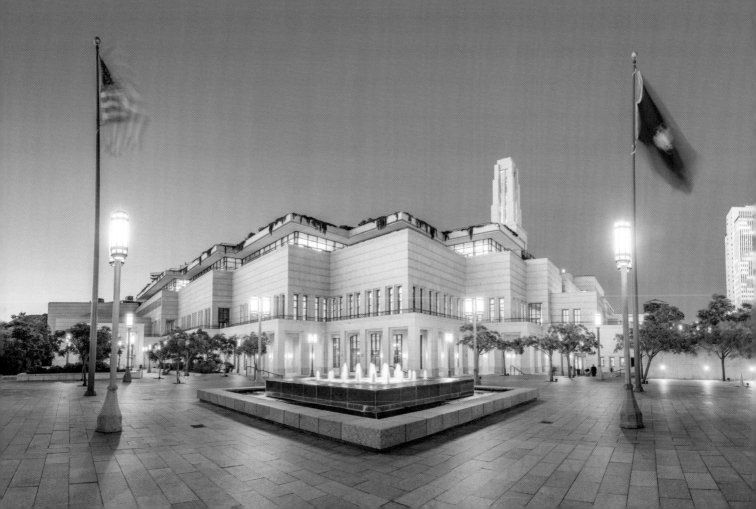

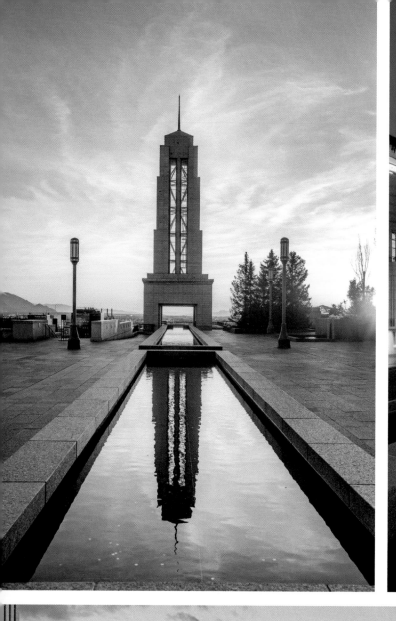

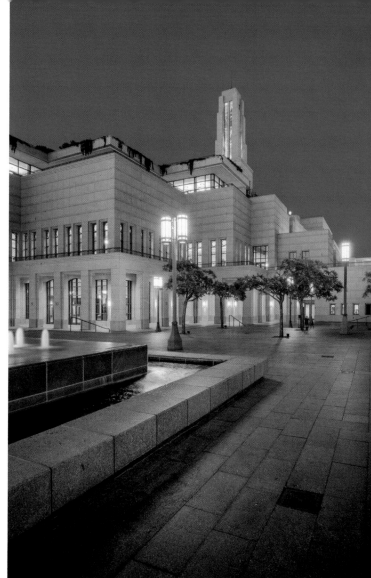

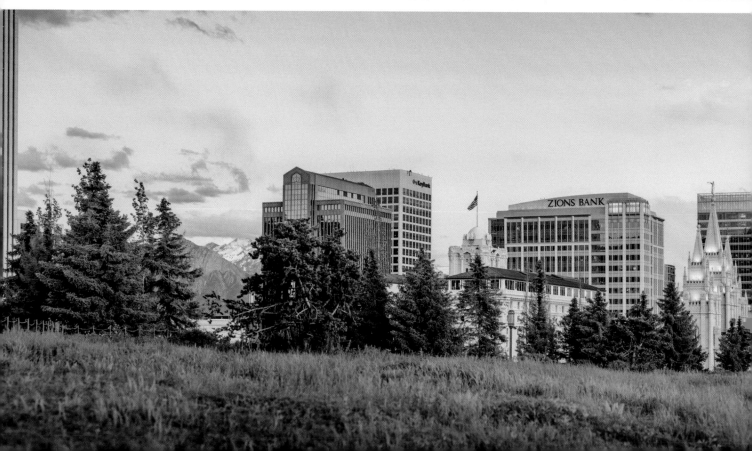

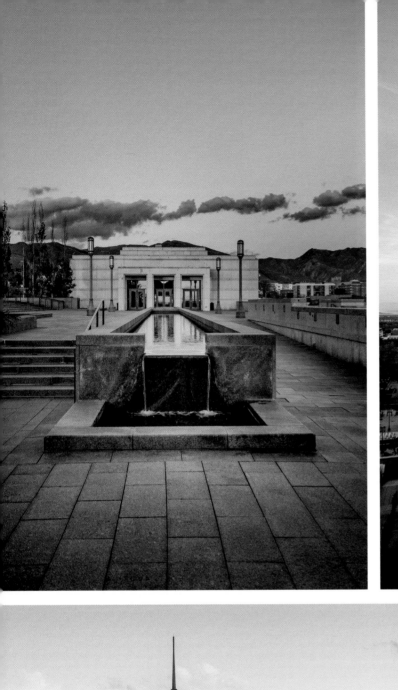
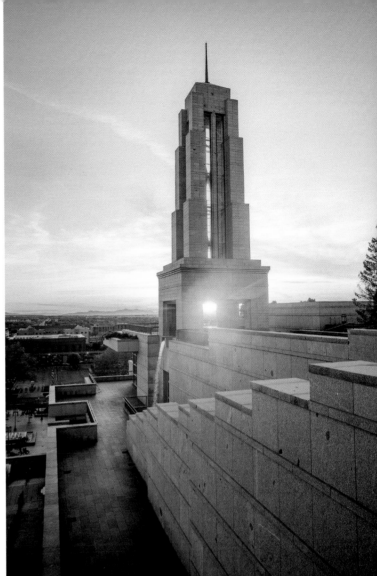
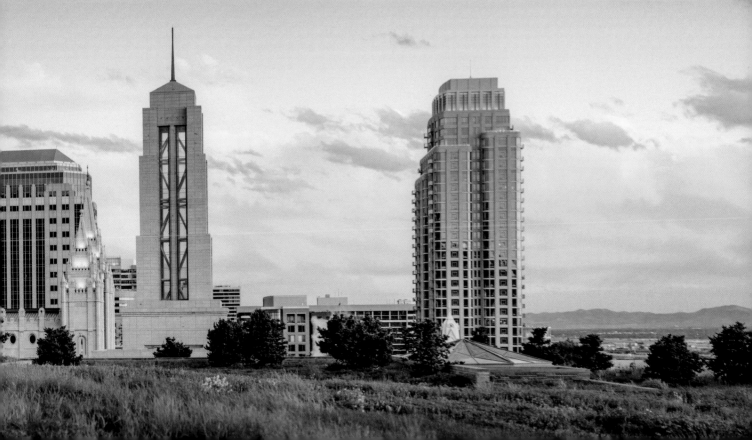

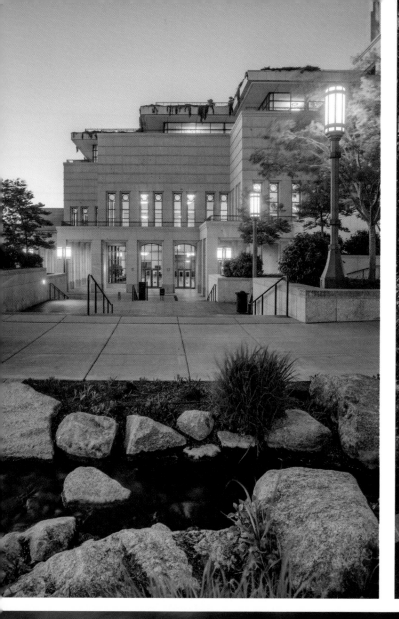

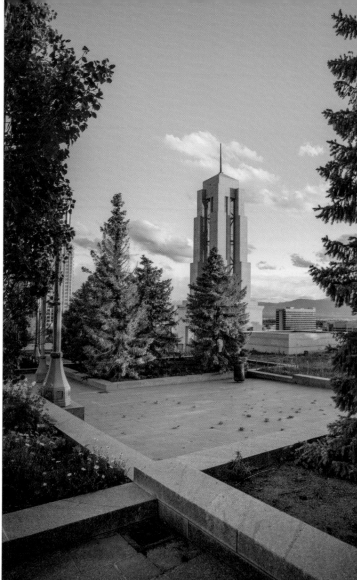

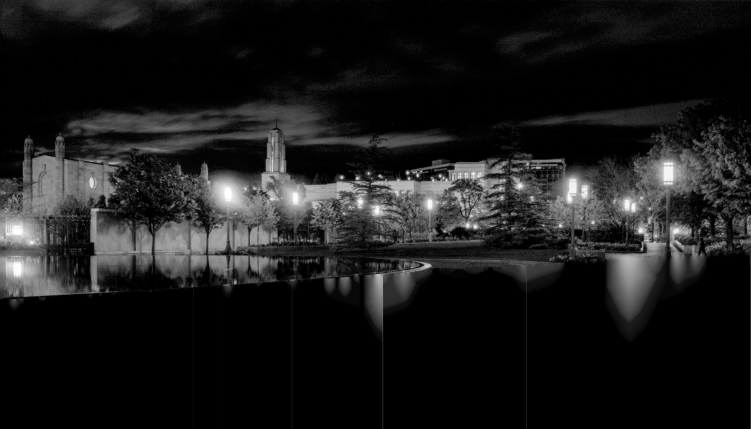

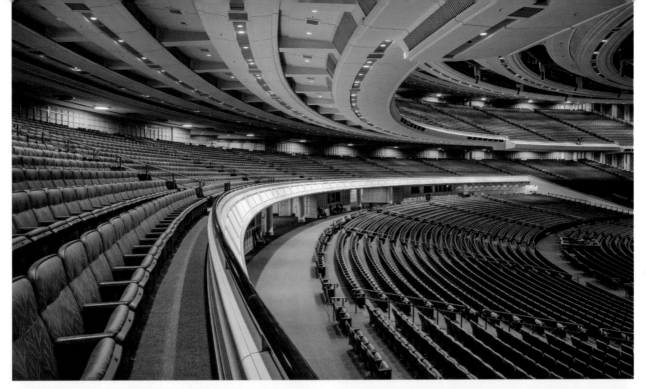

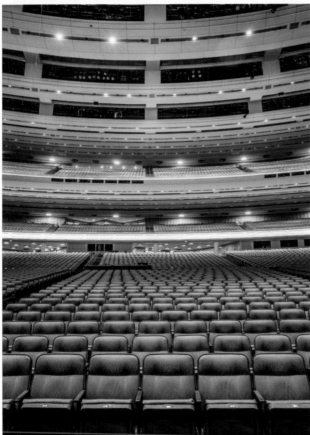

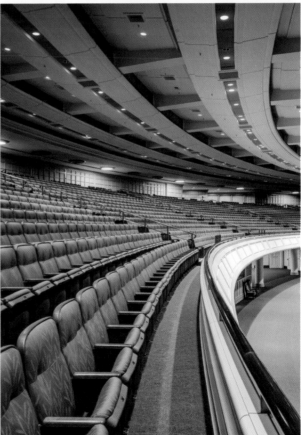

"We hope and we pray that there will continue to go forth to the world from this pulpit declarations of testimony and doctrine, of faith in the Living God, and of gratitude for the great atoning sacrifice of our Redeemer."

–Gordon B. Hinckley[7]

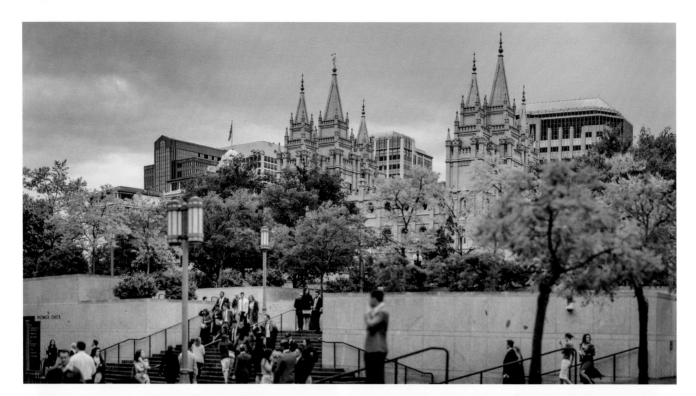

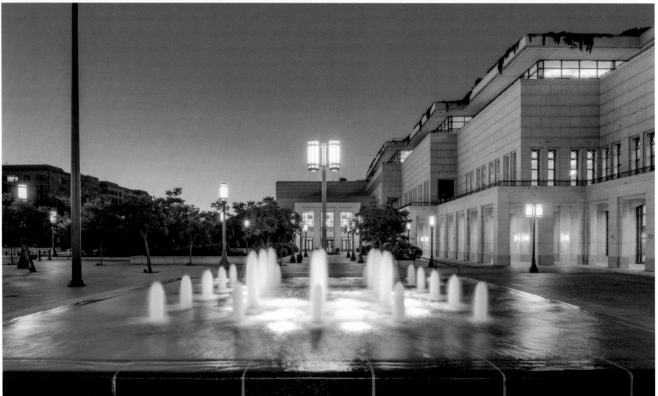

"I remember when I first attended the General Conference as a missionary of Temple Square in 2003. I was amazed by each of the 21,000 seats occupied by so many excited and humble brothers and sisters. When I saw President Gordon B. Hinckley enter, I felt his powerful, yet humble spirit filling up the room. At that moment, I knew without a doubt that he was a true prophet of God. I will never forget such a memorable experience."

—Teriirere Erena, Tahiti, French Polynesia

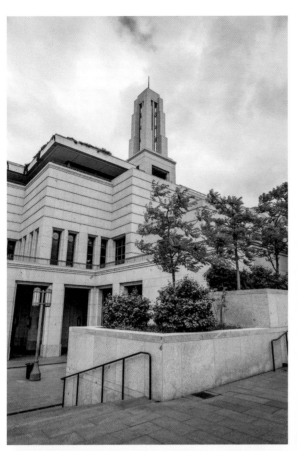

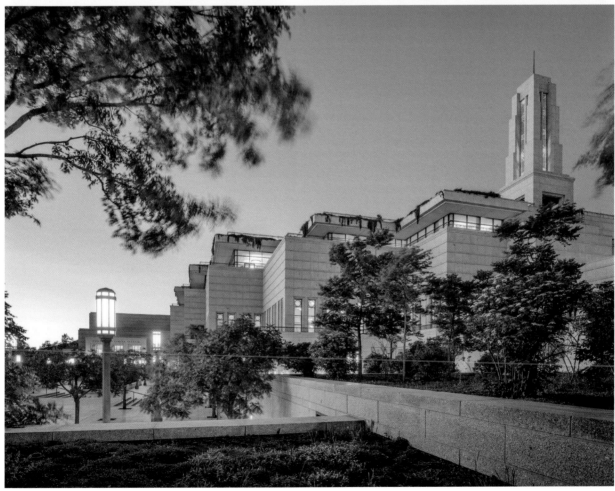

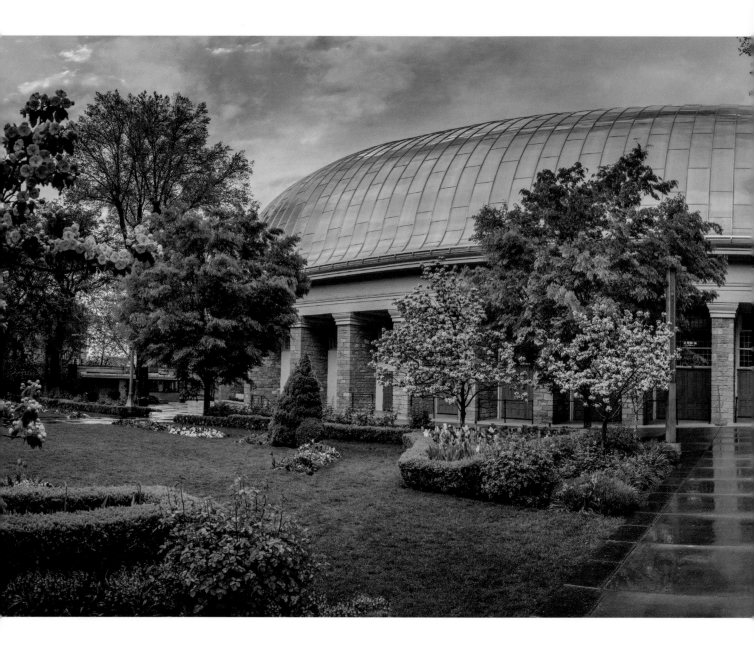

# SALT LAKE TABERNACLE

## *Interesting Facts*

- The Tabernacle was built to allow the Mormon pioneers to gather and hear the words of Brigham Young and other church leaders. Henry Grow, an architect who served as construction director, designed the roof using bridge-building techniques to avoid the need for support pillars and provide an unimpeded view to the audience. Grow's achievement earned the building its status as a Historic Civil Engineering Landmark in 1971.[8]

- The building was completed in 1867, years before the invention of the first microphone. Yet it is so acoustically perfect that they didn't need one. Visitors sitting on the back row can hear a pin drop at the pulpit 170 feet away.[9]

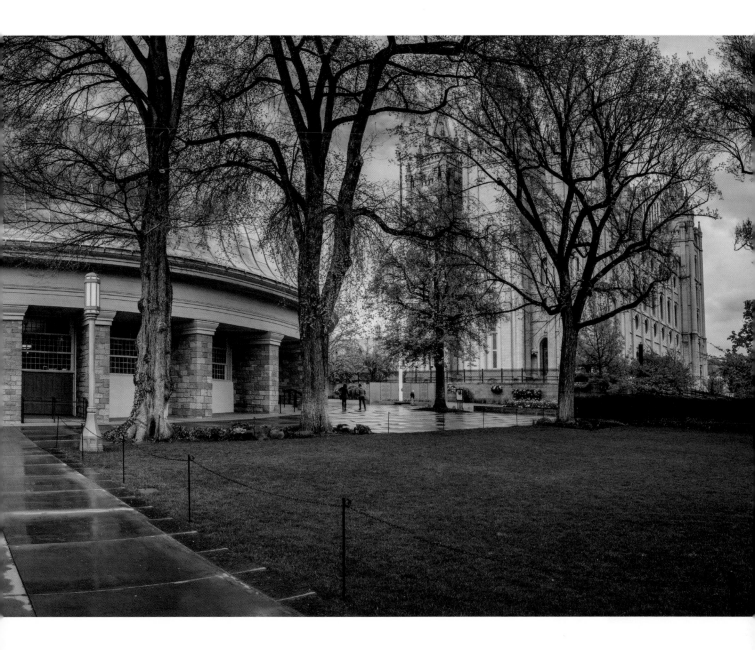

- The original pipe organ that filled the front of the Tabernacle had 700 pipes, carved from local wood. The current organ contains 11,623 pipes, ranging from 32 feet to mere inches long. 122 of them are still original.[8]

- The Tabernacle building is still the home of the Mormon Tabernacle Choir, which began as a small pioneer choir in August 1847, and currently has 360 volunteer members.[10]

- Music and the Spoken Word, performed by the Tabernacle Choir, began its weekly live broadcast in 1929, and moved from radio to television in the early 1960s. It is the longest-running continuous network broadcast in the world.[10]

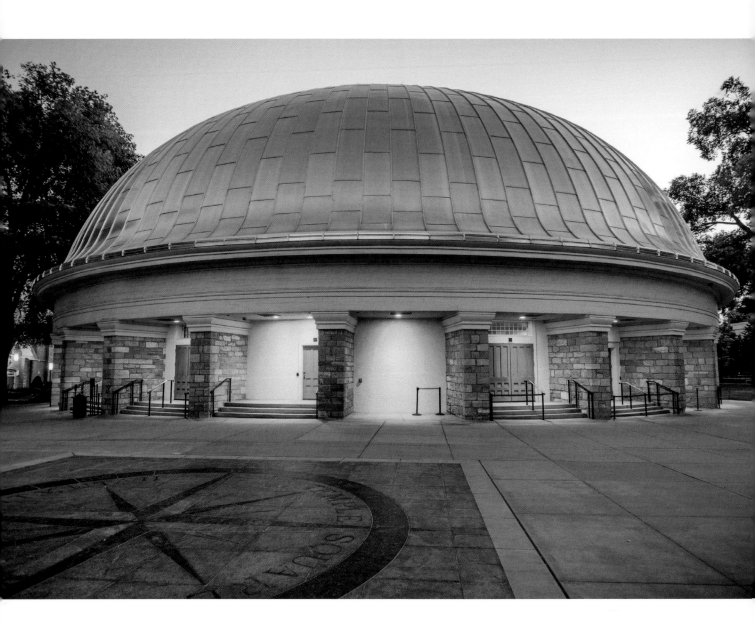

"Great events which shaped the destiny of the Church have occurred in this Tabernacle at Temple Square. ... The Tabernacle stands in the world as one of the great centers of worthy music and culture. But most of all, it stands as a standard of the Restoration of the gospel of Jesus Christ."

—Boyd K. Packer[11]

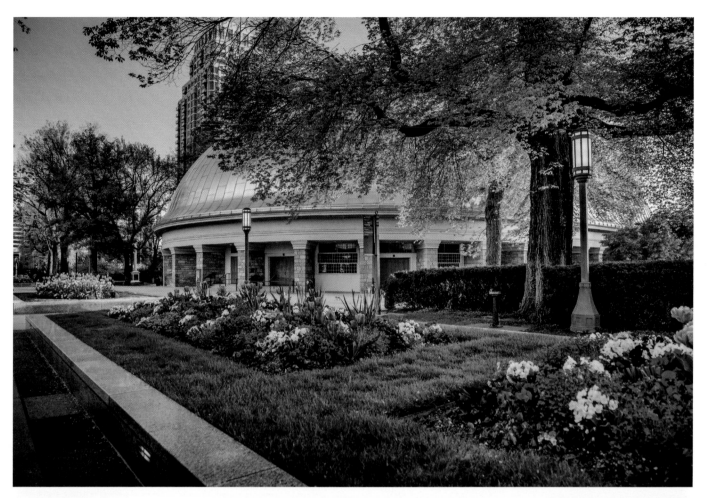

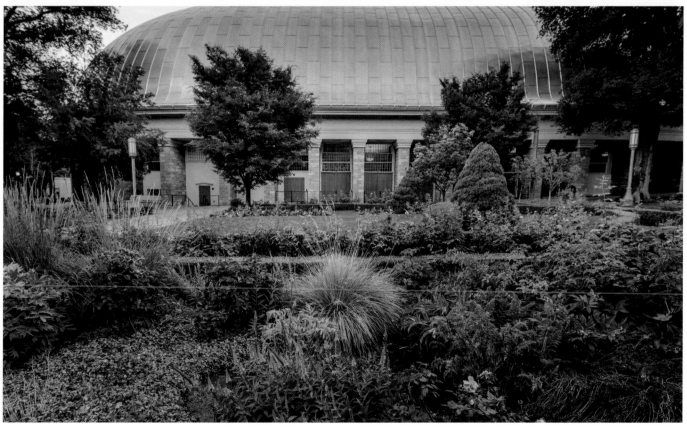

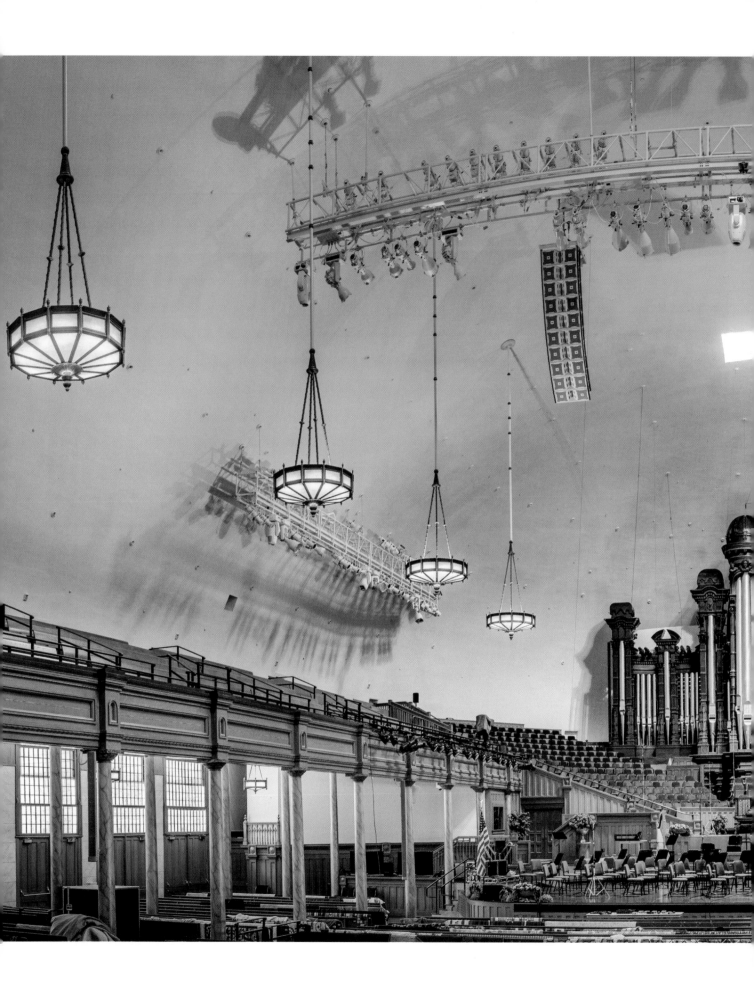

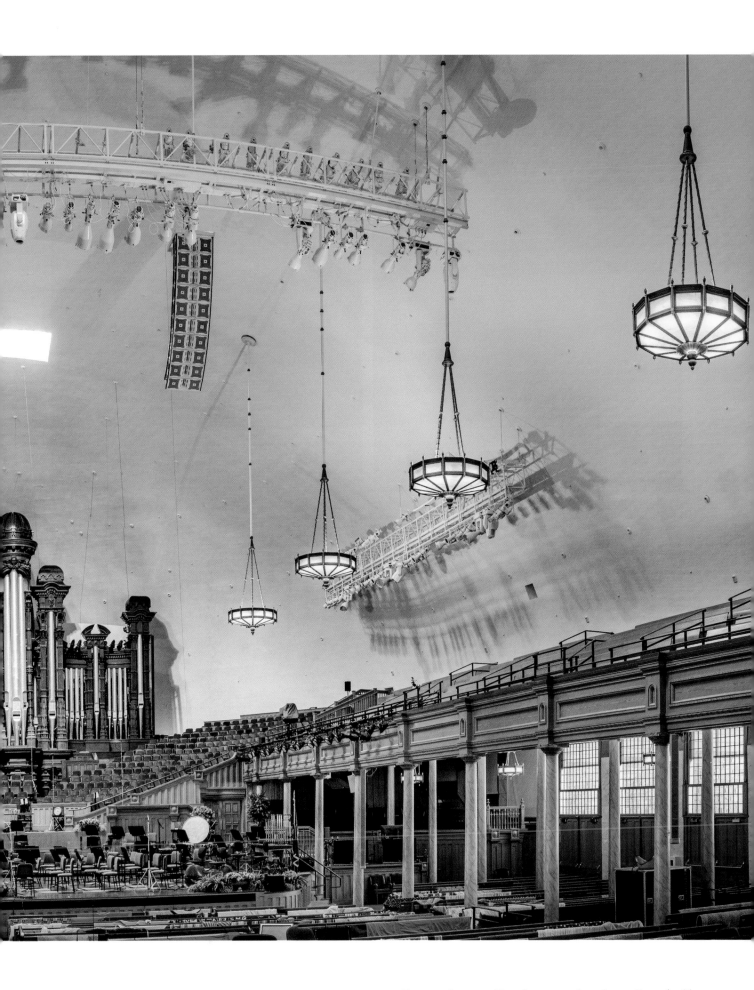

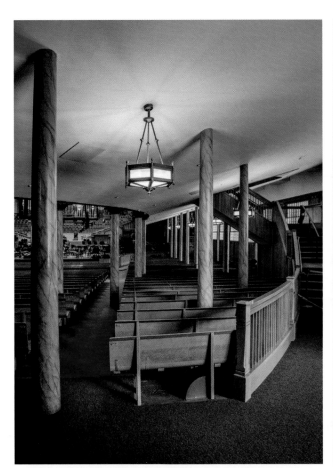

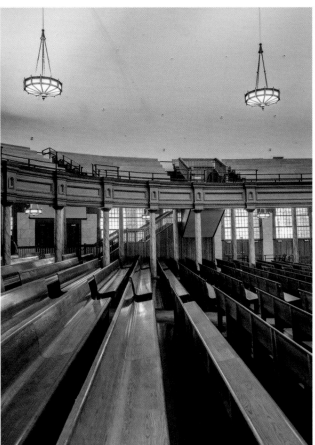

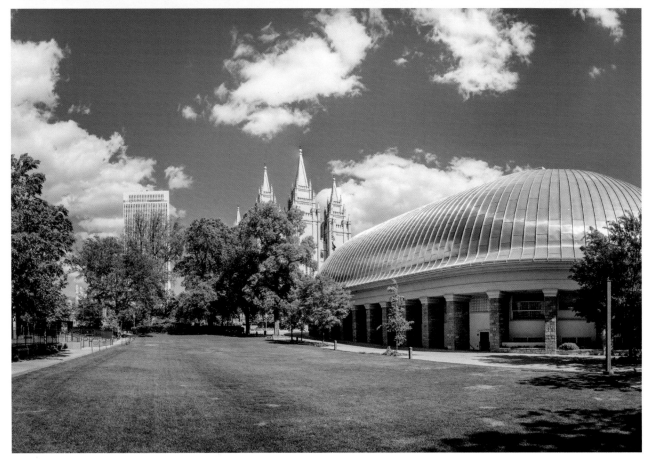

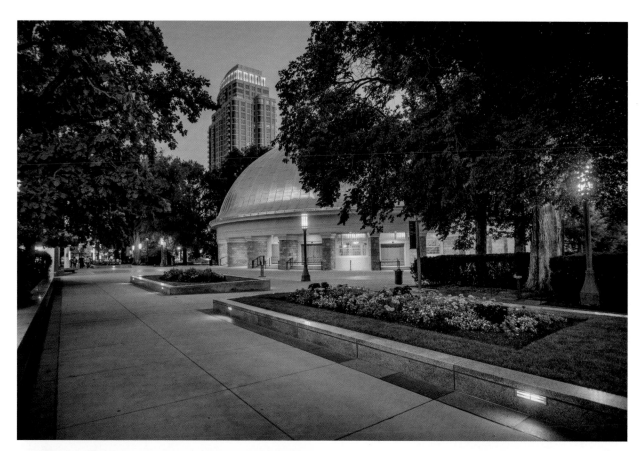

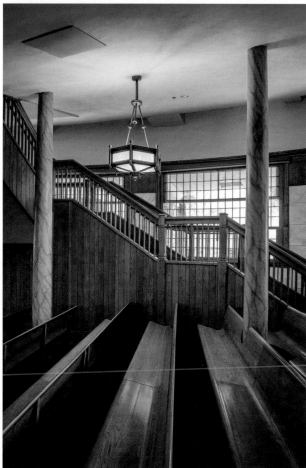

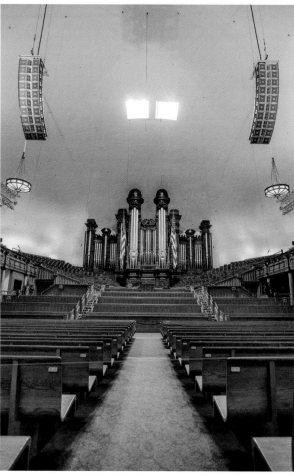

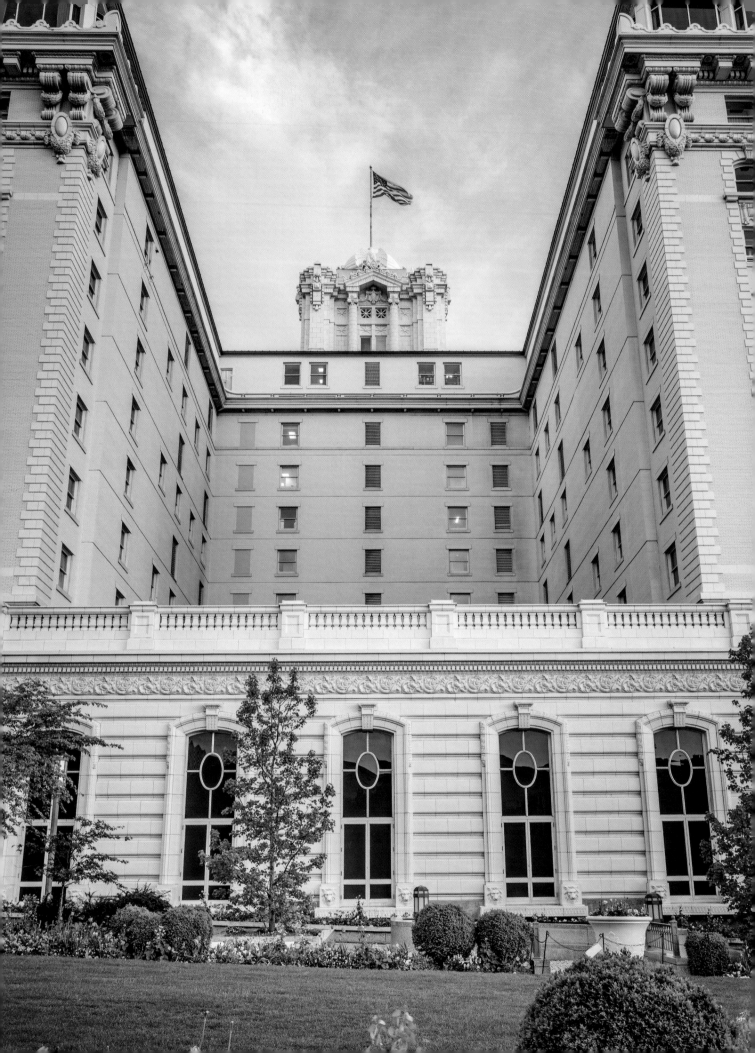

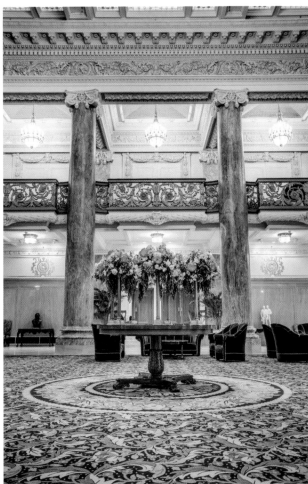

# JOSEPH SMITH MEMORIAL BUILDING

## *Interesting Facts*

- This historic building first opened in 1911 as Hotel Utah. The hotel continued for 76 years, earning a reputation for its elegance and service. In fact, in the hotel's inaugural year, William Howard Taft became the first of many US presidents to stay in a suite.[12]

- Jewish industrialist Samuel Newhouse came up with the idea for Hotel Utah. He and a multi-faith group of citizens presented the proposal to Joseph F. Smith, then president of the LDS Church. Smith was excited by the idea of a hotel on Temple Square and offered his support. The church became the business's majority shareholder.[13]

- Following a complete renovation from 1987 to 1993, the hotel reopened as the Joseph Smith Memorial Building.[12]

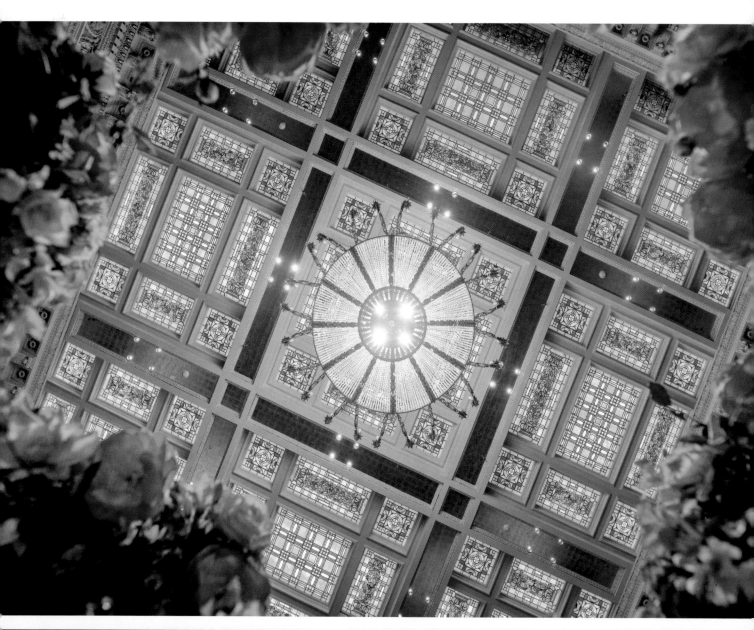

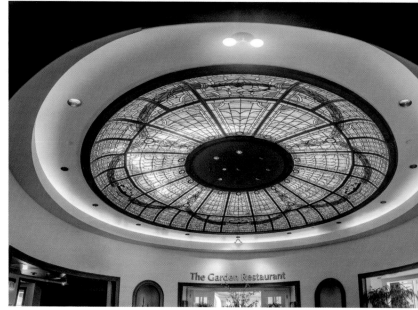

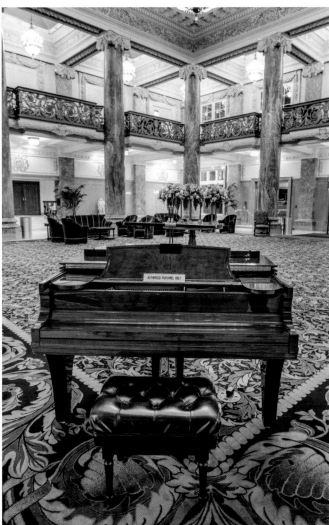

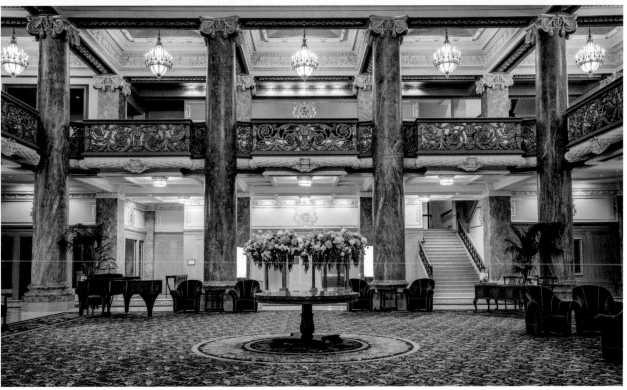

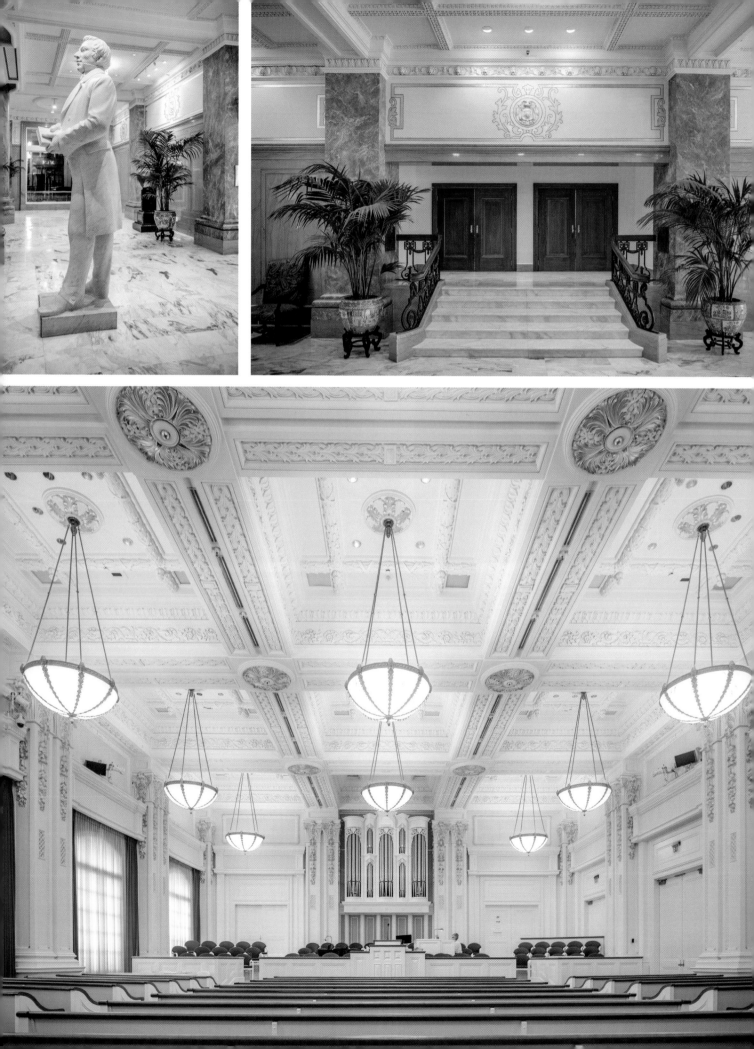

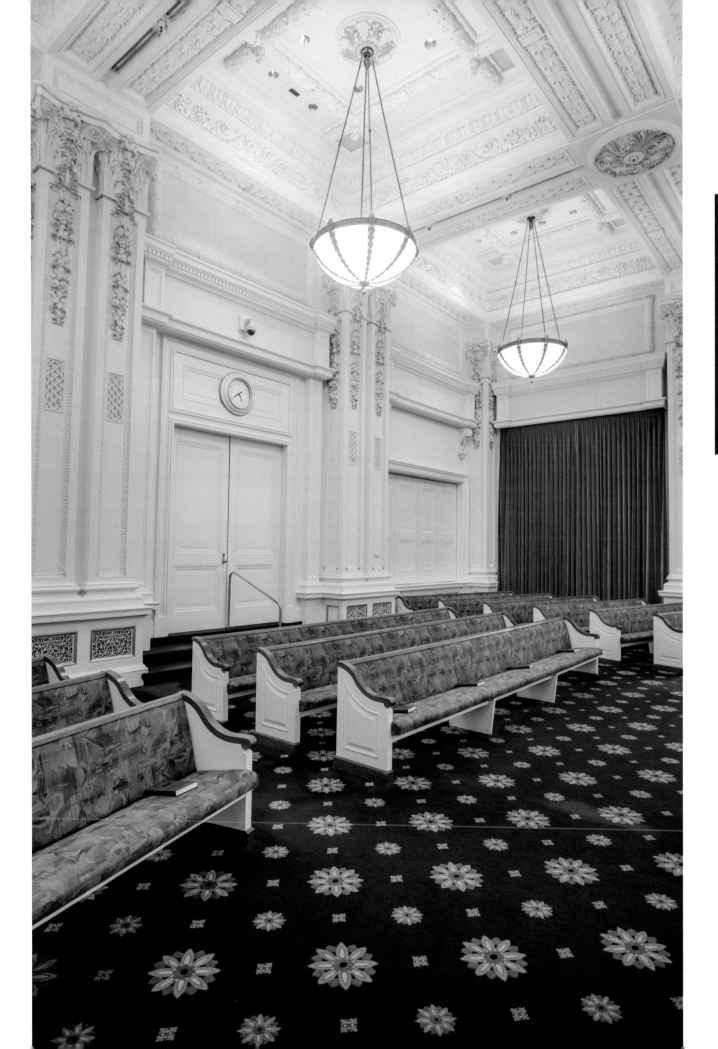

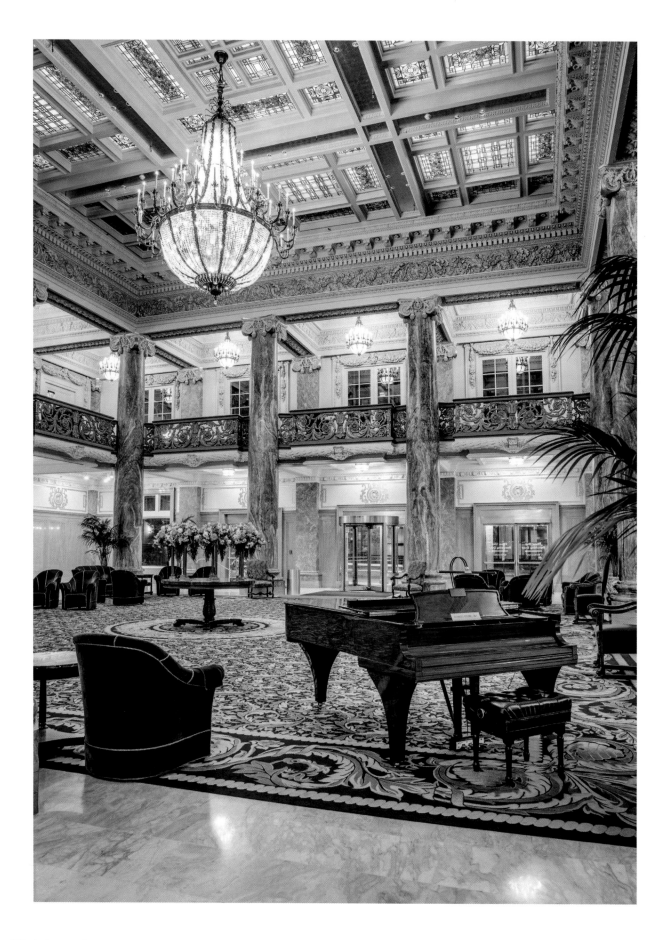

"There is not a hotel from the Atlantic to the Pacific which has the elegance
and comfort and the general beauty possessed by the Hotel Utah."

—Deseret Evening News[14]

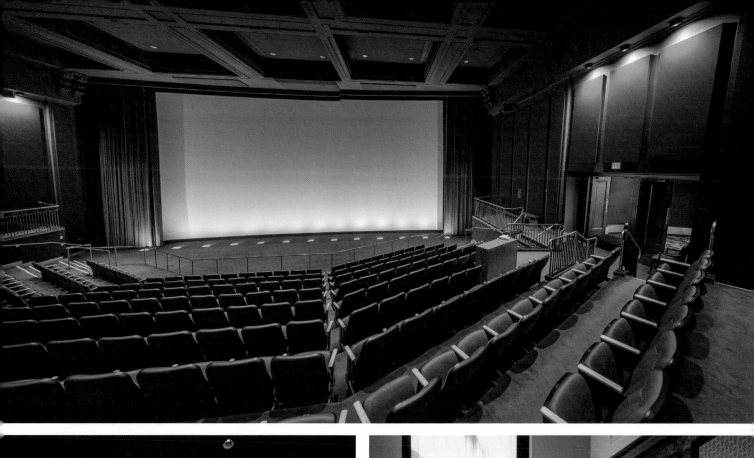

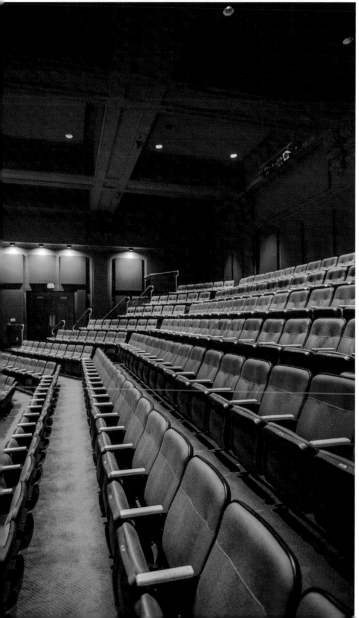

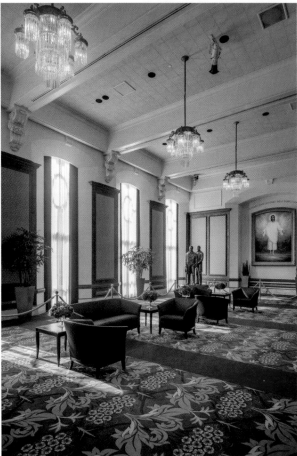

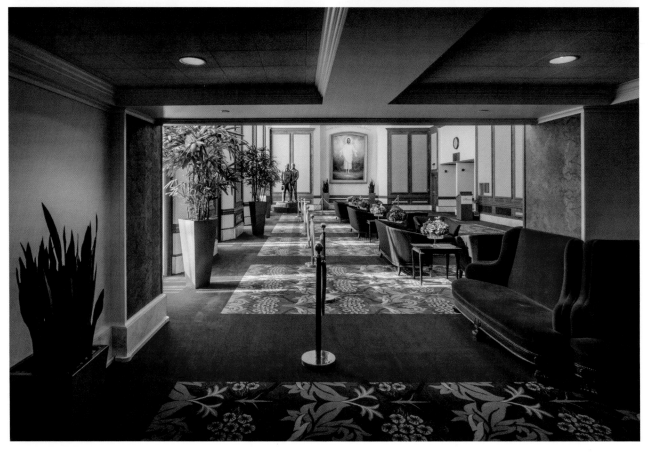

JOSEPH SMITH BUILDING

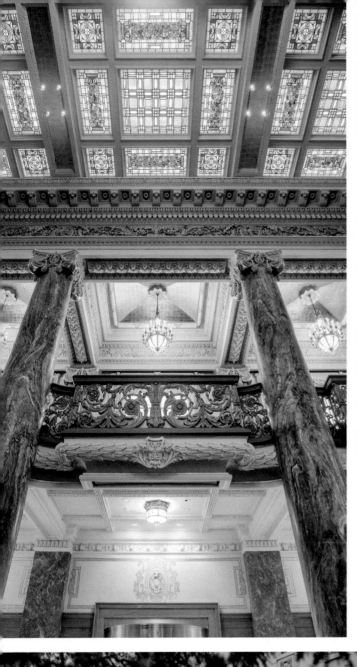

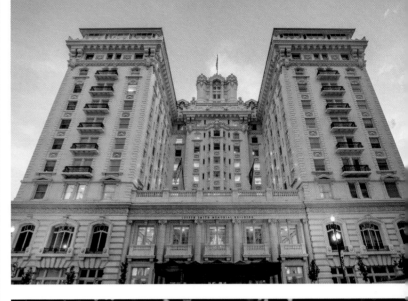

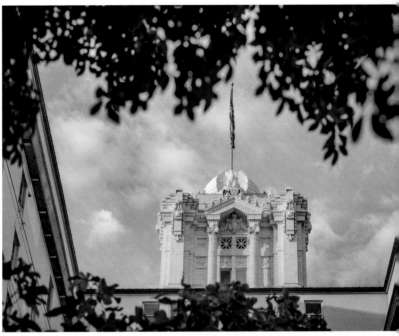

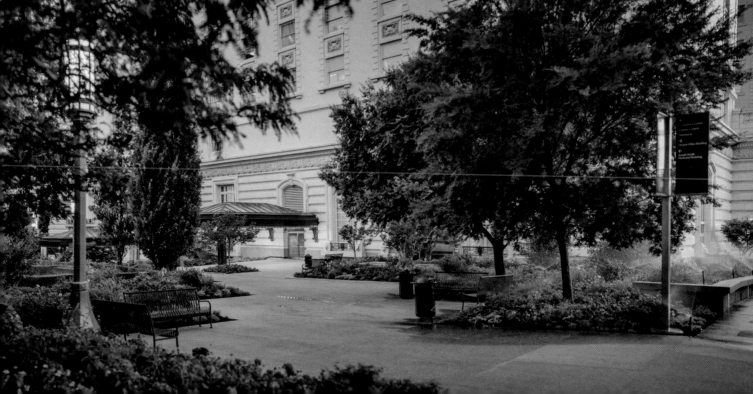

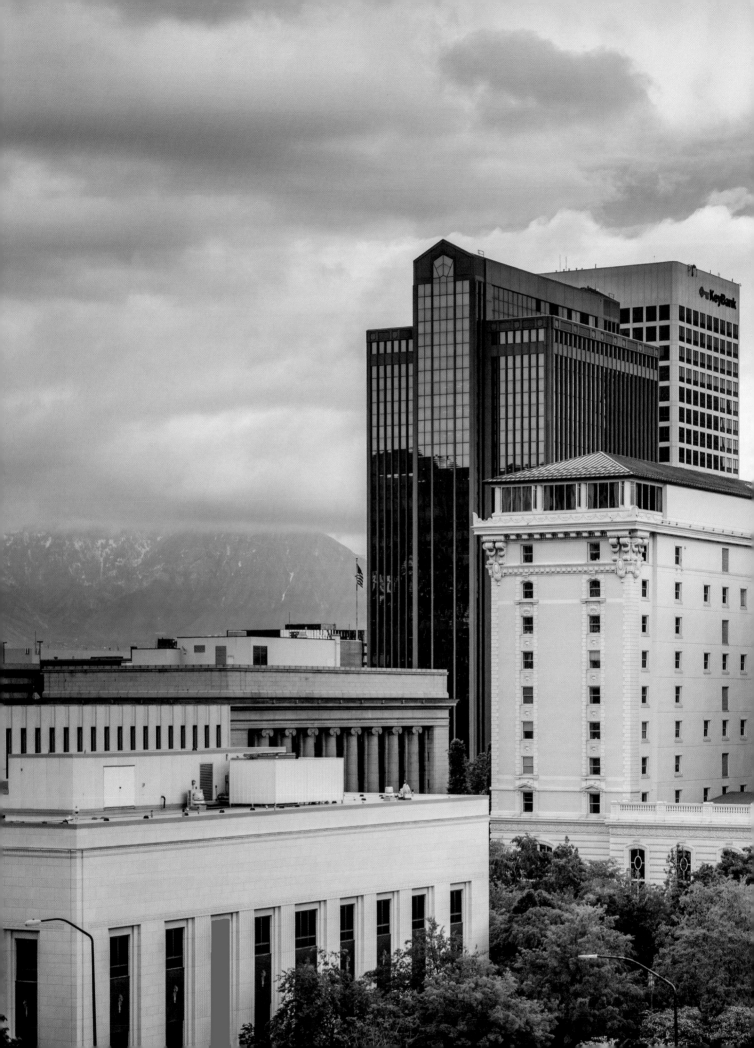

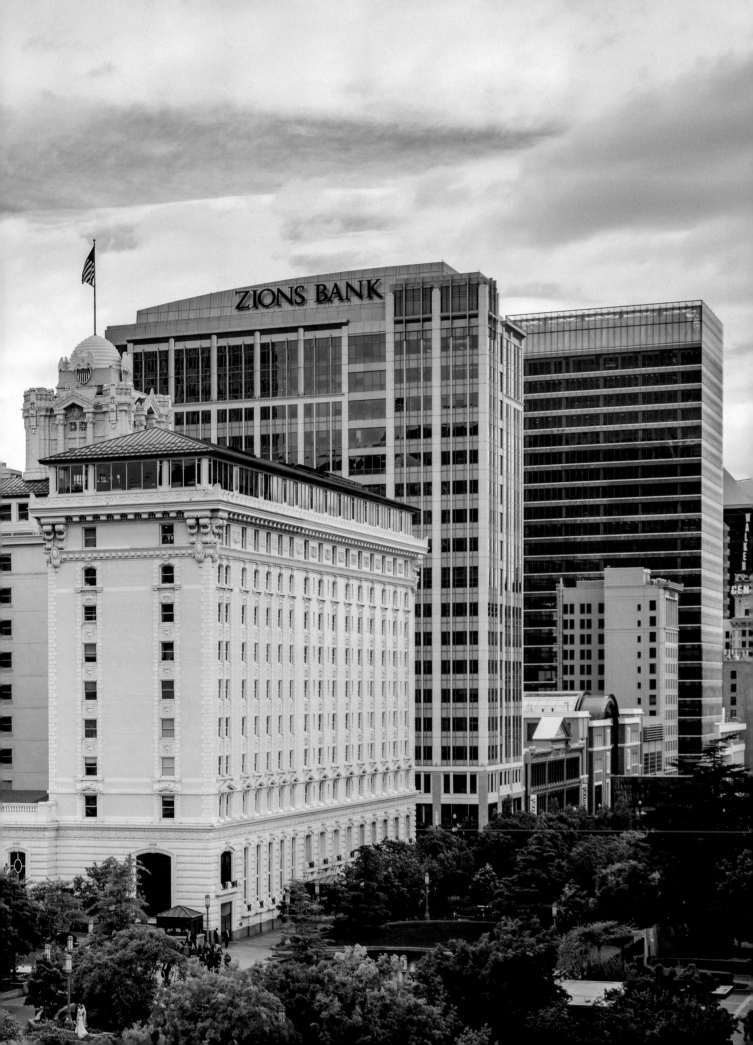

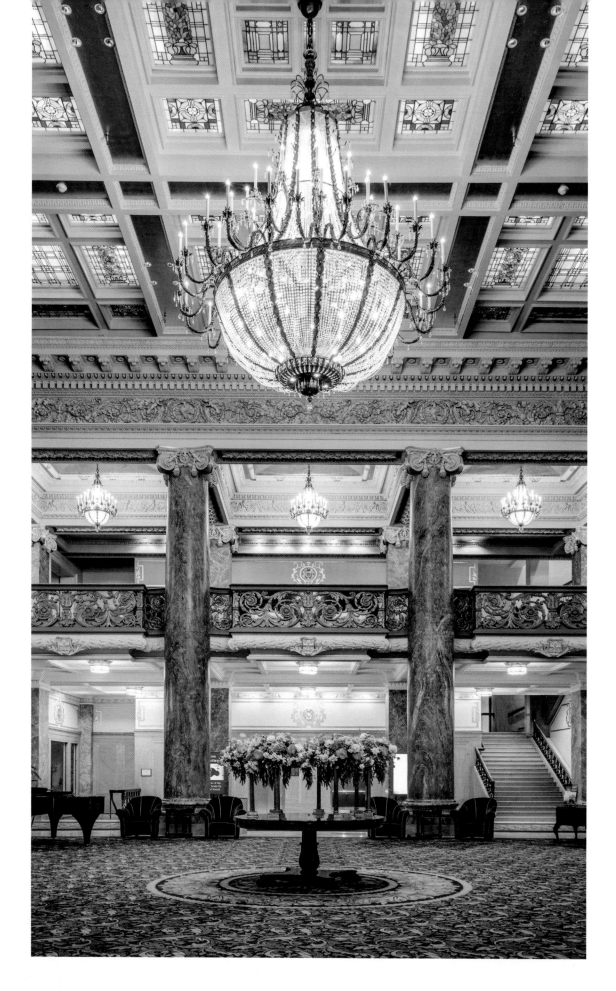

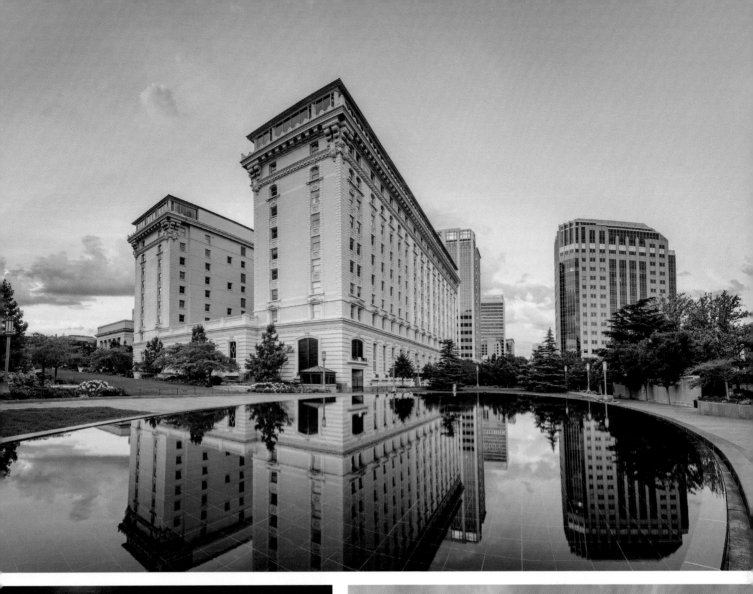

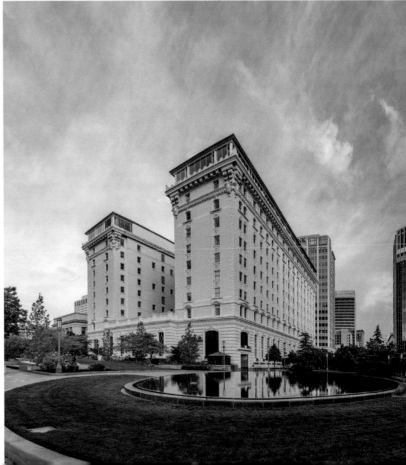

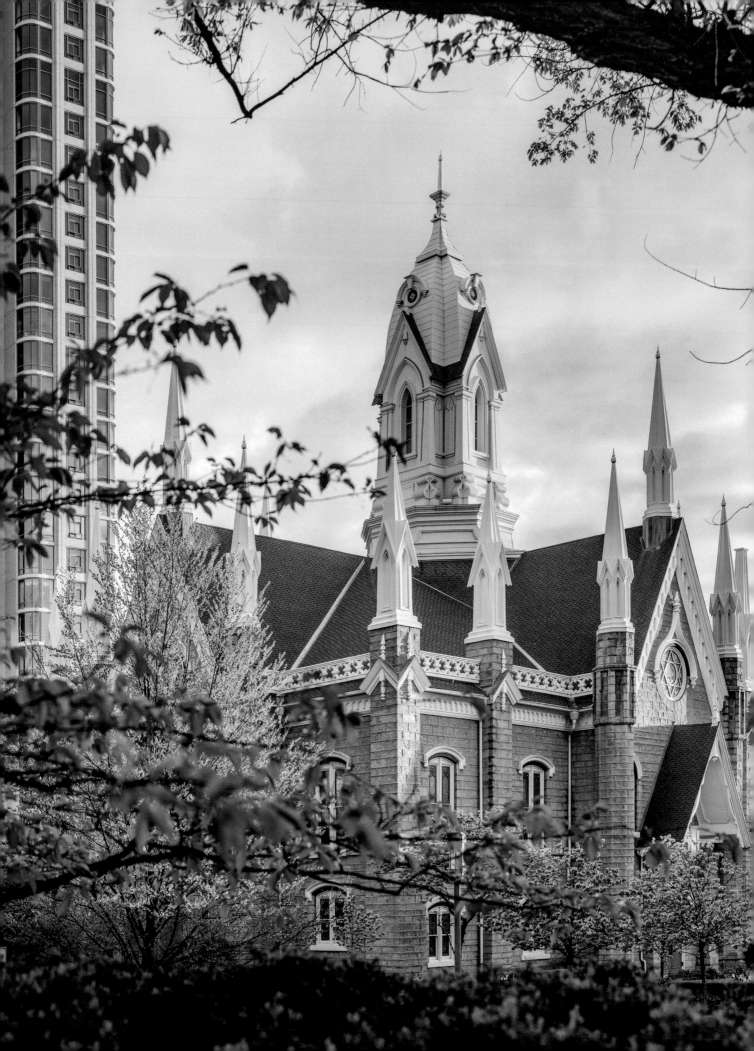

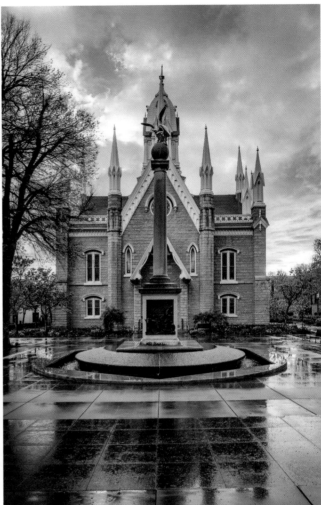

# SALT LAKE ASSEMBLY HALL

## *Interesting Facts*

- Assembly Hall is one of the most historic buildings on Temple Square. In 1877, Brigham Young suggested building a large "tabernacle" that would enable several congregations in the Salt Lake Stake to worship together. The hall was dedicated in January 1882.[15]

- The Gothic-style building was constructed with granite from the same quarry as the Salt Lake Temple.[16]

- In February 1983, the church completed renovations to the hundred-year-old building, repairing and restoring it.[15]

- The current pipe organ in the hall has 3,501 pipes and was specially chosen to complement the Tabernacle organ, but retain a unique voice.[15]

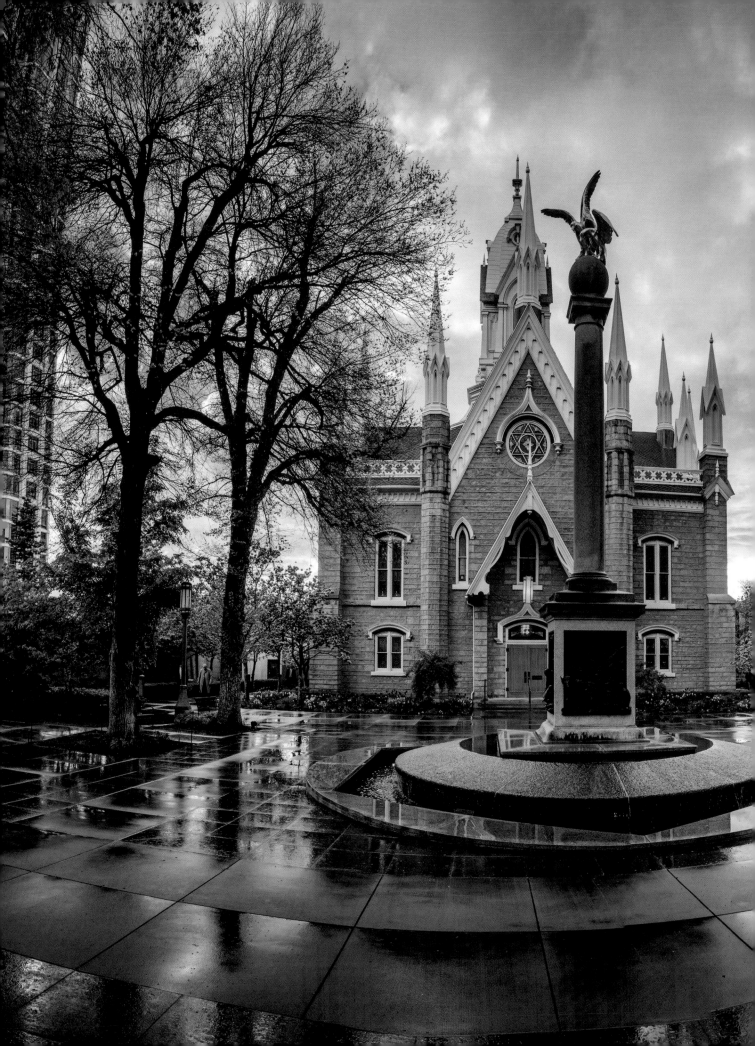

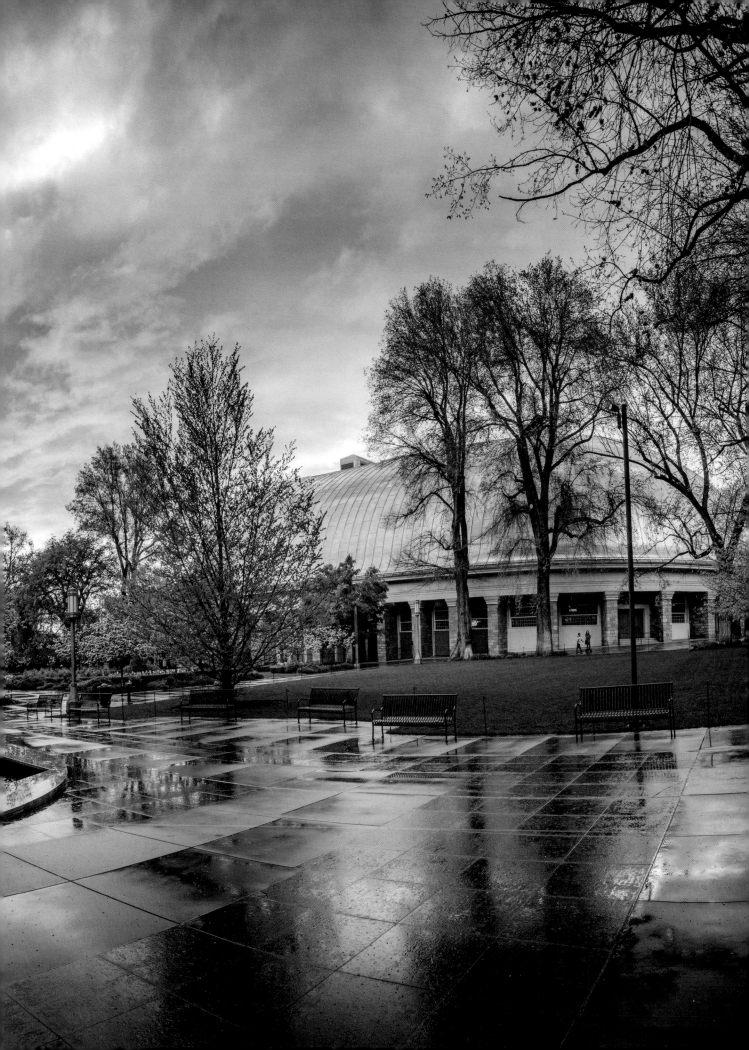

"The Assembly Hall has a special spirit to it as you enter the building. It's the knowledge that the pioneers spent time here worshiping and helping one another. It's such a beautiful place!"

–Helen Stolp, Salt Lake City, UT

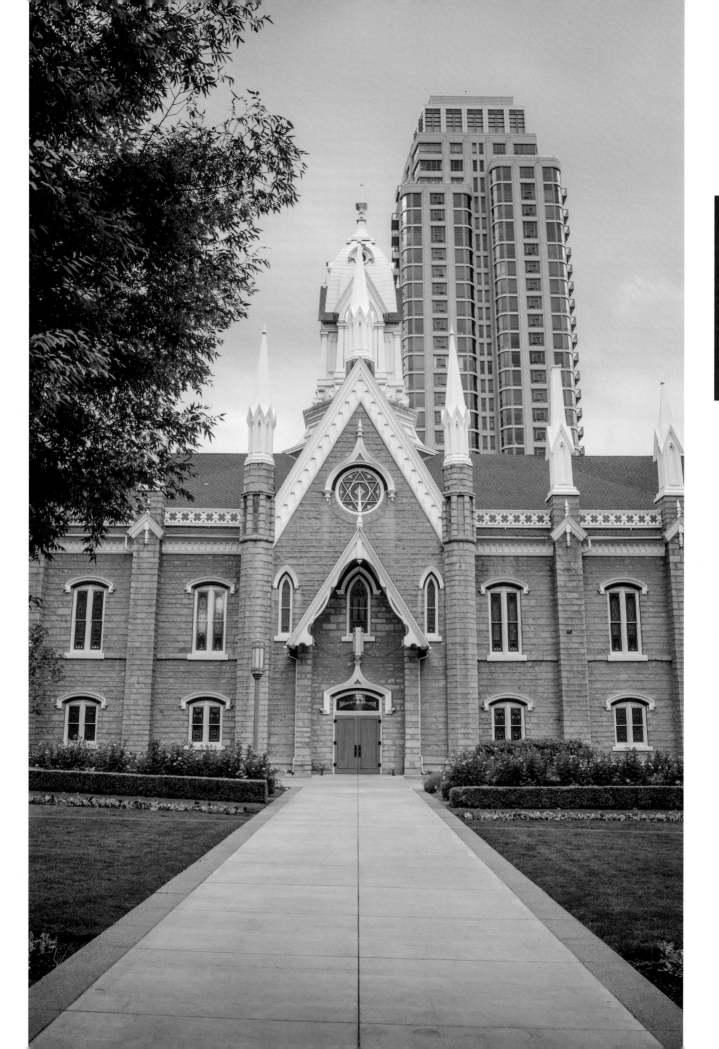

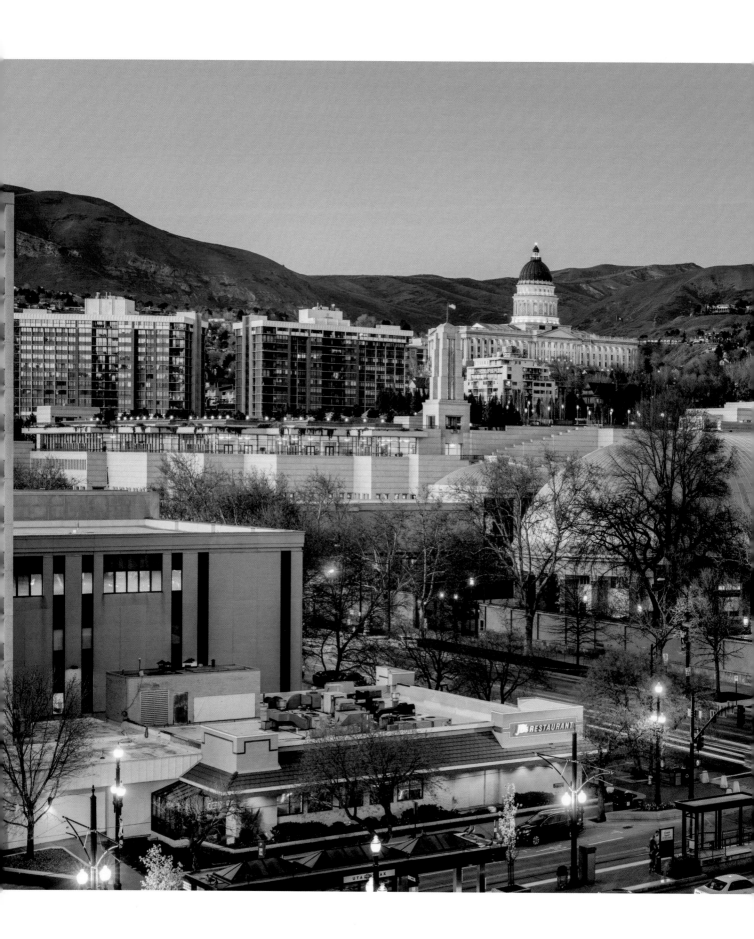

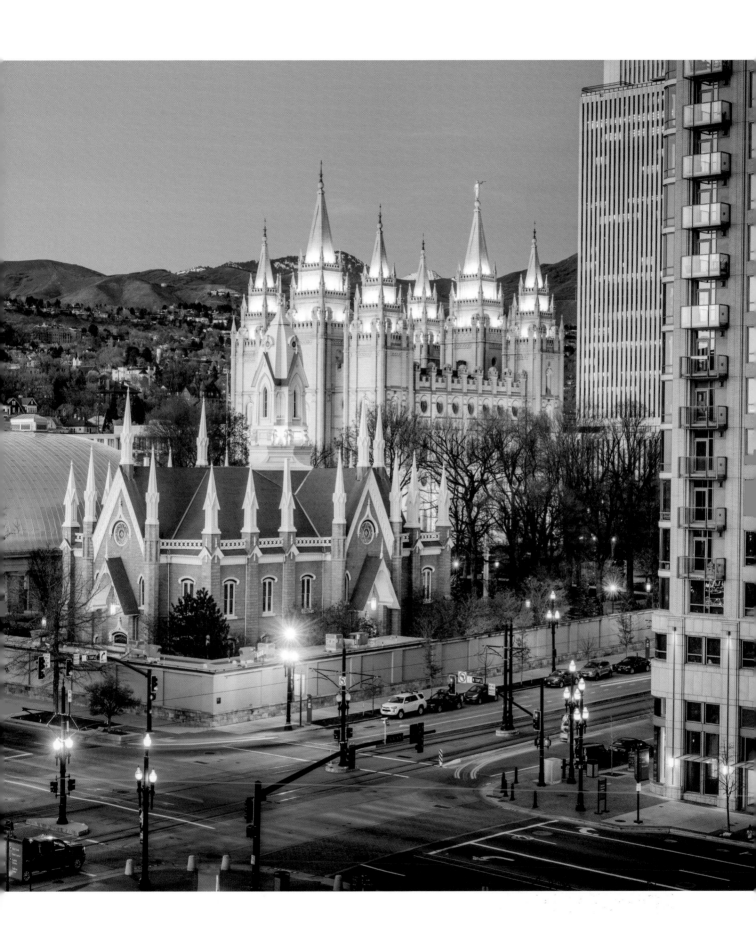

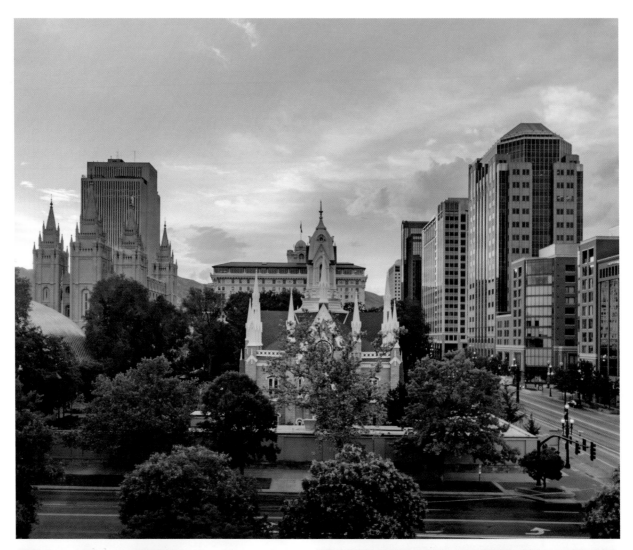

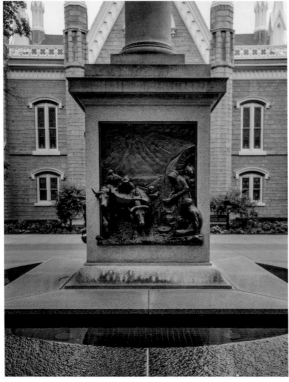

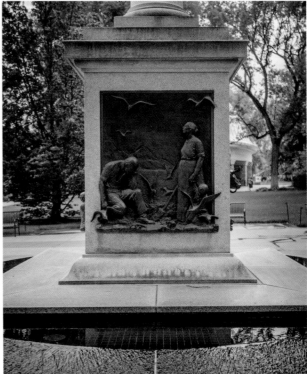

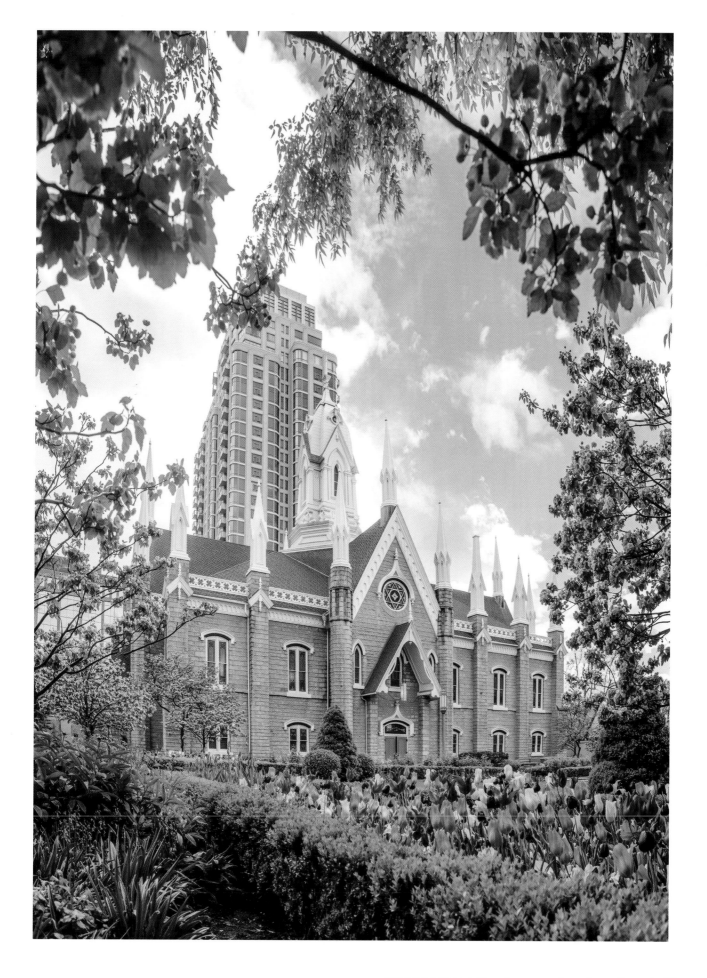

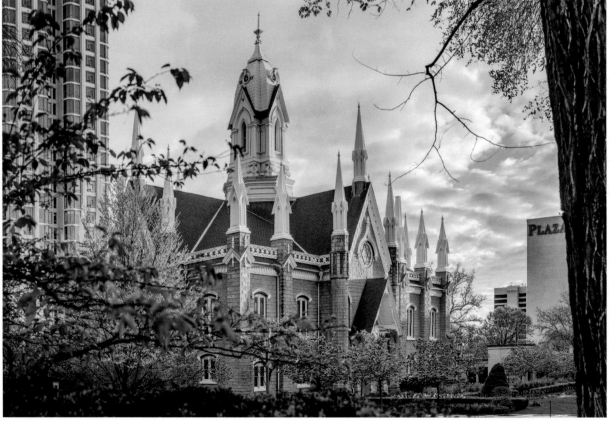

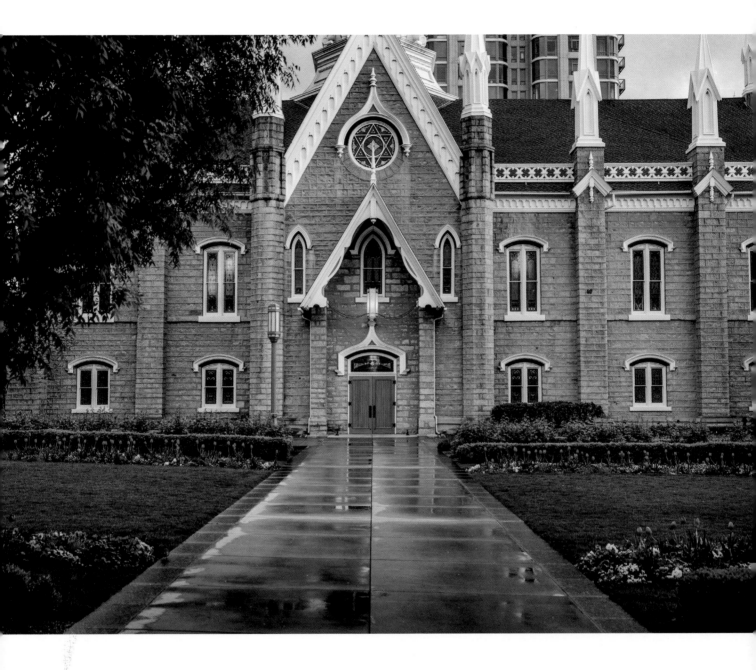

"The Assembly Hall is one of the very precious buildings of the Church; it's a real treasure."

—Emil B. Fetzer, Church architect

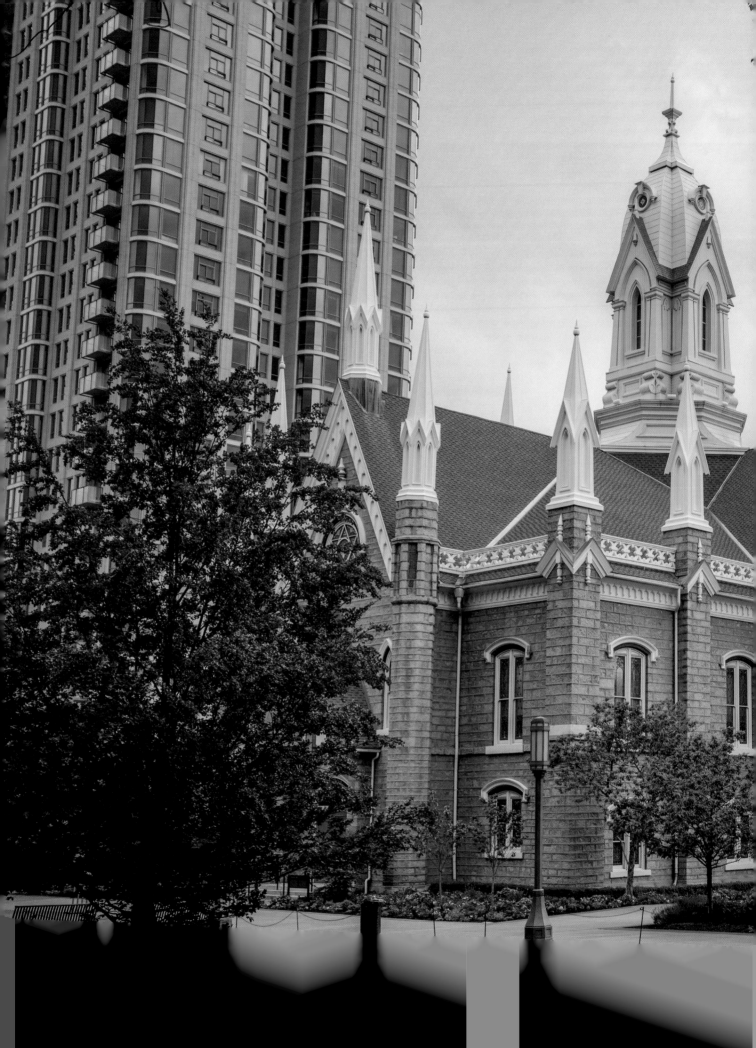

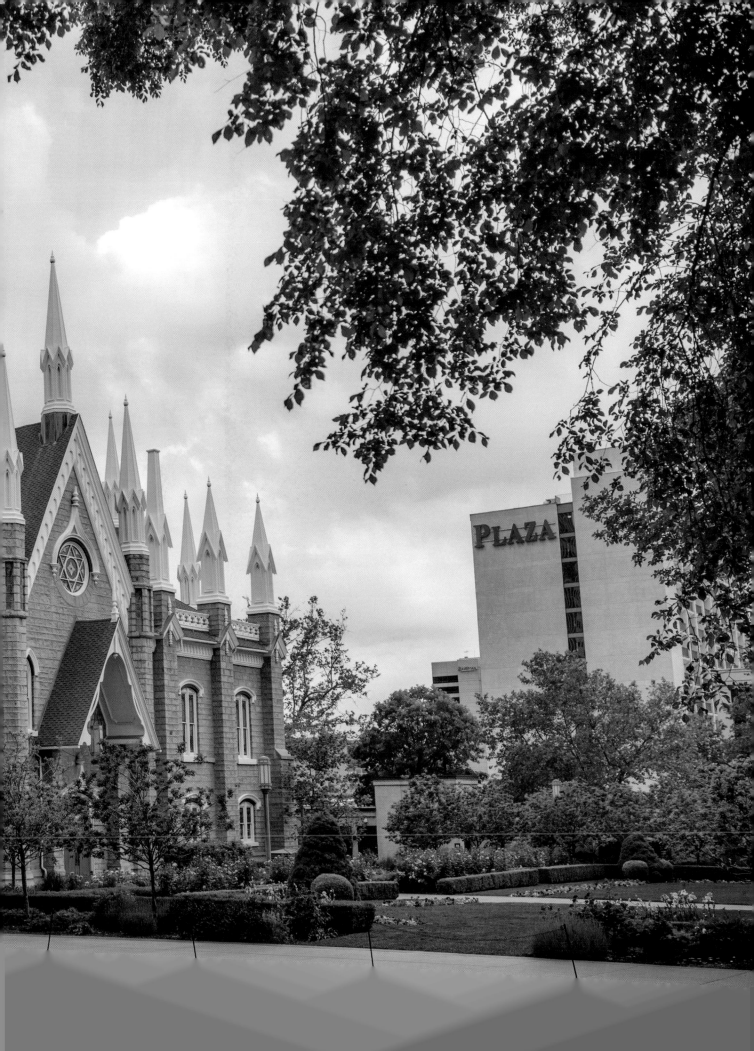

# VISITOR'S CENTERS

## *Interesting Facts*

- The first visitors centers were built on Temple Square in 1902, 1904, and 1910. However, as the number of visitors increased, the LDS Church realized there was a need for additional exhibit space. In 1963, it opened today's north visitors center, which includes theaters, artwork, dioramas, and other displays.[17]

- The crowning jewel of the north visitors center is the Christus statue, a replica of the masterpiece sculpted by the Danish artist Bertel Thorvaldsen. After seeing the original Christus for the first

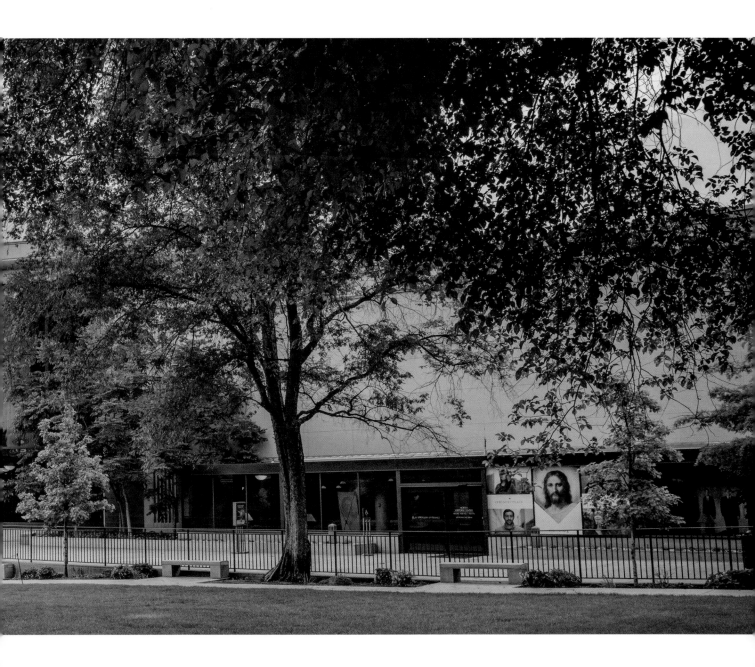

time at the Church of Our Lady in Copenhagen, President Spencer W. Kimball said, "the man who created [this statue] was surely inspired of the Lord."[18]

- Preliminary plans for the north visitors center had the Christus displayed outside, but concerns that the elements would damage the statue led the architects to create a special room for it instead. The figure was so large that during construction, workers had to lower the 11-foot-tall, 12,000-pound statue into the site and then build the rotunda around it.

- The south visitors center was dedicated in 1978. Its exhibits focus on God's plan for His children and the importance of the family.[17]

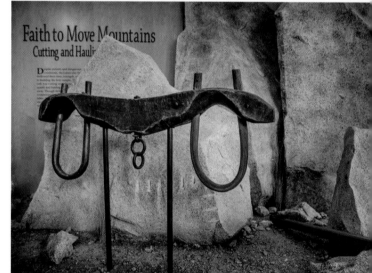

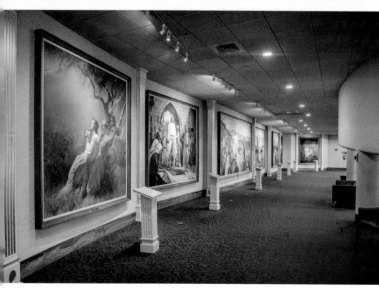

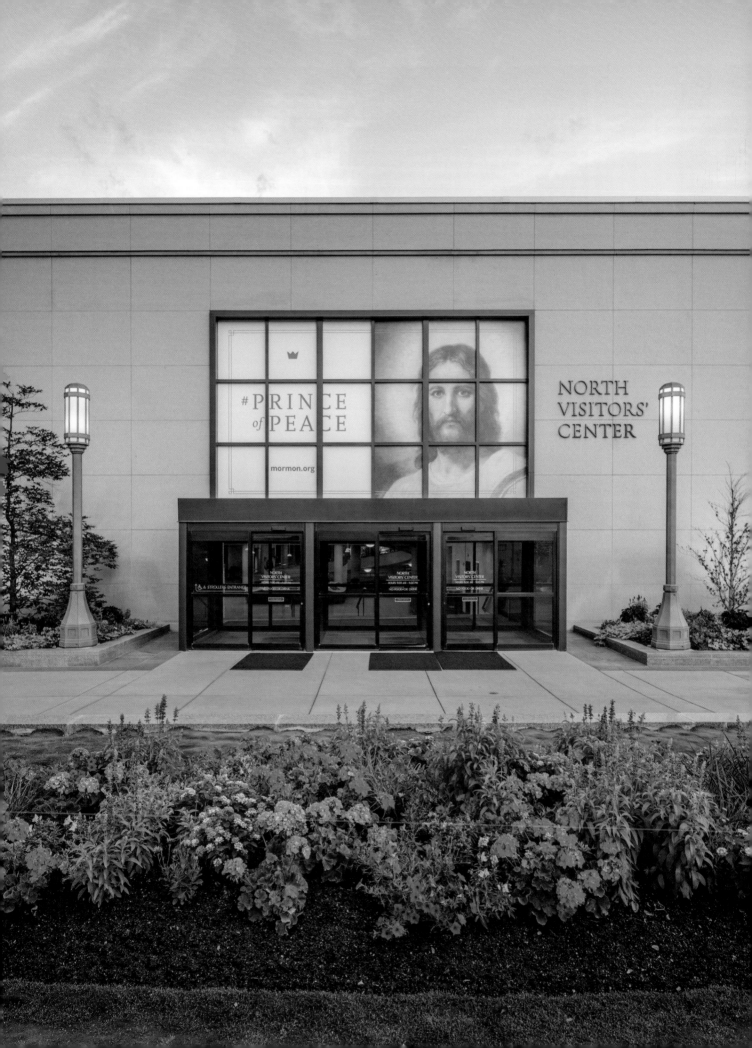

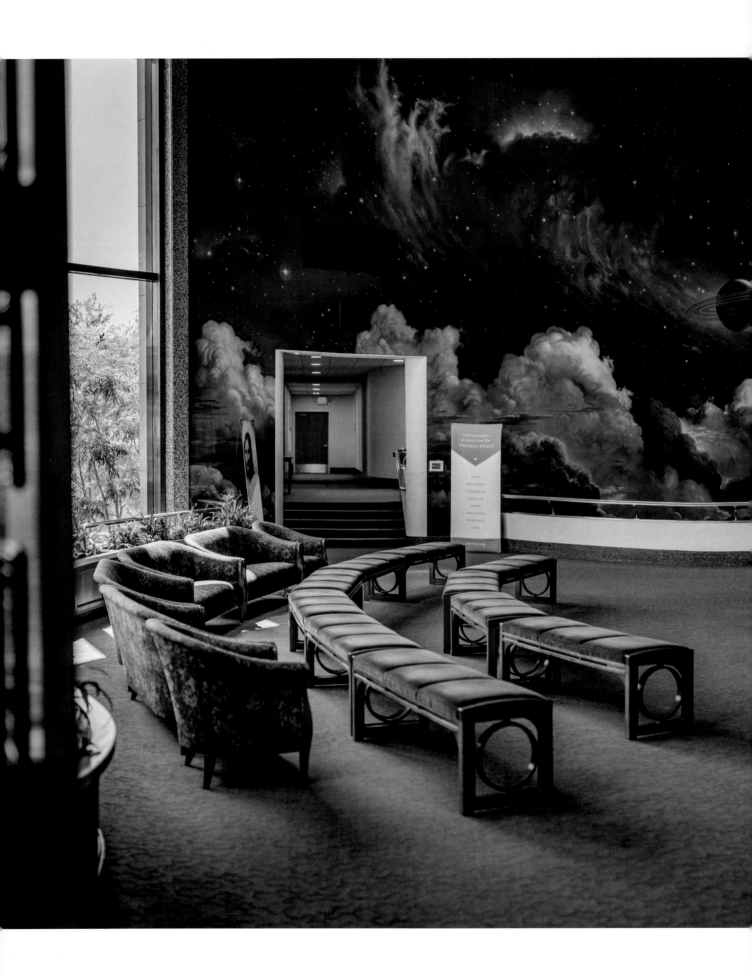

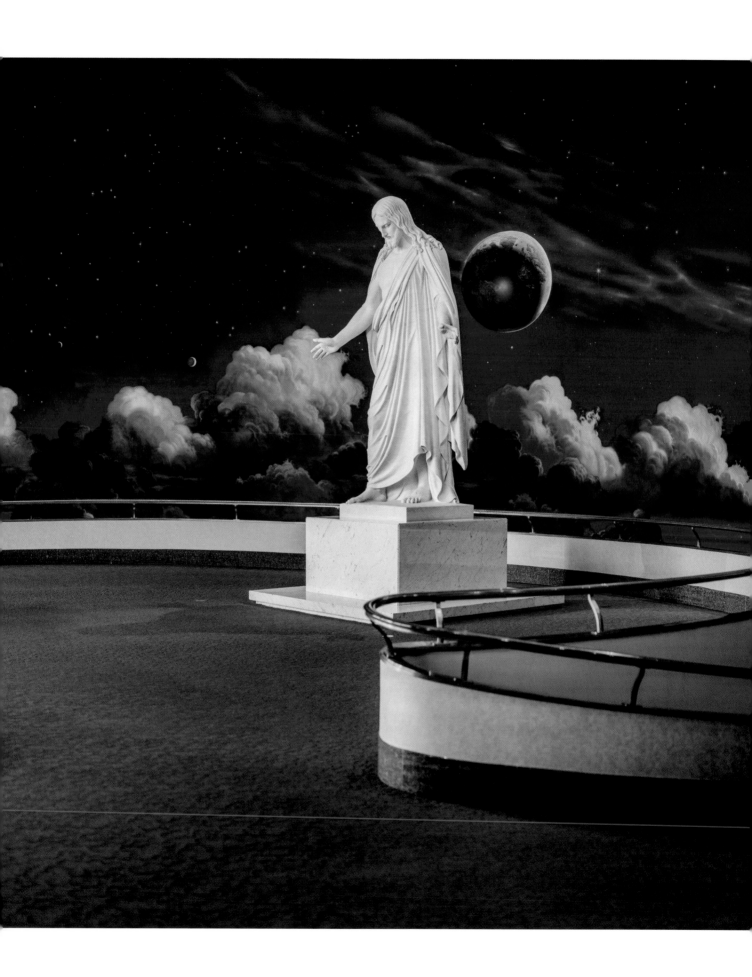

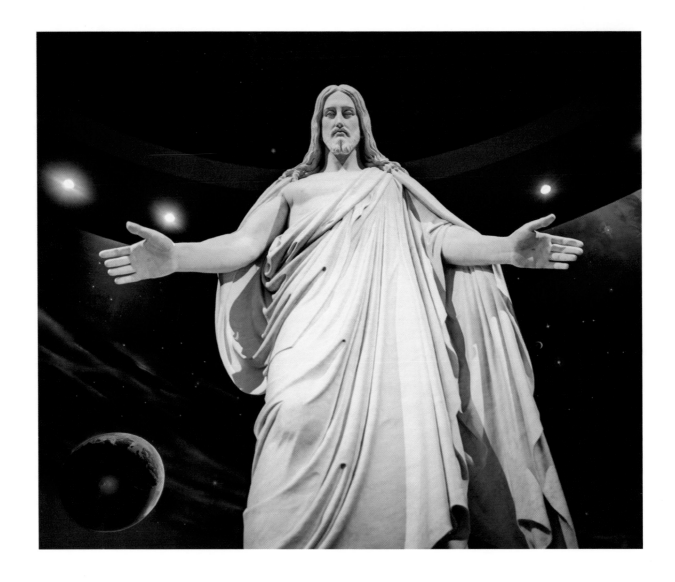

"The visitor centers are constructed with the purpose of inspiring people to wonder and ask themselves about LDS religion. ... My favorite place is the statue of the Christus in the North Visitor Center. No matter their religion or beliefs, people have come here and shown reverence for Jesus Christ."

—Paola Polanco, Guatemala

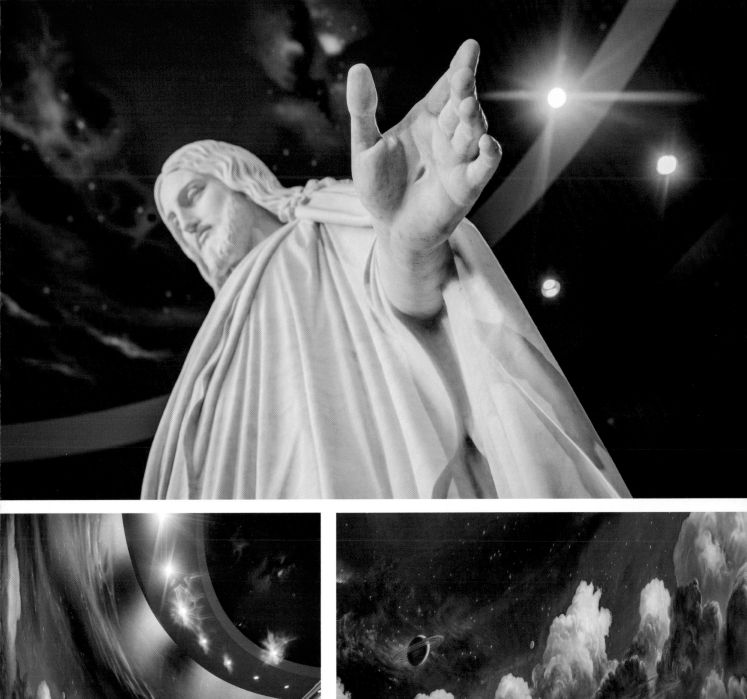

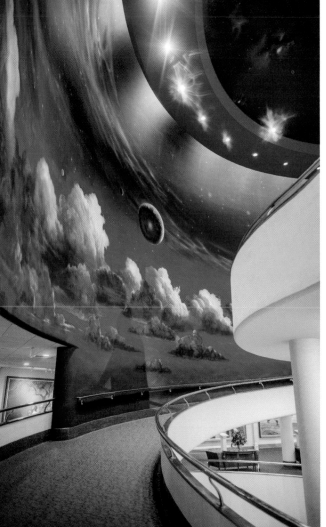

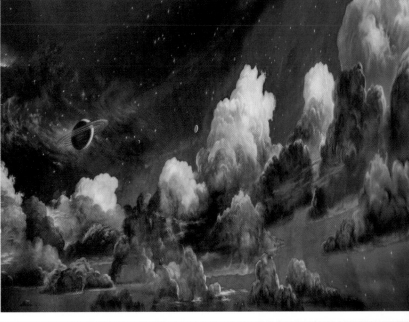

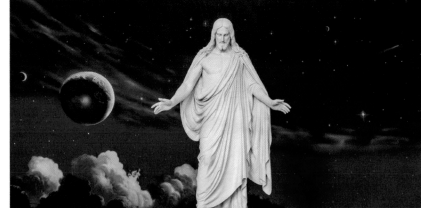

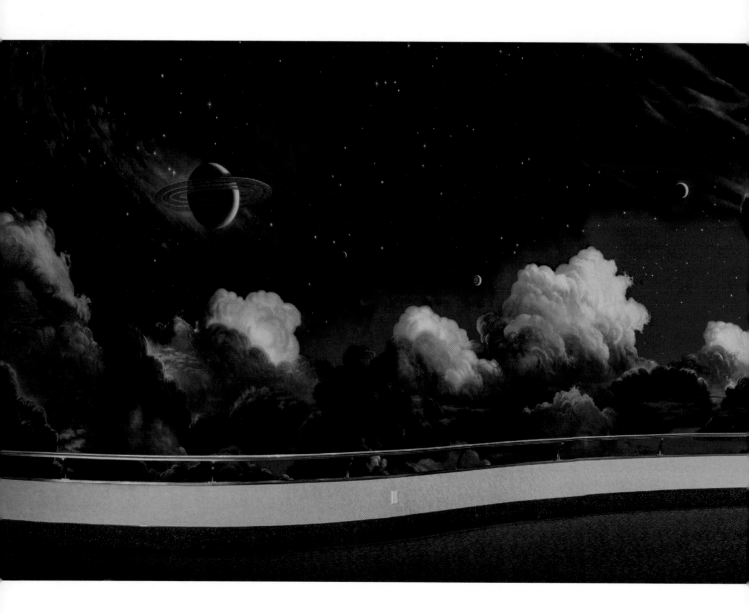

## He Can Fix You

My mission companion and I met a man with an extremely troubled past. He was once a member but felt he couldn't continue attending based on his lifestyle choices. He was standoffish at first but he slowly opened up as we took him from building to building. I'll never forget the moment we arrived in the north visitors center.

We were talking about repentance and how because of the atonement of Christ we can be forgiven and start fresh. I pulled out my copy of the Book of Mormon and asked if he could read Alma 36:18-20.

As soon as he touched the book he began to sob. Shaking uncontrollably, he said, "I can't even touch the book. I know what it contains and I am not worthy to hold it!"

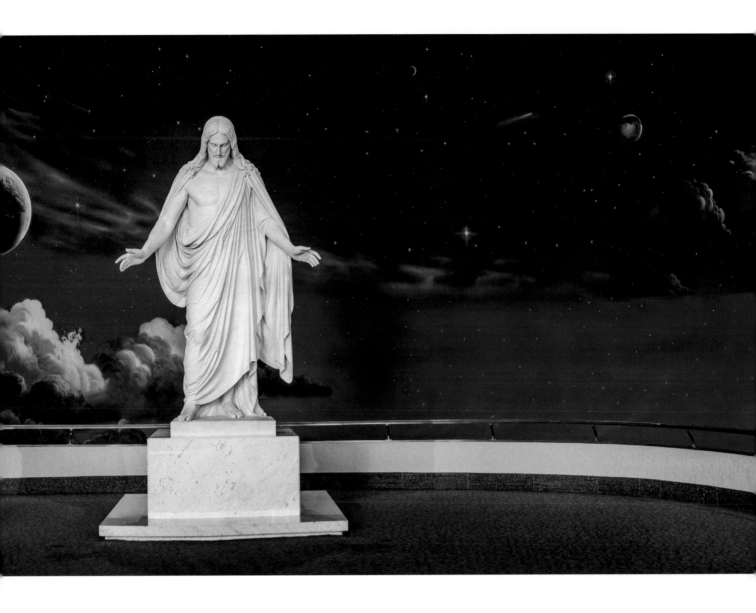

My heart broke. We rushed him over to the painting of Christ in Gethsemane where my companion testified of the love our Savior had for him. I wanted to say something truly Ensign worthy but only could manage to say "John, this Man...He can fix you."

I started to cry as the words I had said hit me. I felt the love our Heavenly Father had for this man and it was overwhelming. I knew He could heal him if John would let him. We all sat and cried together as the Spirit filled the room. I'll forever be grateful for the Spirit and the atonement and for what we were able to witness that day: a son of God coming to know for himself the mercy and grace of God and his Son.

–Karly Parker, Utah

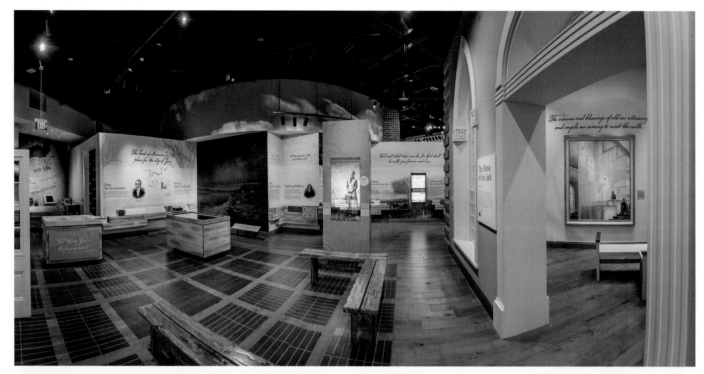

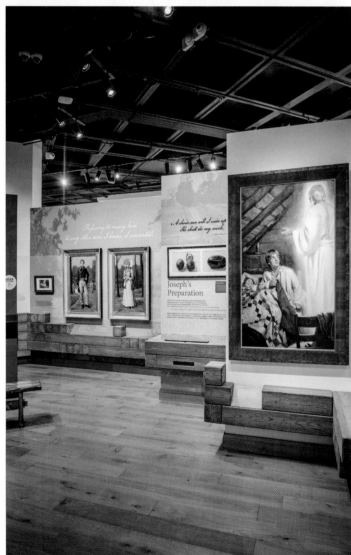

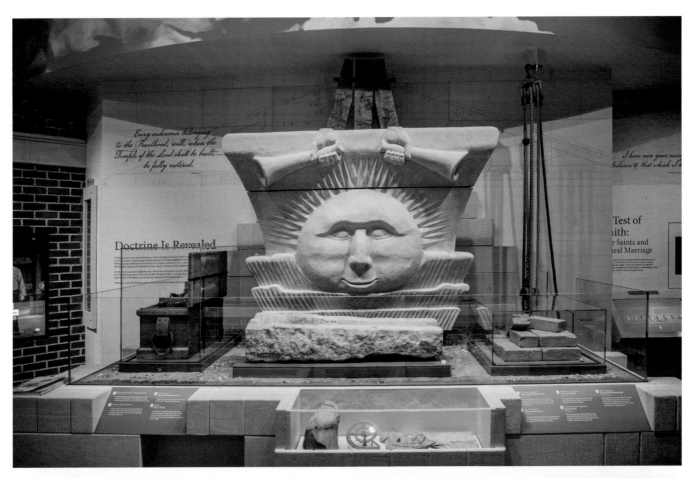

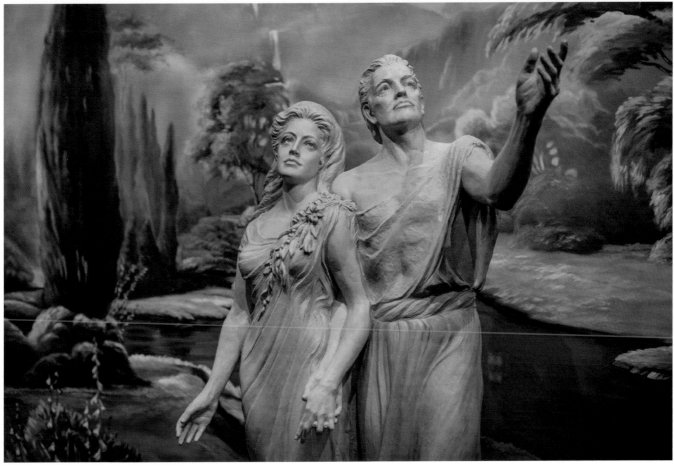

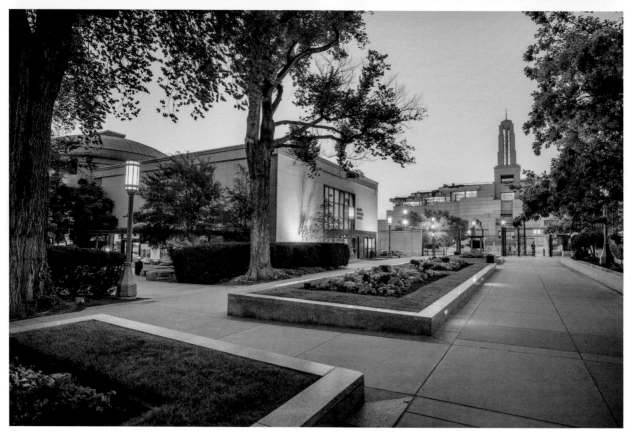

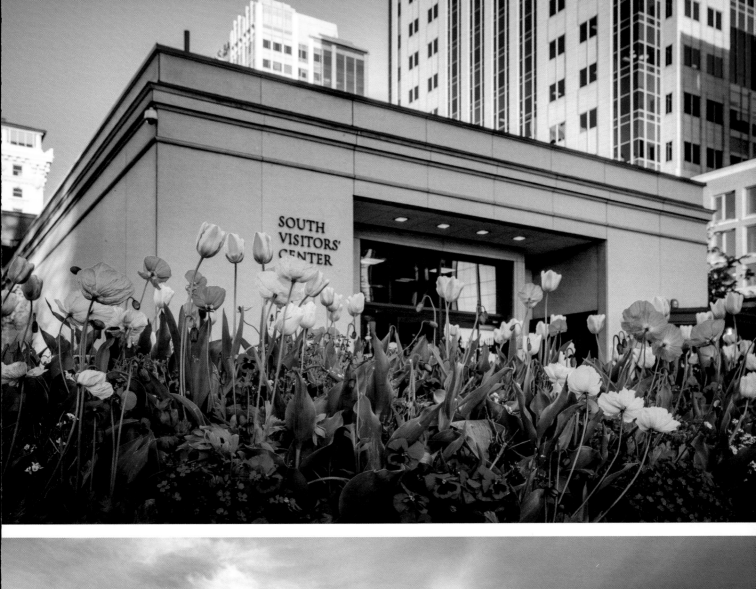

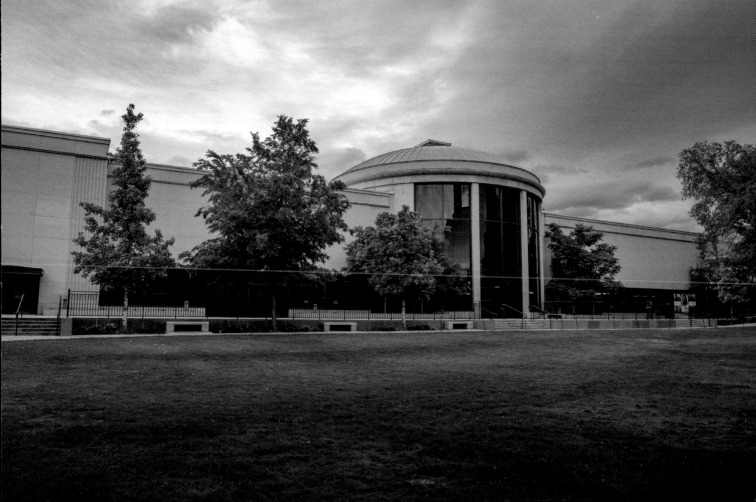

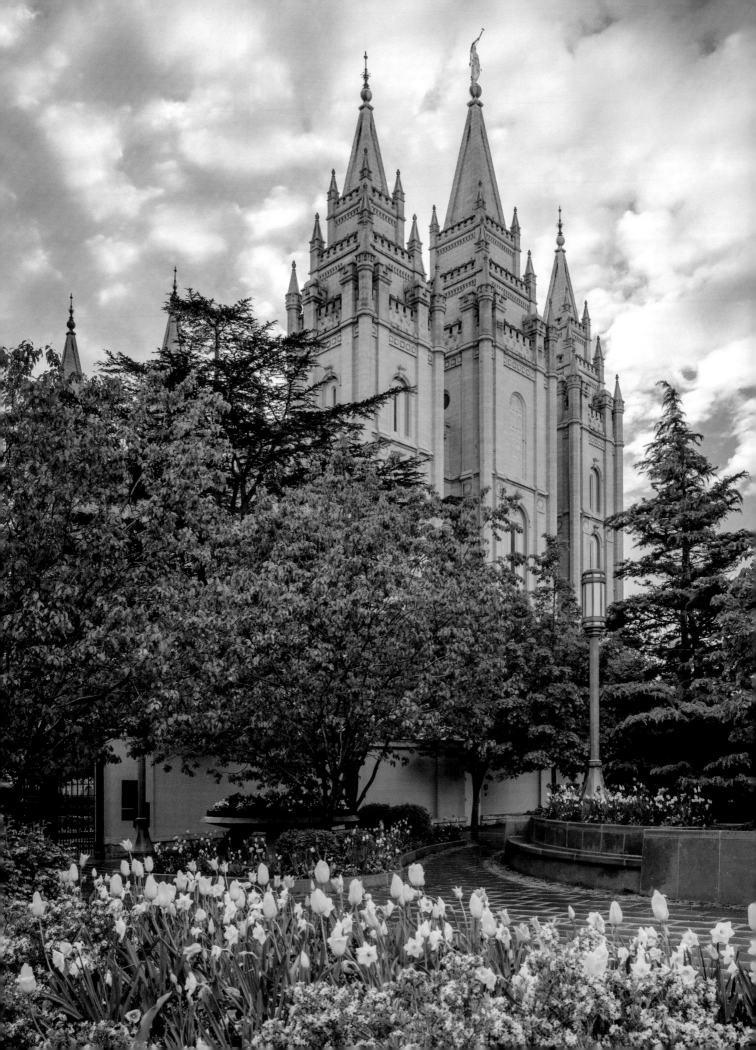

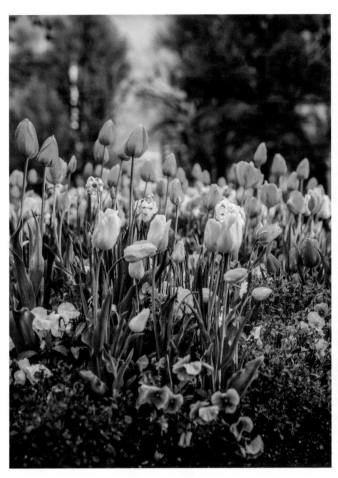

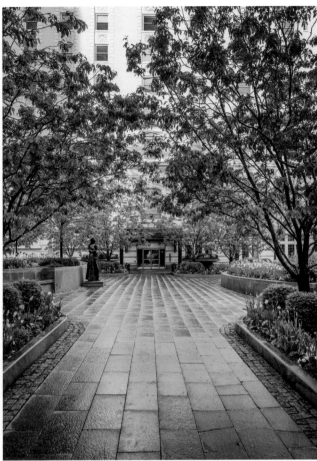

# GROUNDS & PARKS

## *Interesting Facts*

- In total, Temple Square covers an area of 10 acres. The grounds are beautifully landscaped and meticulously maintained. A variety of statues and monuments can be found scattered throughout the square.[19]

- Each year at Christmas, thousands of lights are strung in the branches of each tree. One tree, symbolic of the Cedar of Lebanon as found in the scriptures, requires 75,000 red lights alone. In addition to lights, several nativity scenes are set up on the grounds, including in the center of the reflecting pool east of the temple. The displays begin the day after Thanksgiving and stays until January.[20]

- It takes the ground crews months to put up and take down all the Christmas lights in the winter. They begin stringing lights in September and are still taking down lights in February or March.[20]

- Brigham Young Historic Park was once part of Brigham Young's family farm. During the summer, concerts are held twice a week and Garden Talks are held once a week in the park.[21]

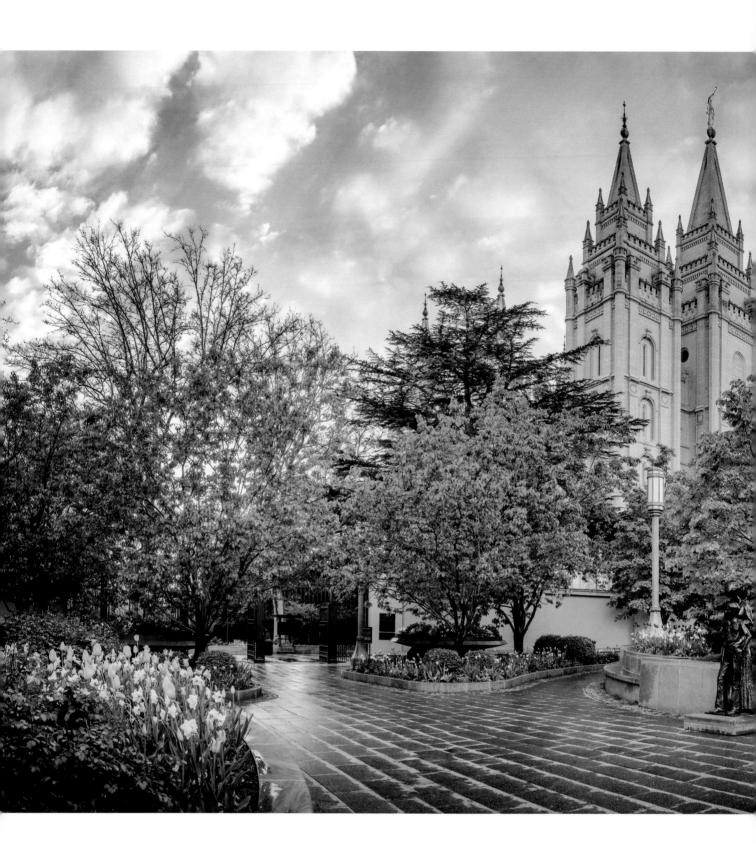

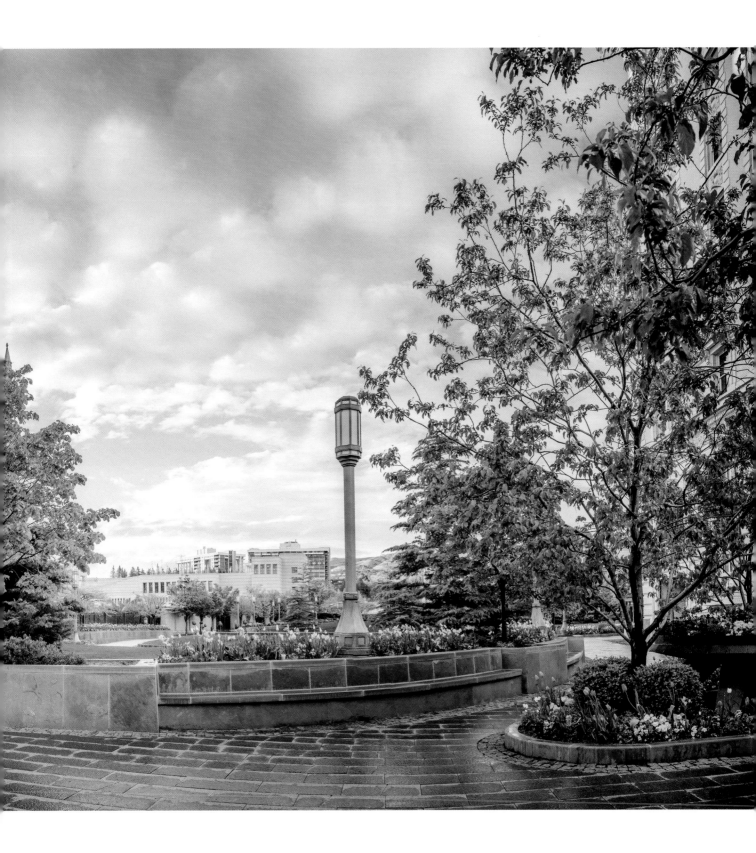

# TEMPLE SQUARE GROUNDS

Temple Square is a 10-acre complex, built in 1853

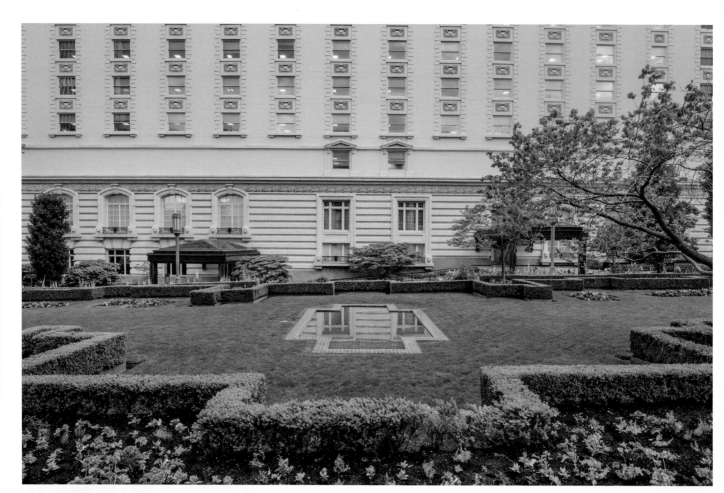

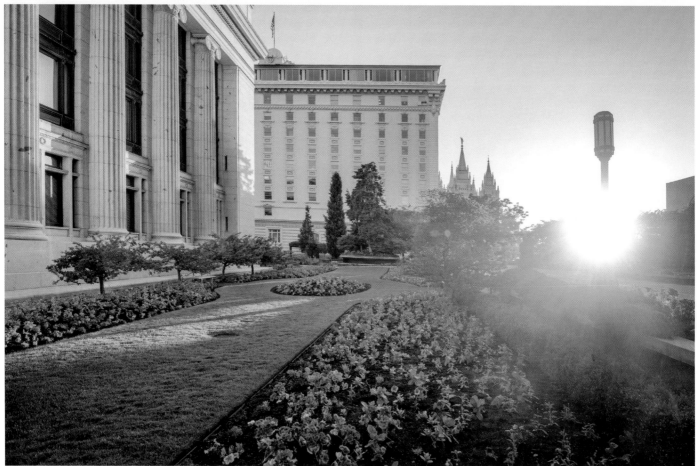

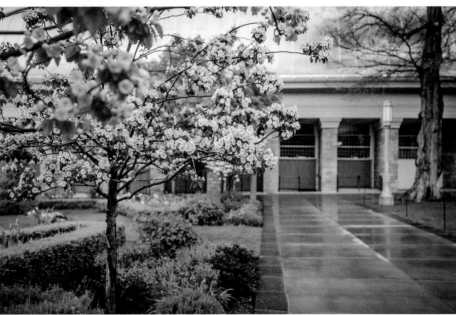

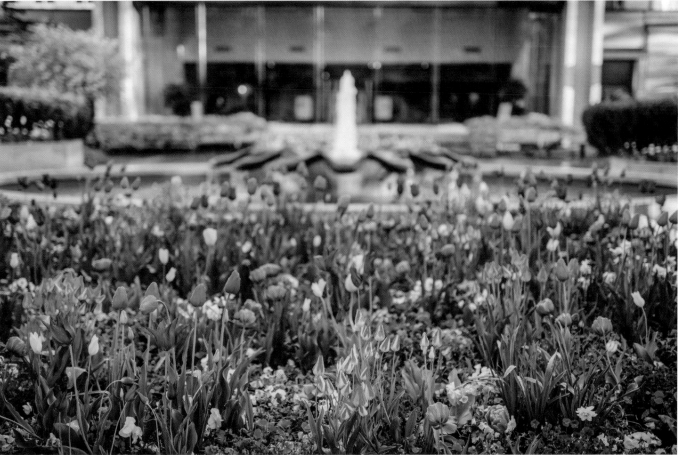

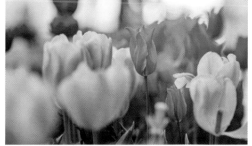

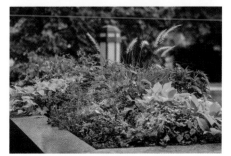

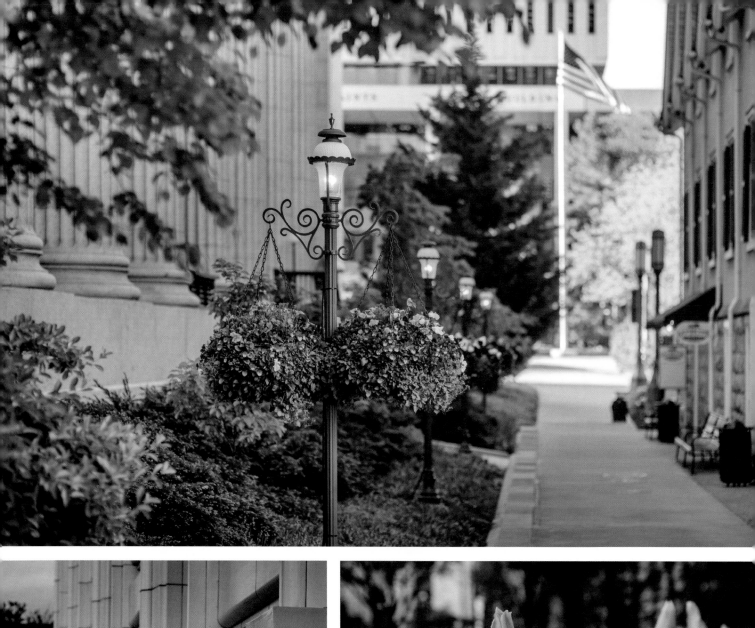
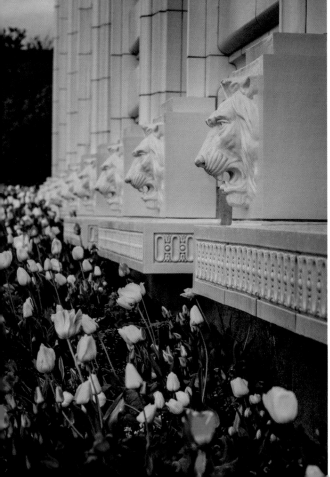

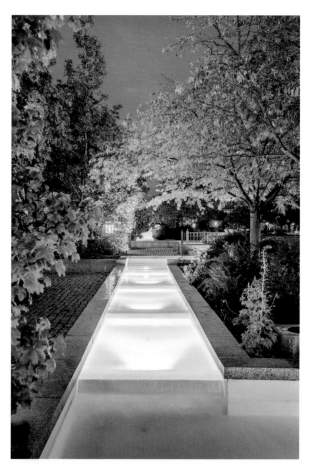

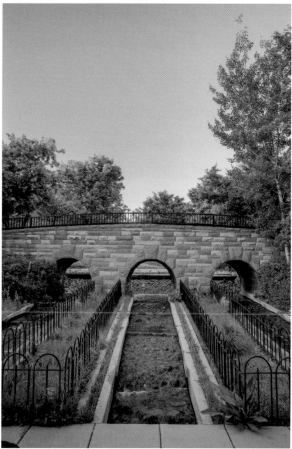

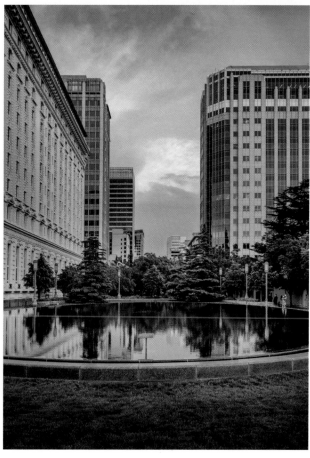

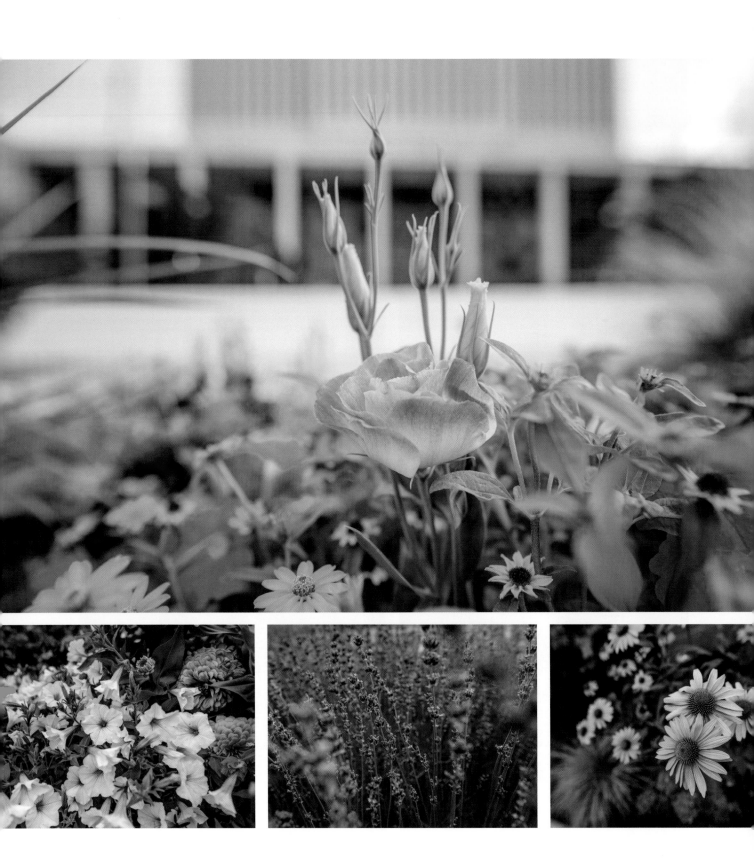

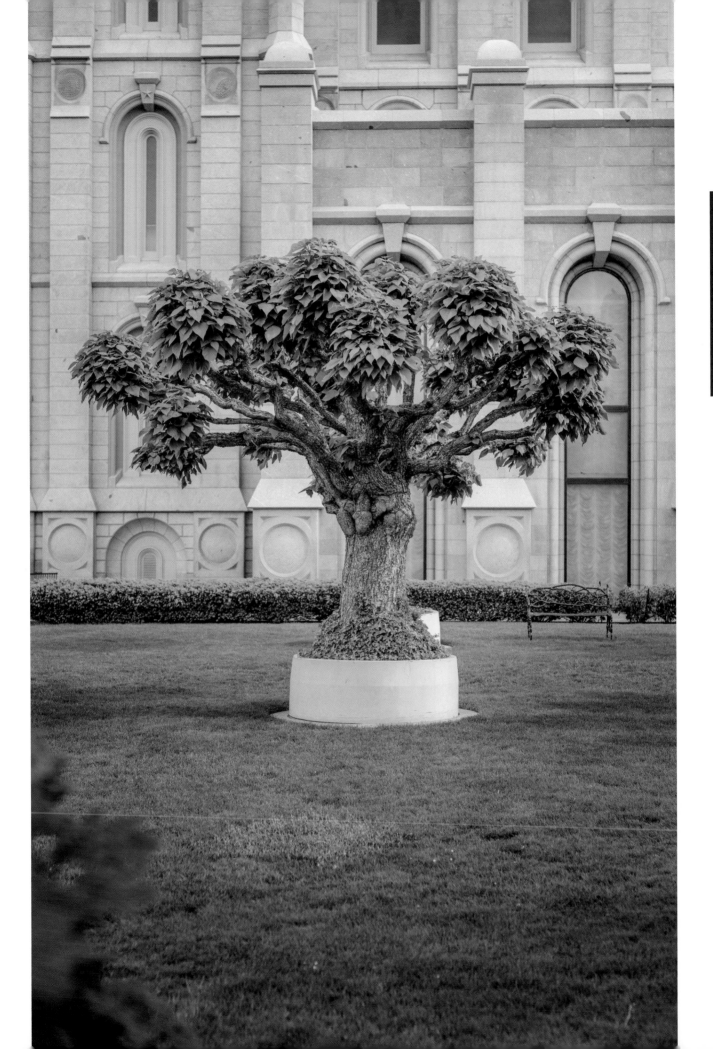

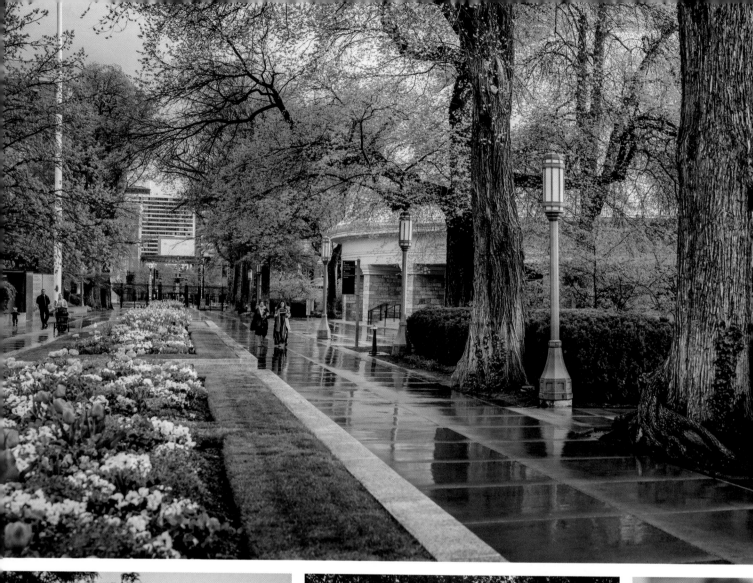

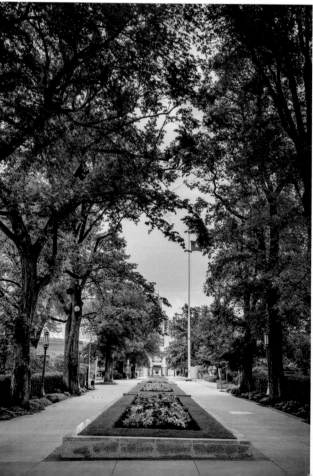

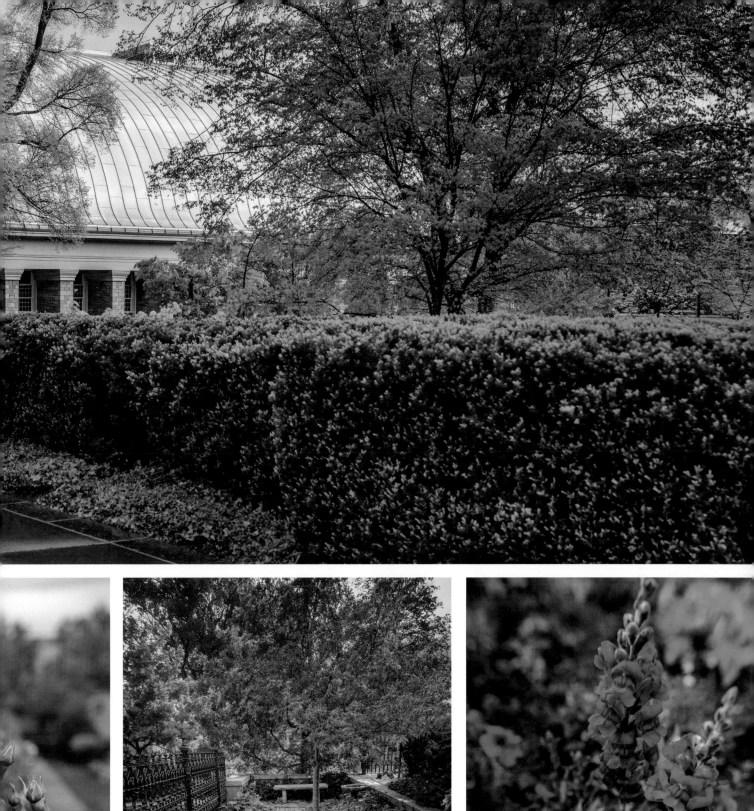

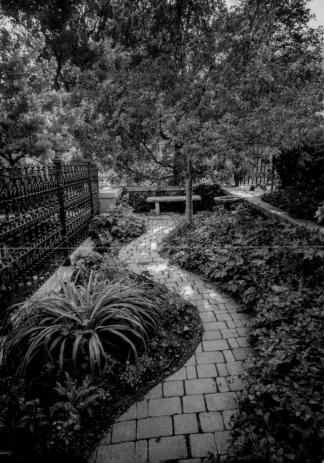

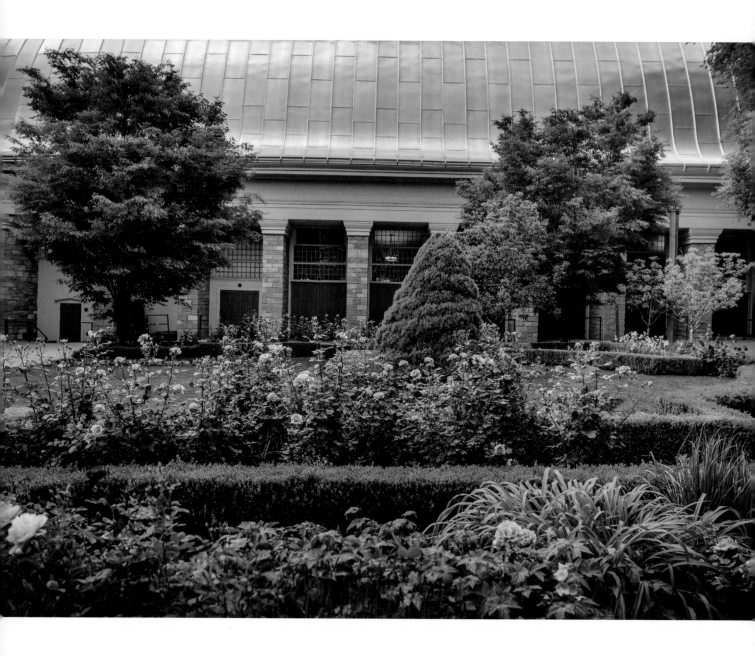

"Temple Square is the perfect place to walk around and take pictures, but it's also perfect to sit and ponder."

—Tammy Reque, Temple Square Hospitality

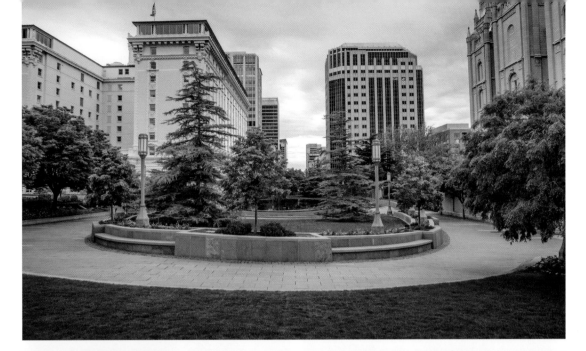

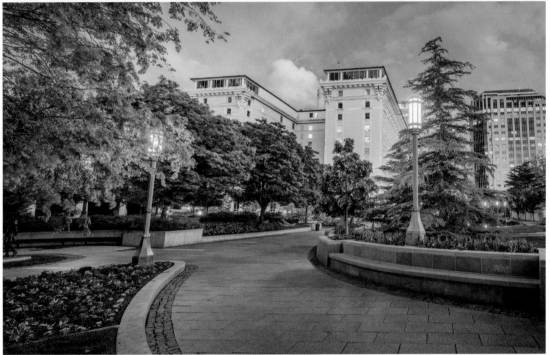

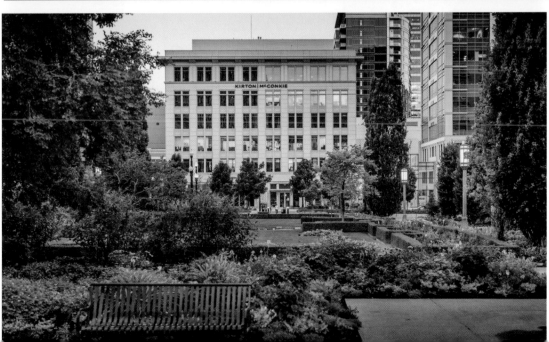

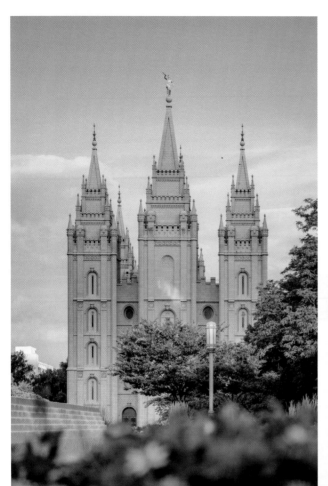
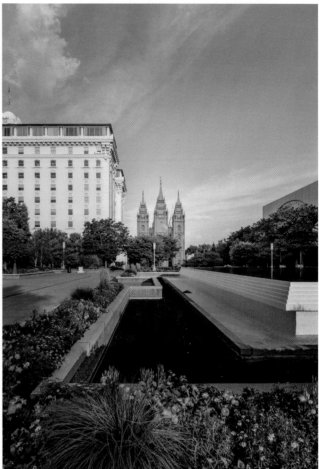
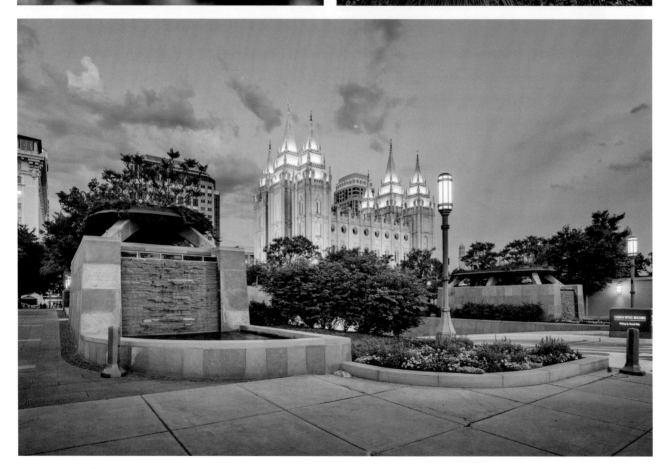

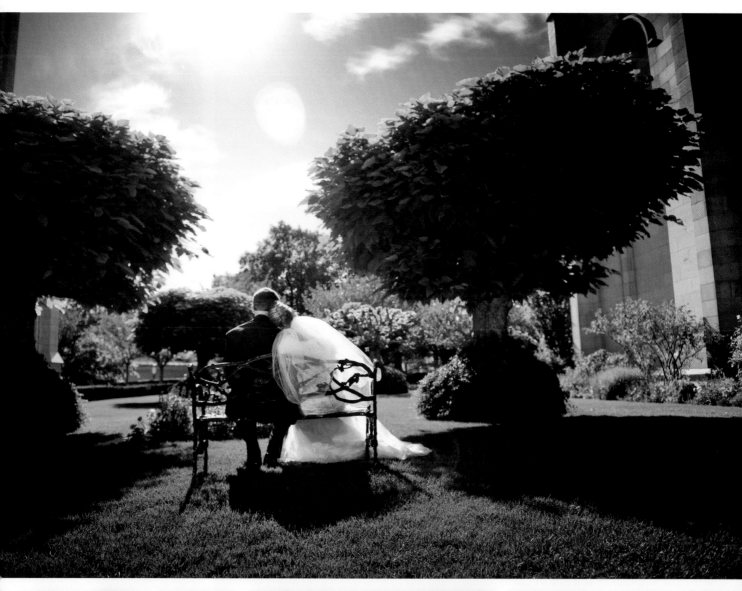

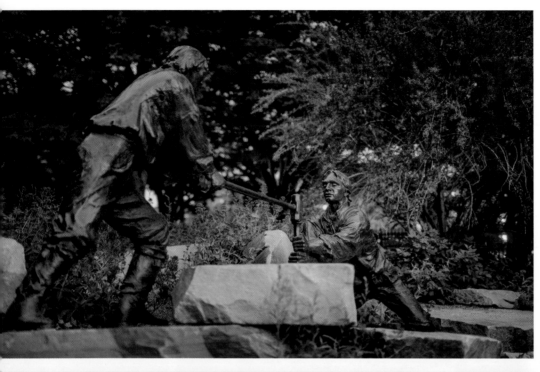

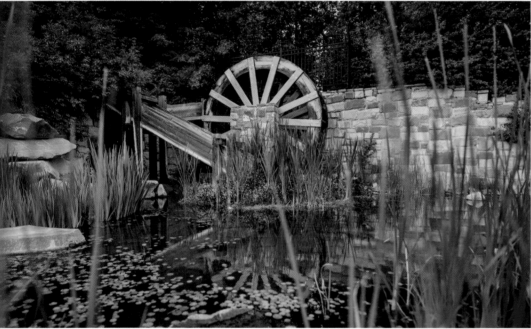

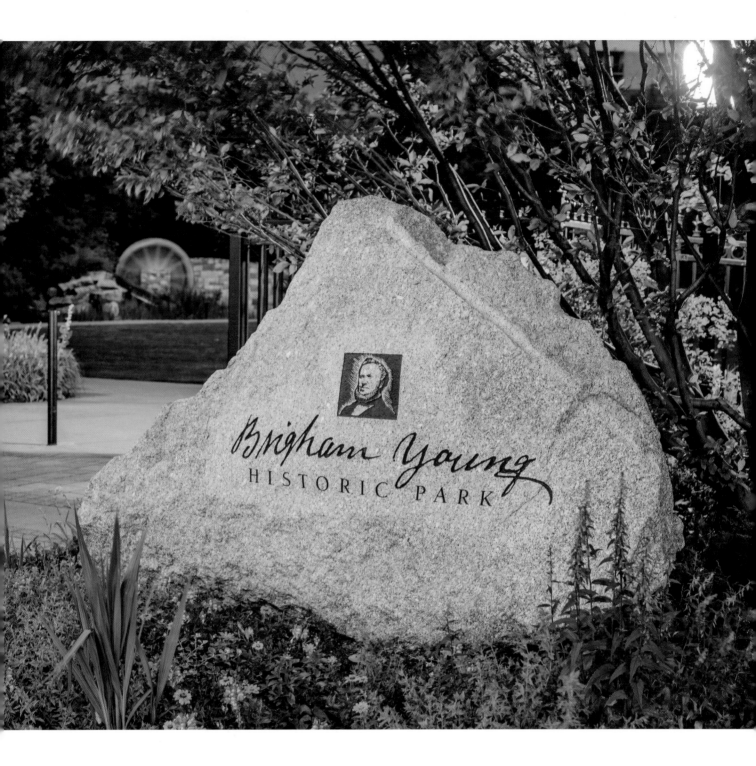

# BRIGHAM YOUNG HISTORIC PARK

One of several exhibits just east of Temple square that serve as memorial to Brigham Young. This Historic Park occupies land that once belonged to Brigham Young as part of his farm.

THE AMERICAN INSTITUTE OF CERTIFIED PLANNERS

has designated

THE PLAT OF THE CITY OF ZION

as a

NATIONAL HISTORIC PLANNING LANDMARK

The "Plat of the City of Zion," incorporated in a remarkable treatise on urban design addressed to the leadership of the Church of Jesus Christ of Latter-Day Saints by Joseph Smith on June 25, 1833, guided the development of over 500 settlements in the Intermountain West, establishing a continuing commitment to the building of well-proportioned, socially nurturing cities.

The American Institute of Certified Planners
The Society for American City and Regional Planning History
The Utah Chapter, American Planning Association

The city of Zion plat, for which this award was given, was designed by the Prophet Joseph Smith, Brigham Young's predecessor. The plat defines a mile-square city laid out on a grid. Three fifteen-acre blocks form the civic center. The surrounding ten-acre blocks are subdivided into half-acre lots with one home per lot. Farms with livestock, barns, and stables circle the city.

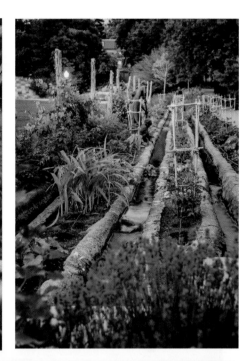

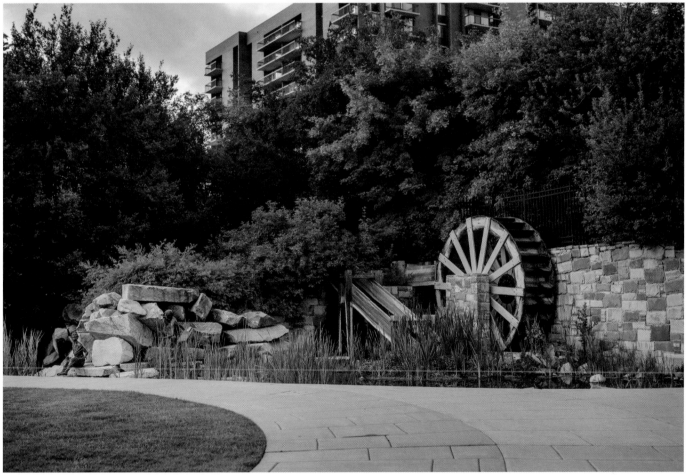

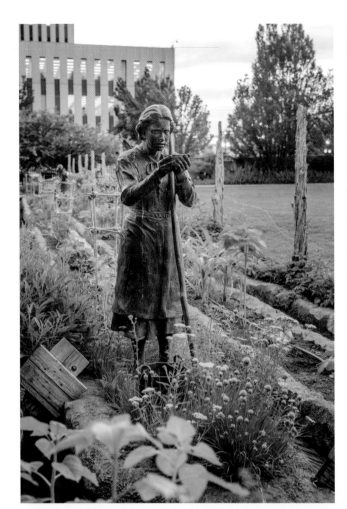

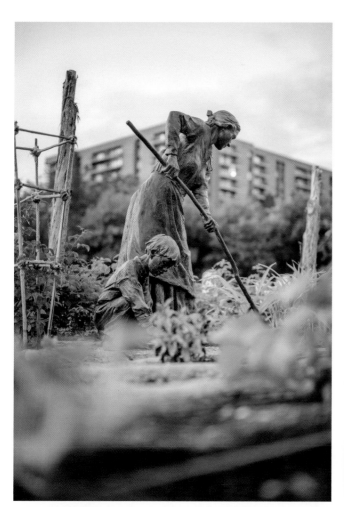

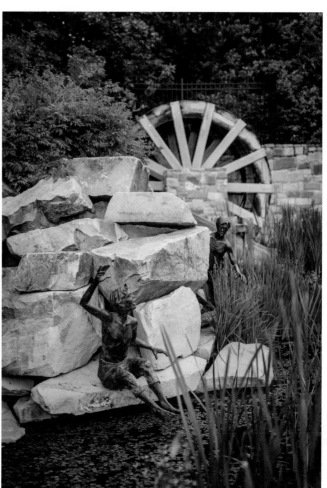

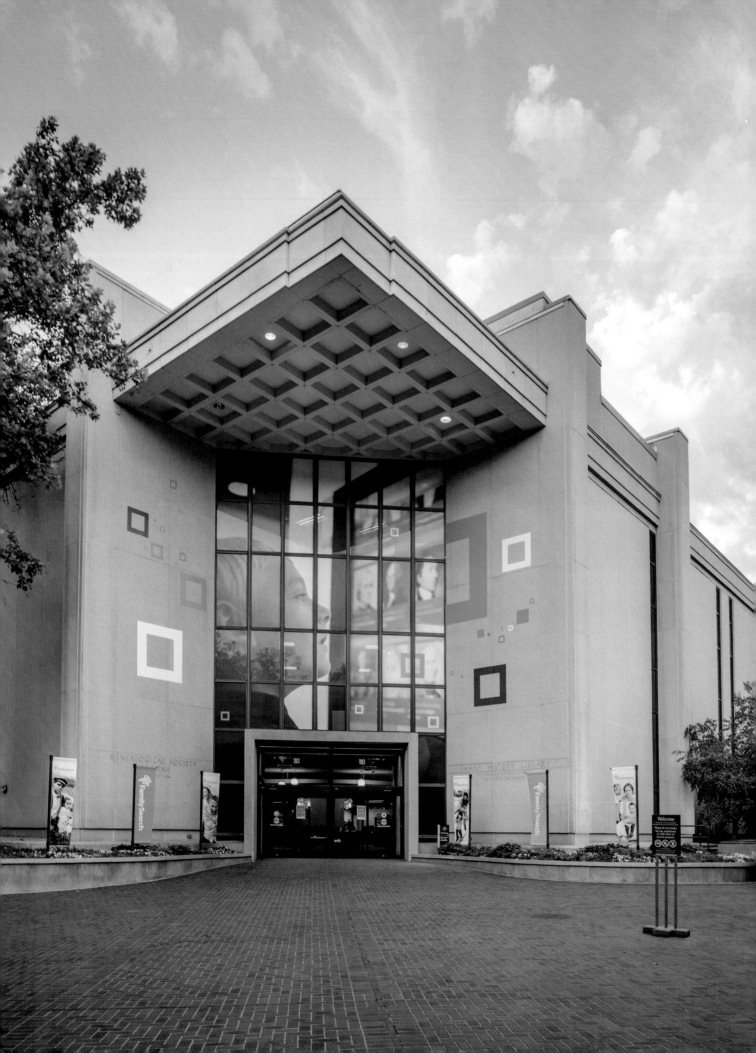

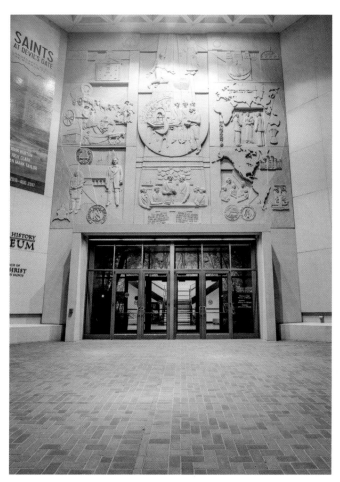
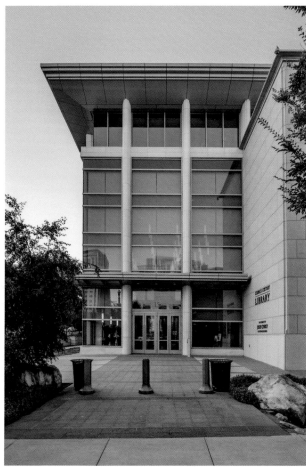

# MUSEUMS & LIBRARIES

## *Interesting Facts*

- The Church History Museum first opened in 1894. Its collection of artifacts, artwork, and multimedia help people better understand the history of the LDS church, beginning with the history of the prophet Joseph Smith. In 2014, the museum underwent an extensive renovation to create more interactive exhibits.[23]

- The Church History Library is a relatively new addition to Temple Square. Located just east of the Conference Center, the building was completed in 2009. It contains historical records of the LDS Church and its congregations worldwide, from the year 1830 to the present day. Visitors are invited to explore the library during its regular hours.[21]

- With more than two million rolls of microfilmed records as well as books, newspapers, and other resources, the Family History Library contains the world's largest collection of genealogical resources. It is open to the public Monday through Saturday to help them learn about their ancestors and family line. Tens of thousands of people visit the library each year.[24]

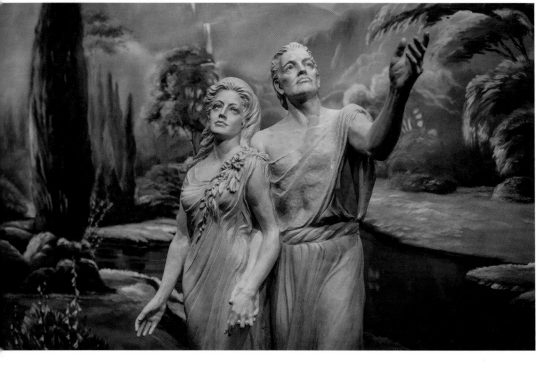

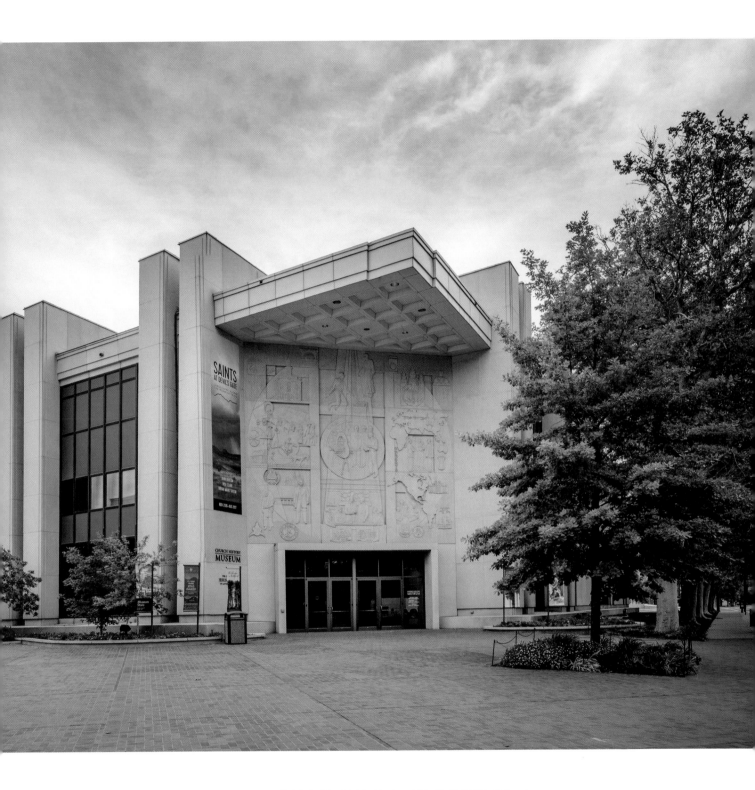

# CHURCH HISTORY MUSEUM

A premier museum operated by The Church of Jesus Christ of Latter-day Saints that was originally dedicated and opened on April 4, 1984.

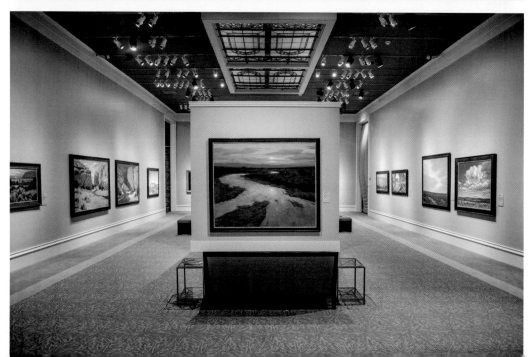

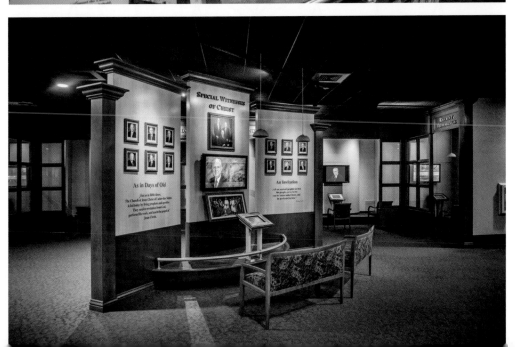

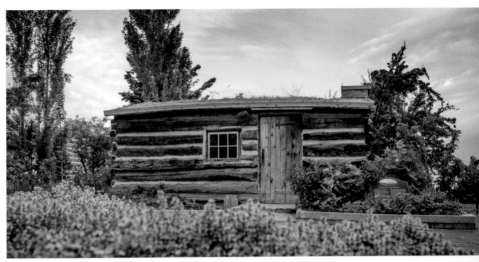

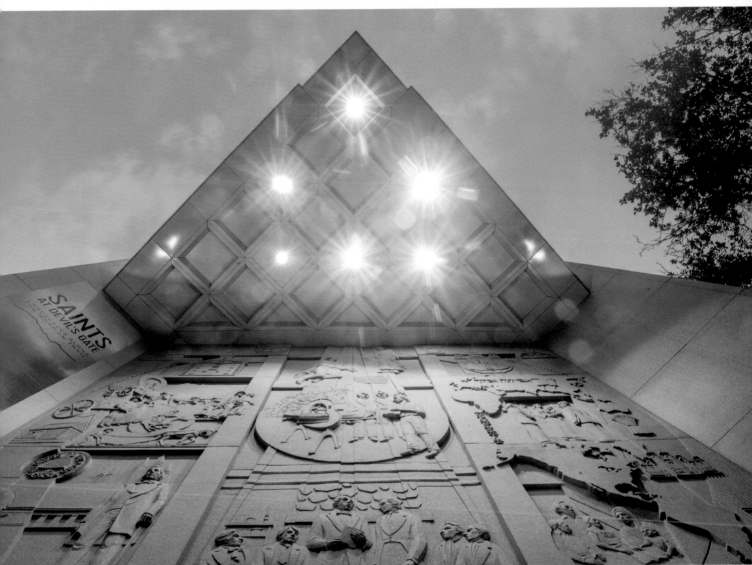

"Every new generation asks different questions of our history. The goal of the Church History Museum is to build the faith of the next generation of Latter-day Saints and to help others outside of our faith understand our history."

–Reid Neilson, assistant Church historian[23]

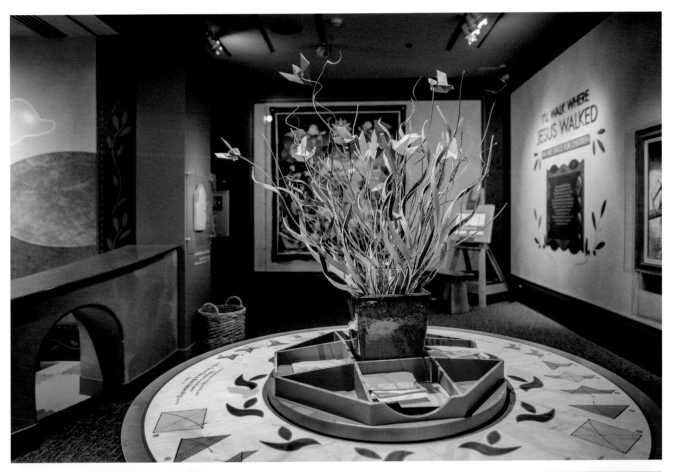

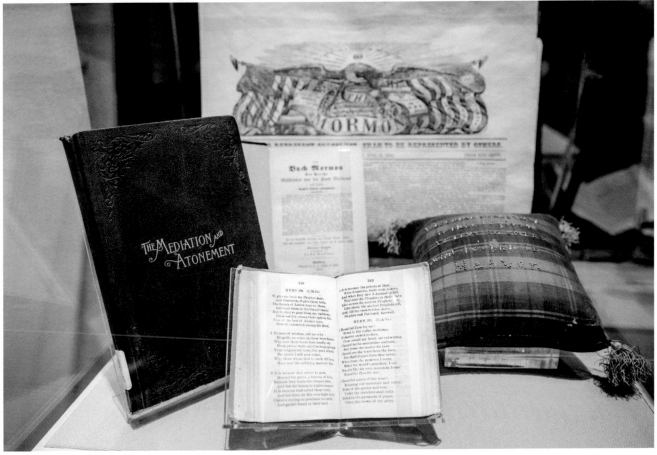

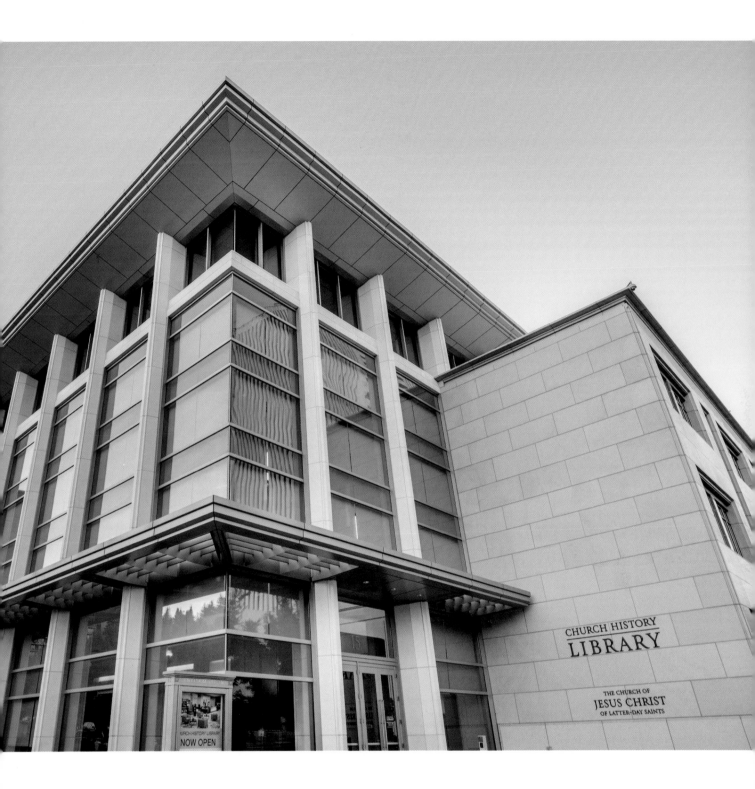

# CHURCH HISTORY LIBRARY

Houses materials chronicling the history of The Church of Jesus Christ of Latter-day Saints. This new building opened to the public on June 22, 2009.

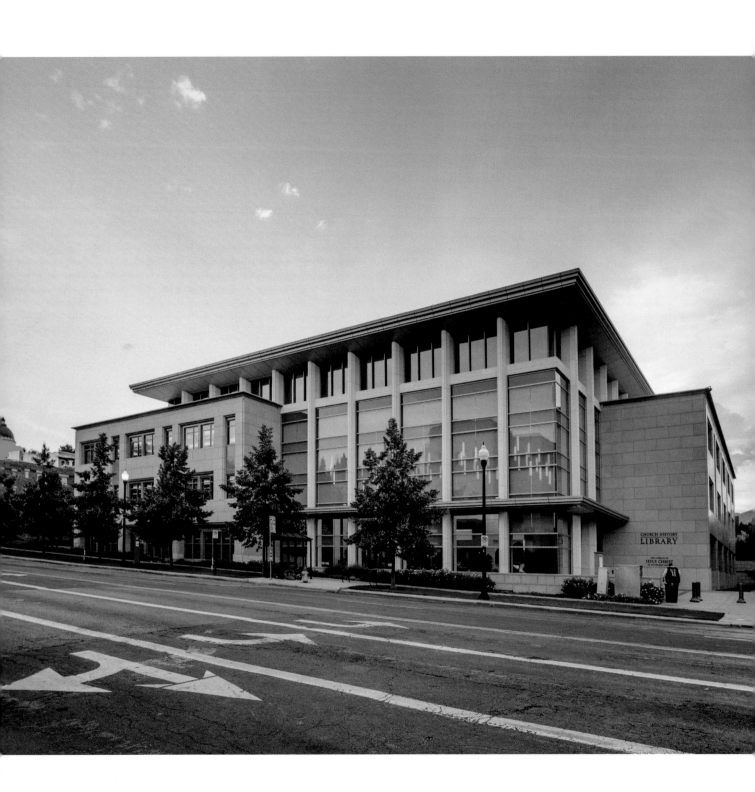

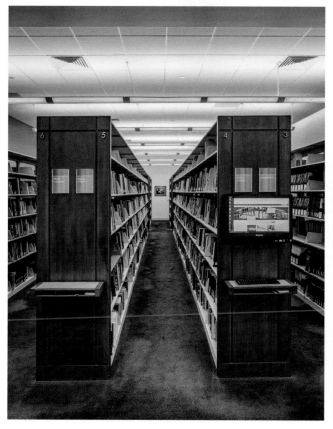

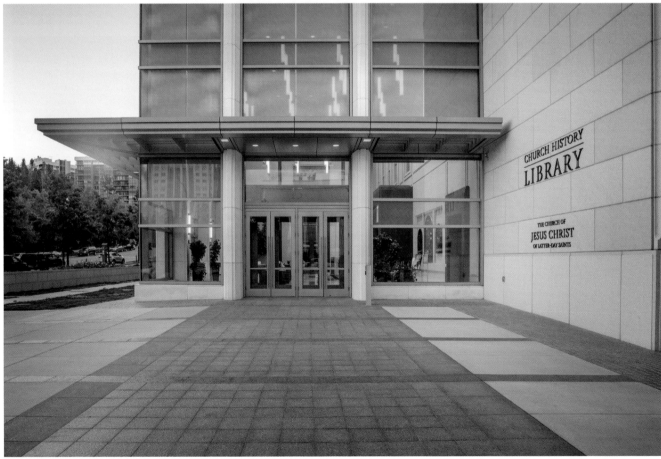

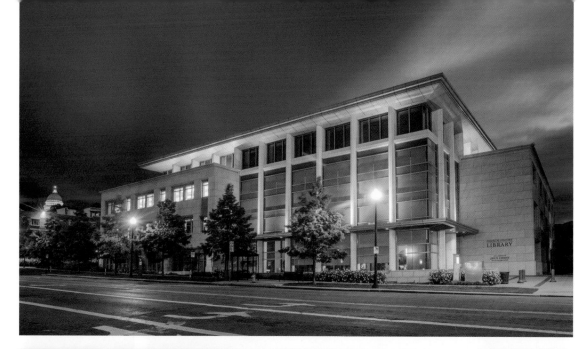

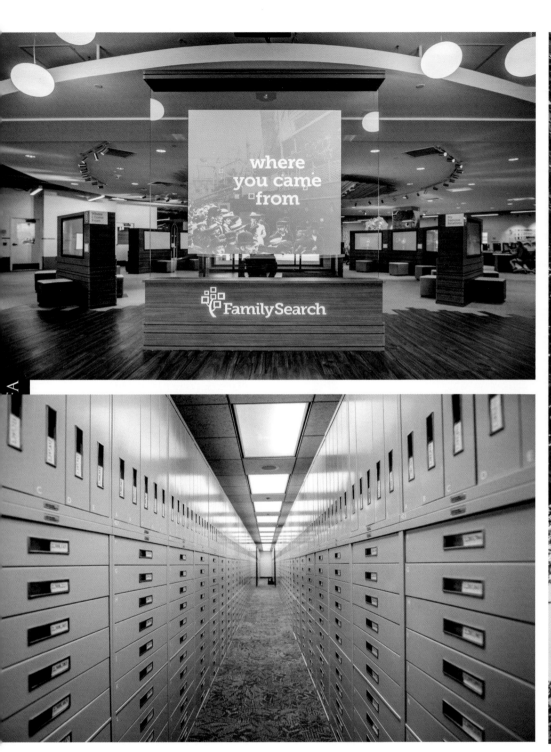

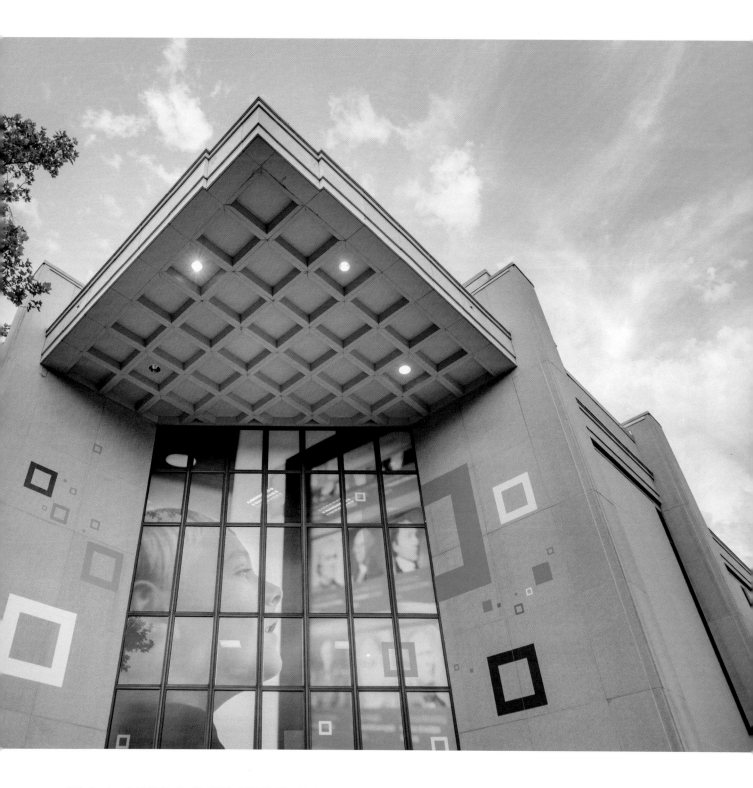

# FAMILY HISTORY LIBRARY

Contains the world's largest collection of genealogical resources.
Opened on October 23, 1985.

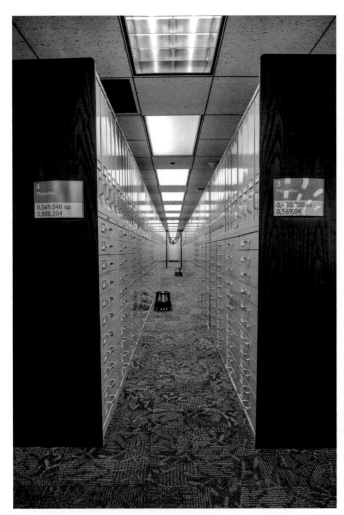

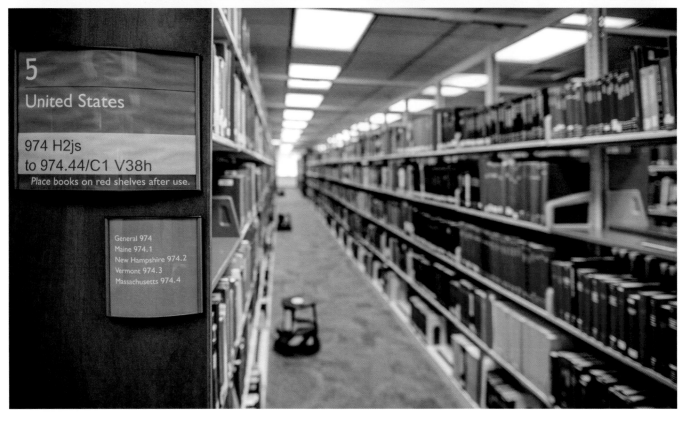

COPY CENTER

Photo Scanning Area

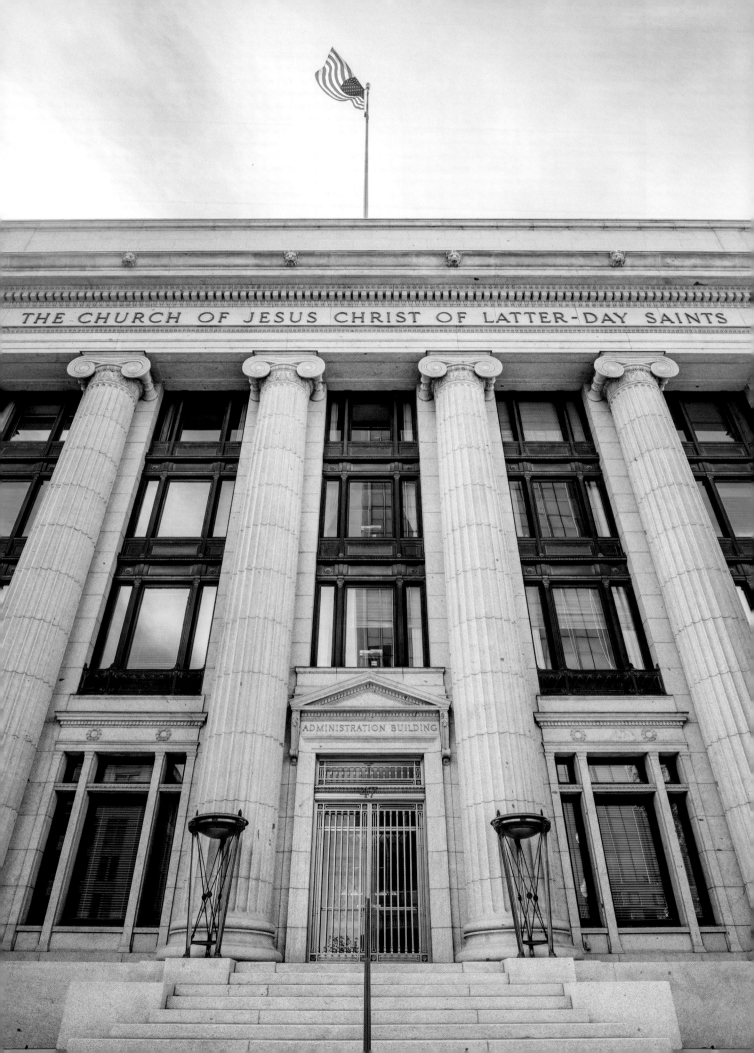

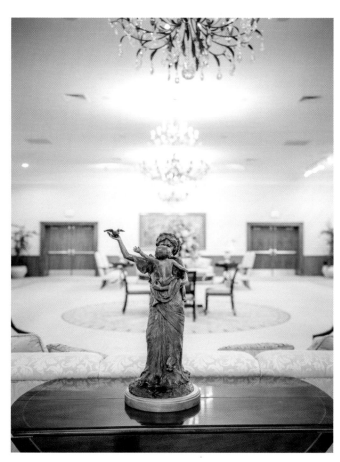

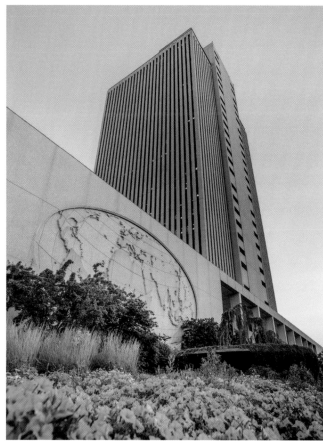

# OFFICE BUILDINGS

## *Interesting Facts*

- The 28-story Church Office Building serves as the headquarters of The Church of Jesus Christ of Latter-day Saints. Although offices are not open to the public, visitors are welcome to take a tour of the building[21] or visit the observation deck on the 26th floor.[25]

- Prior to the construction of the office building in 1973, church employees were spread out through several office buildings in downtown Salt Lake City. When it came time for the big move under one roof, six separate moving companies were utilized.[26]

- The Relief Society Building houses resources and offices for general leaders of three of the church's auxiliary organizations: Relief Society, Young Women, and Primary.[27] It was built in the 1950s after nearly a decade of fundraising by Relief Society General President Belle Spafford. Women around the world donated money or items to make the structure a reality.[28]

- The Administrative Building opened in October 1917. It was built from granite quarried in Little Cottonwood Canyon, just like the Salt Lake Temple. Originally, it contained offices for the First Presidency, Council of the Twelve Apostles, First Council of the Seventy, and Patriarch to the Church, among others. Today, it continues to provide offices for general church leaders.[29]

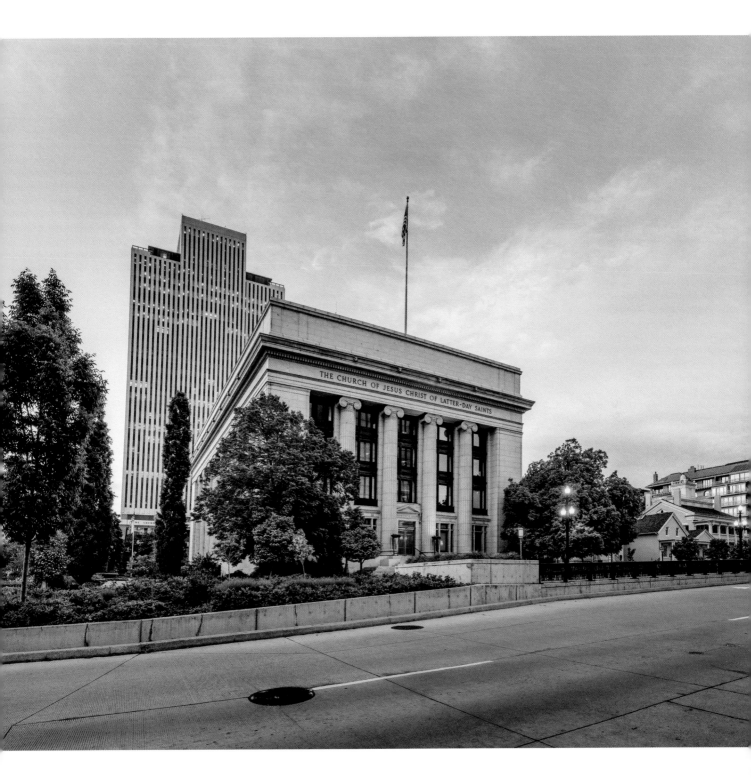

# CHURCH OFFICE BUILDING

Houses the administrative support staff for the lay ministry of The Church of Jesus Christ of Latter-day Saints throughout the world. The Church Office Building is the second-tallest building in Salt Lake City at 420 ft.

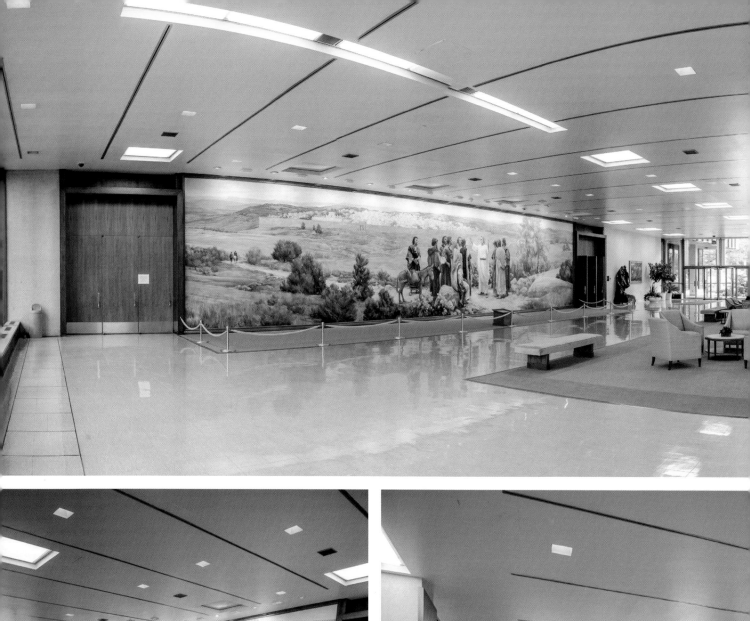
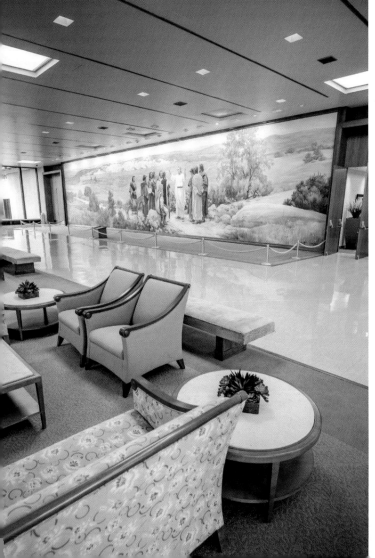

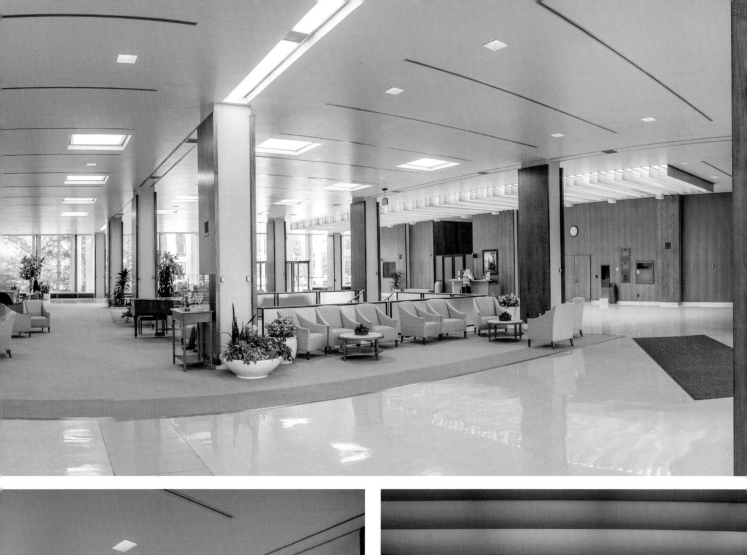

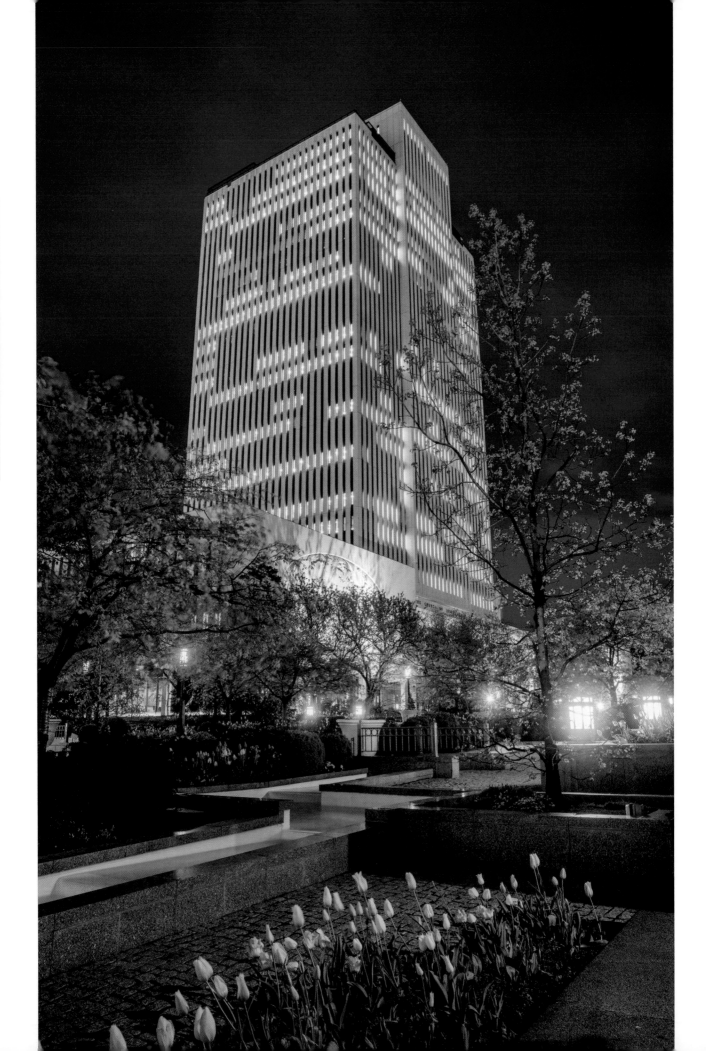

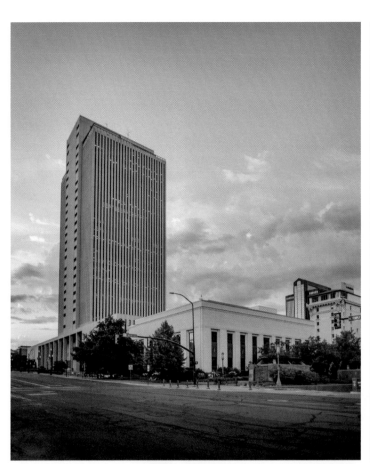

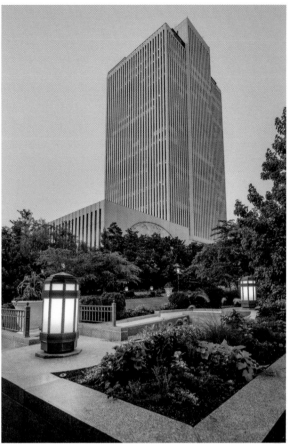

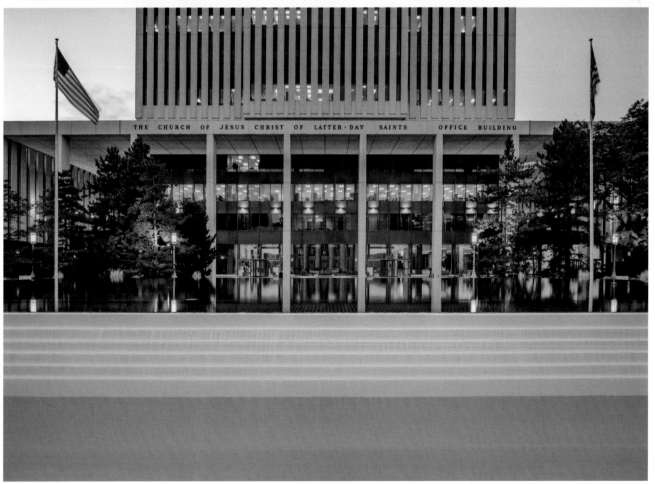

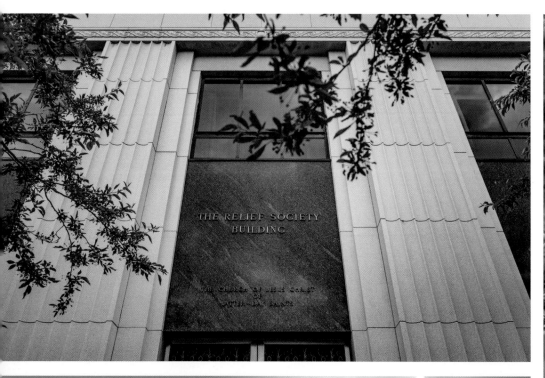

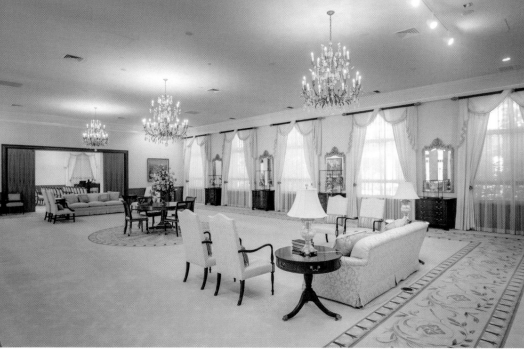

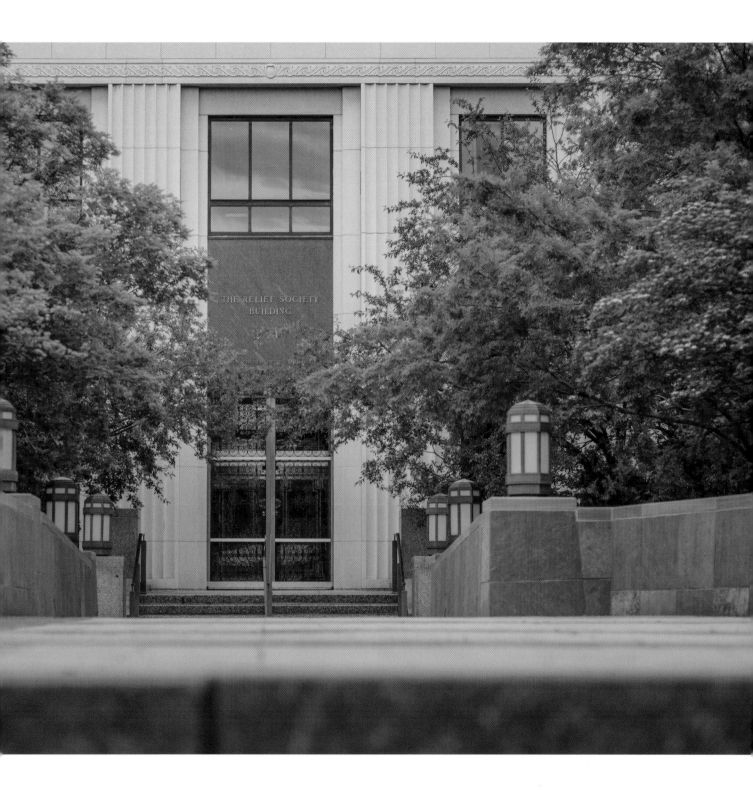

# THE RELIEF SOCIETY BUILDING

Was built in the 1950s after nearly a decade of fundraising.

"On this memorable occasion, we praise Thy name for the organization of the Relief Society of The Church of Jesus Christ of Latter-day Saints, for the thousands of loyal, faithful, beautiful women who compose its membership. Their devotion to duty is never-ending; their loyalty to Thee and to Thy Priesthood unquestioned; their administrations to the sick and to the needy, untiring; their sympathetic gentle services give hope to the dying, comfort and faith to the bereaved."

—David O. McKay, Dedicatory Prayer of the Relief Society Building

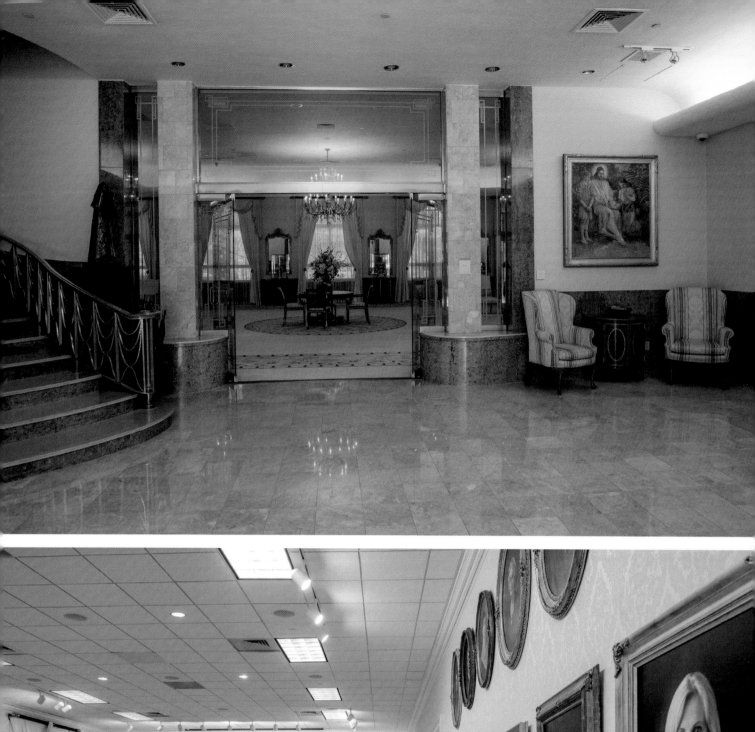

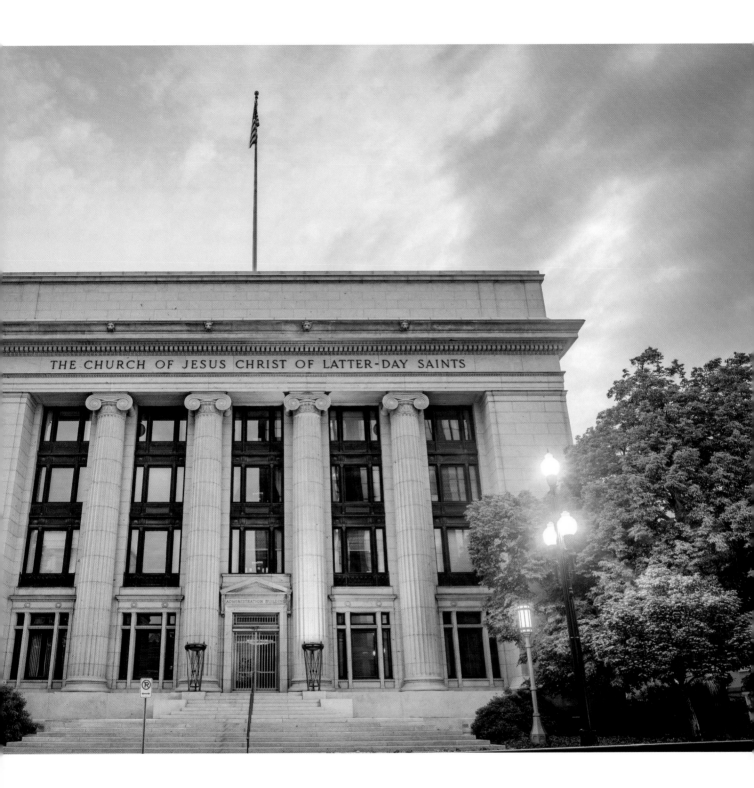

# CHURCH ADMINISTRATION BUILDING

Was built in 1917 from granite quarried in Little Cottonwood Canyon,
just like the Salt Lake Temple.

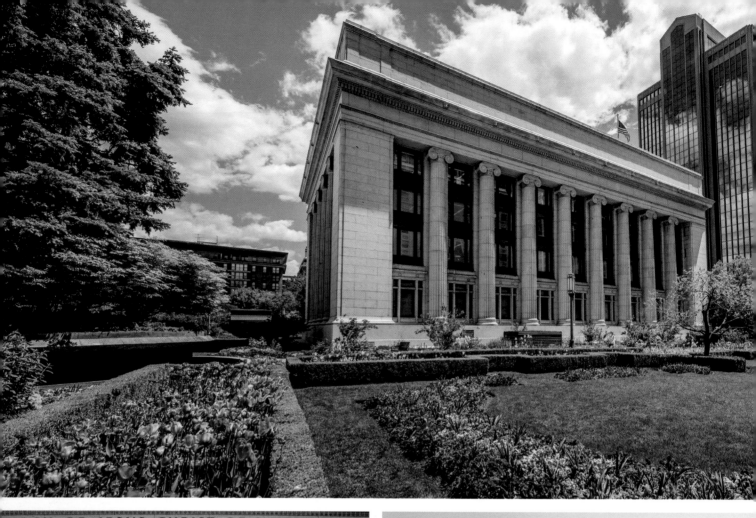

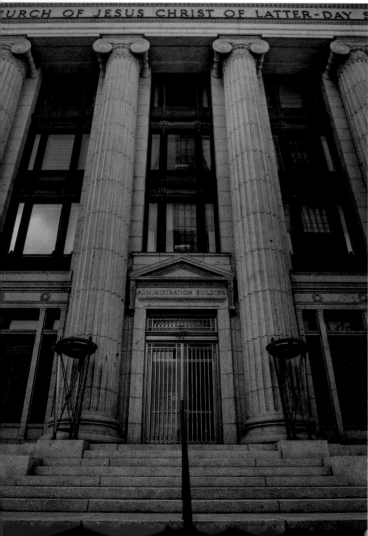

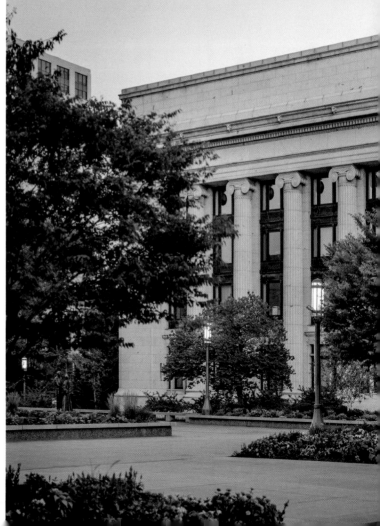

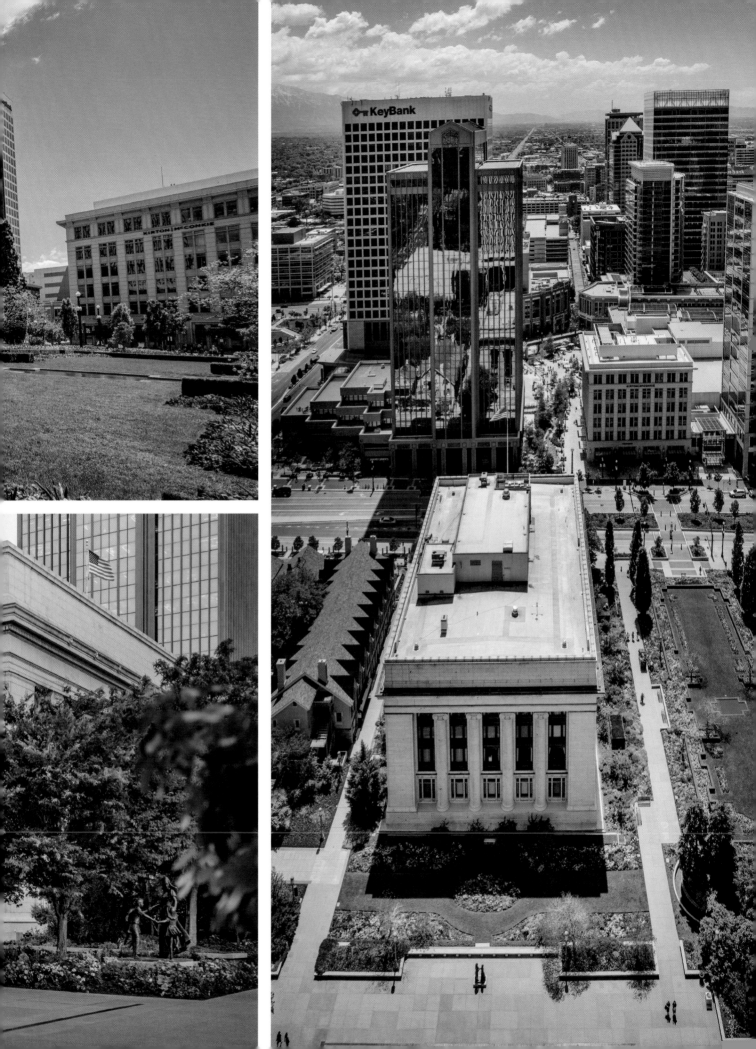

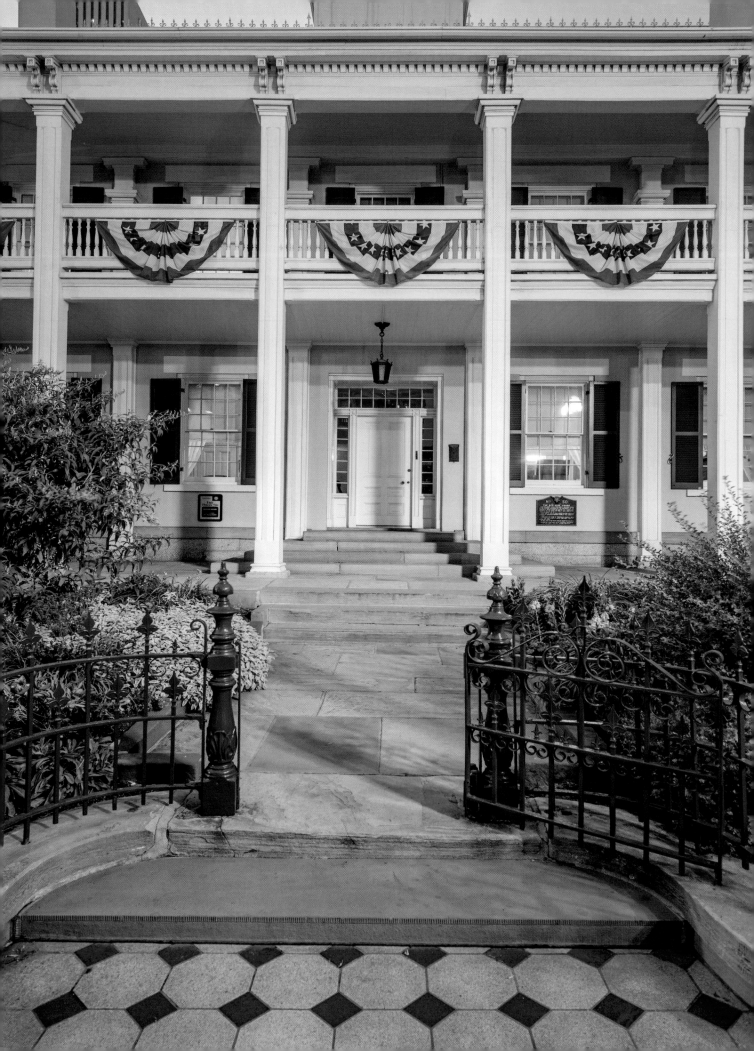

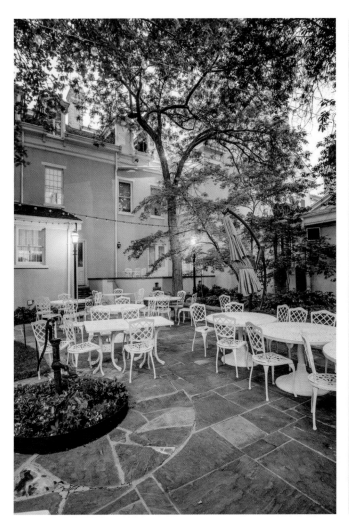

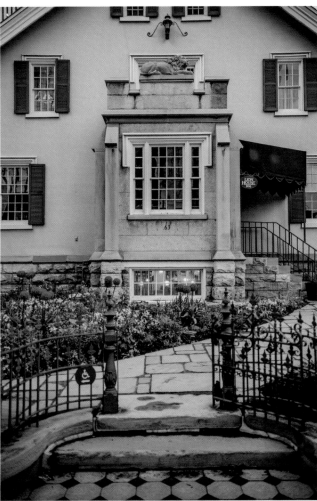

# THE HOUSES

## *Interesting Facts*

- Designed by Truman O. Angell and constructed in 1854, The Beehive House was originally a home for Brigham Young and other LDS Church leaders. It also contained offices for many years. Today, the restored house is as a museum.[30]

- The beehive symbol was used to represent the industriousness demonstrated by the Mormon pioneers.[31]

- The Lion House was built in 1856 as an expansion to the Beehive House. The two houses are connected by a suite of rooms, where Brigham Young's private bedroom was located. It received its name from a lion statue, created by William Ward, which sits above the front entrance. Today, the building serves as a restaurant.[31]

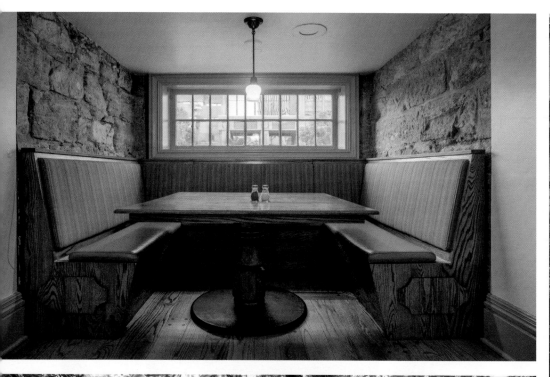

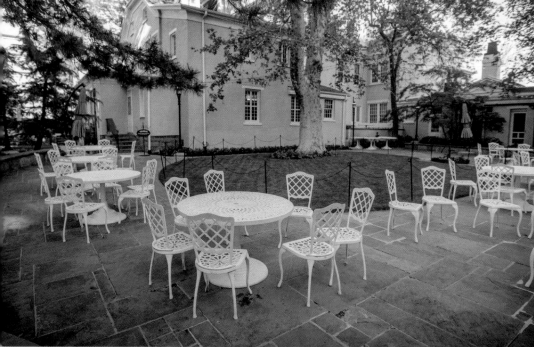

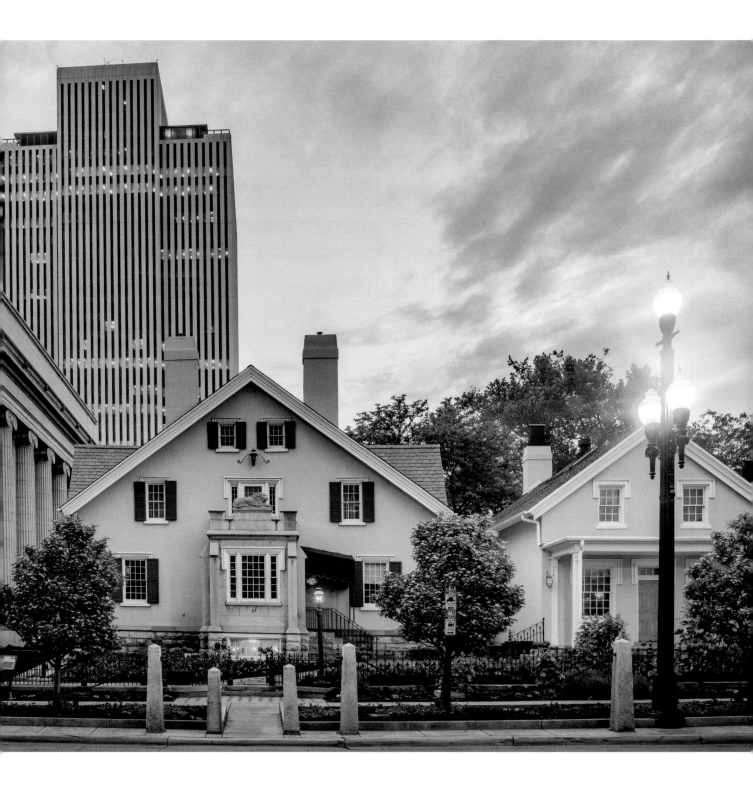

# THE LION HOUSE

A large residence built in 1856 by Brigham Young, second President of The Church of Jesus Christ of Latter-day Saints, in Salt Lake City, Utah, to accommodate his large family.

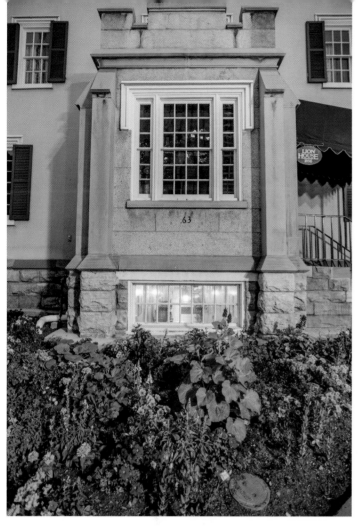

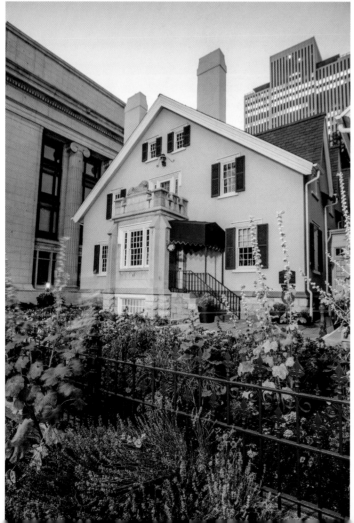

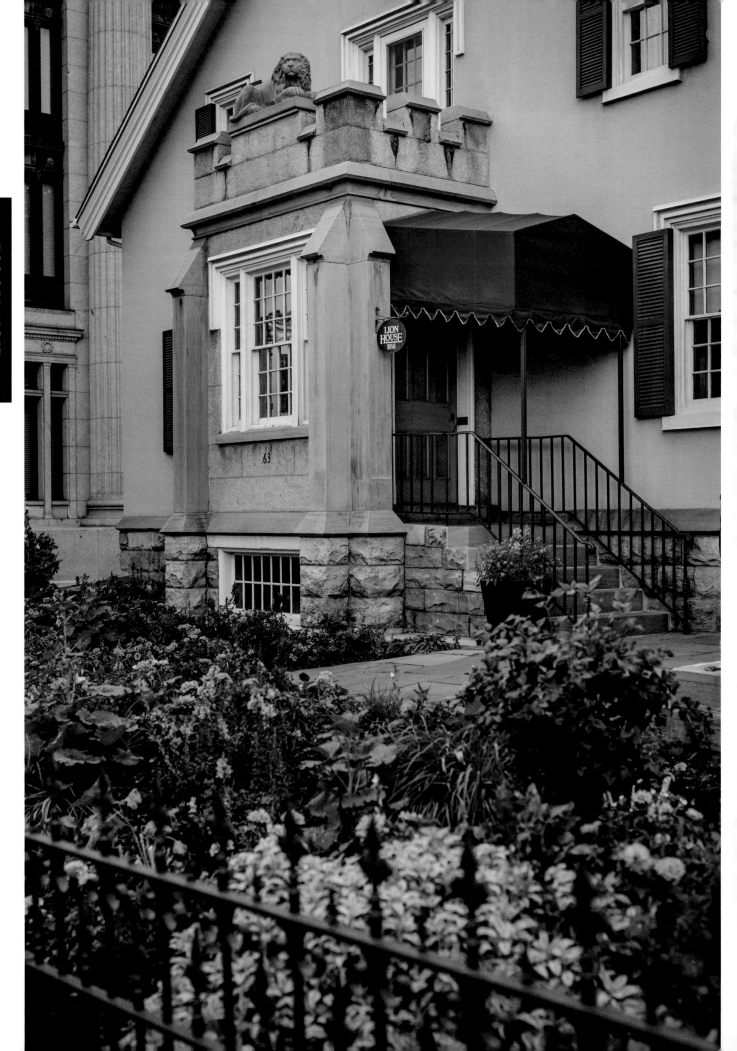

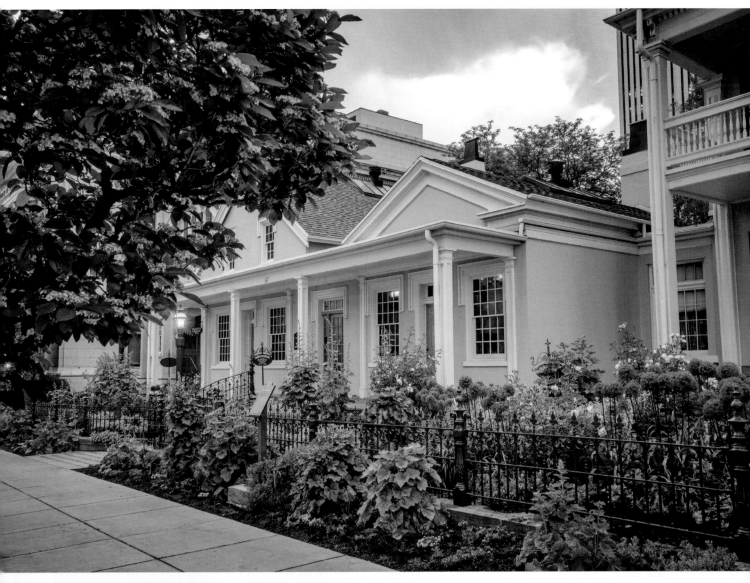

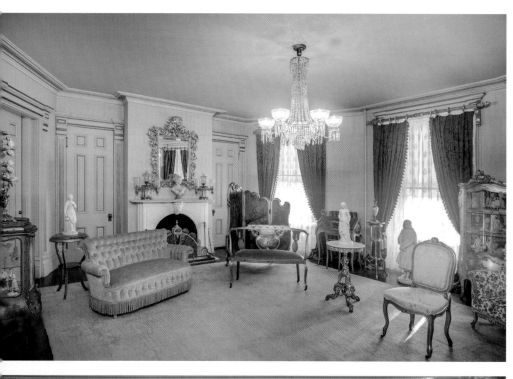

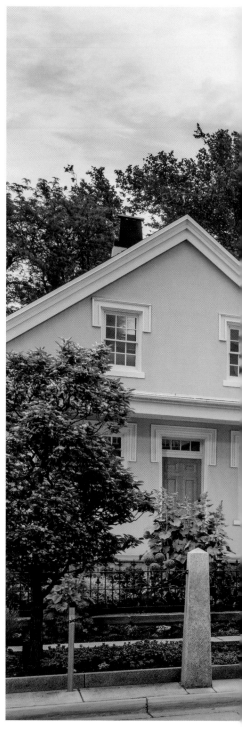

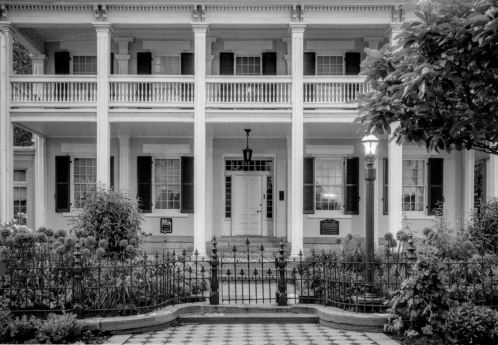

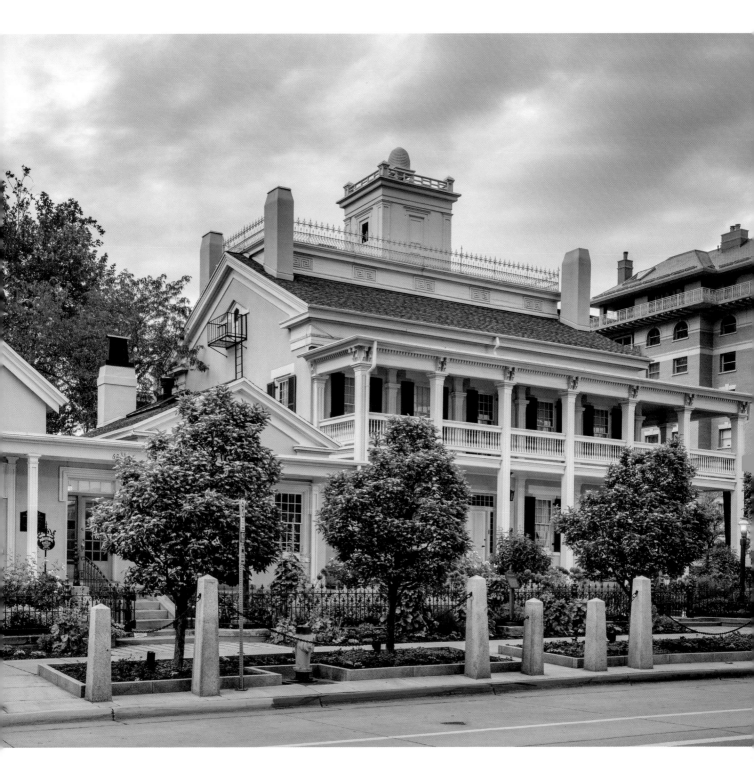

# THE BEEHIVE HOUSE

Constructed in 1854, two years before the neighboring Lion House was built (also a residence of Brigham Young's). Both homes are one block east of Temple Square.

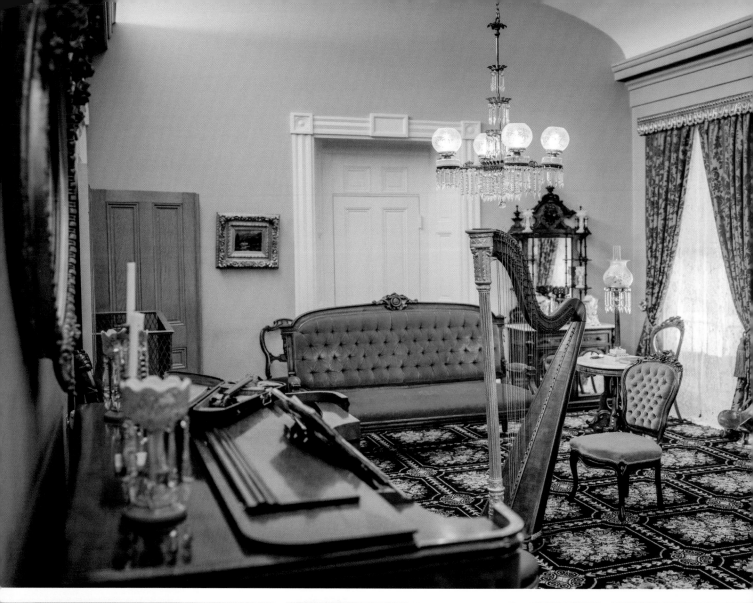

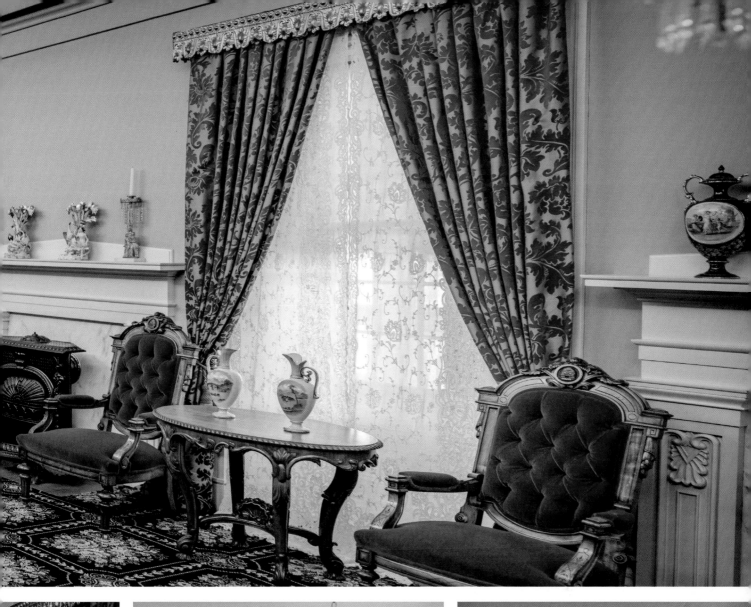

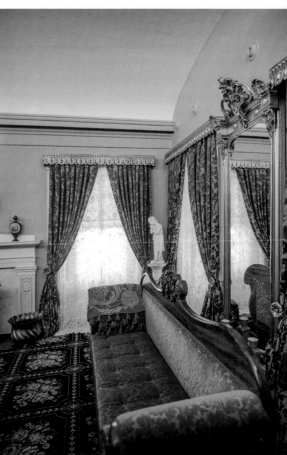

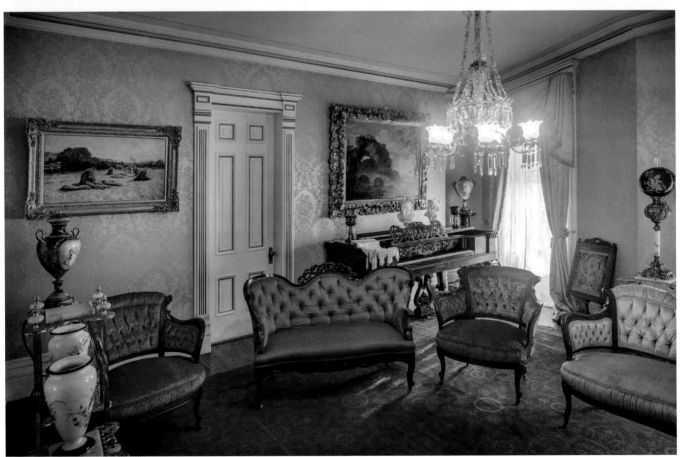

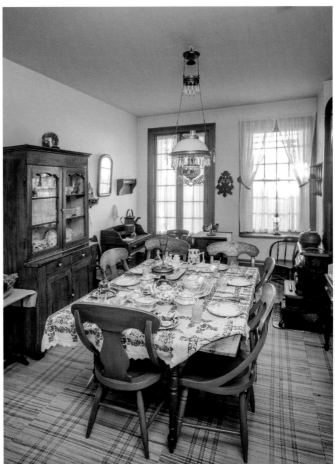

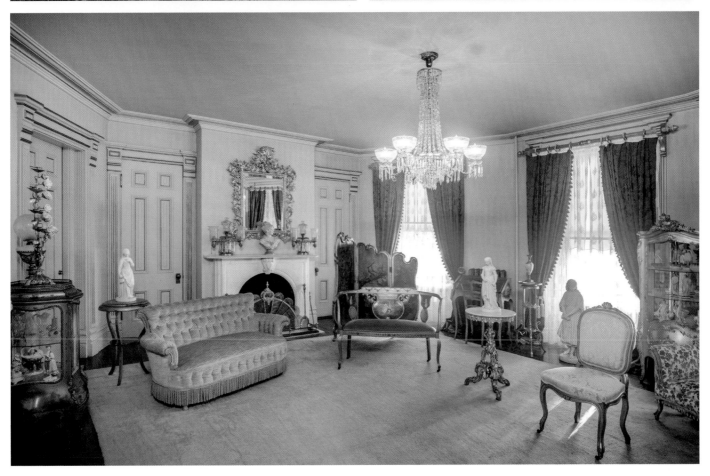

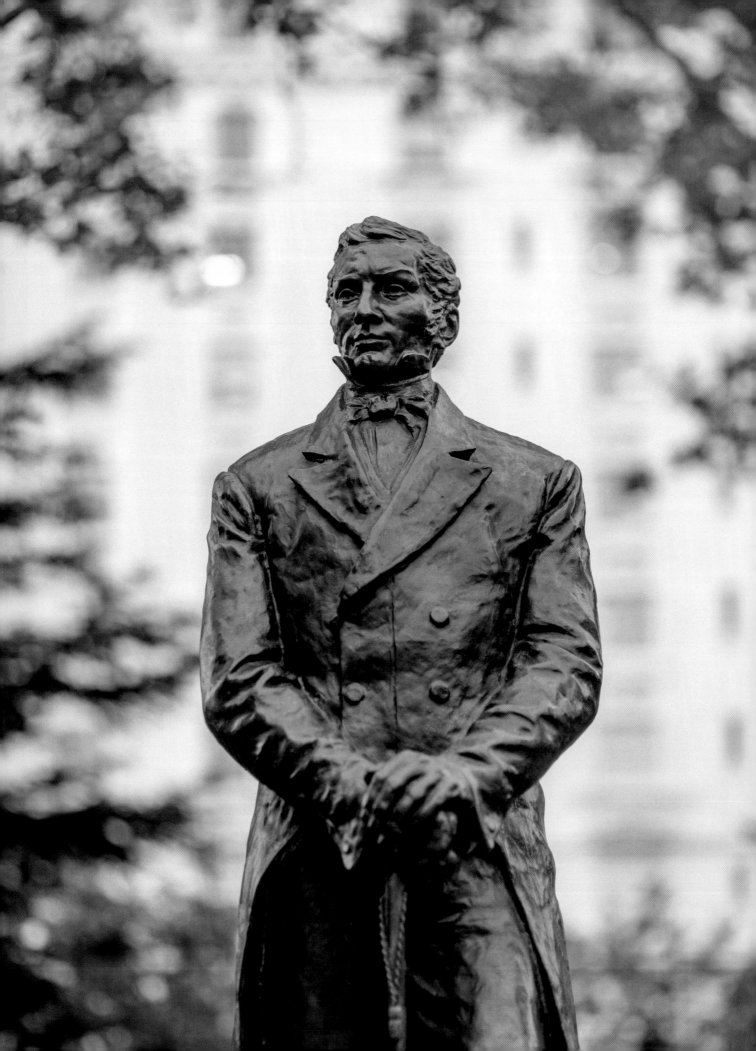

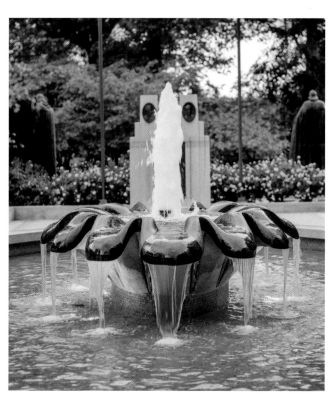

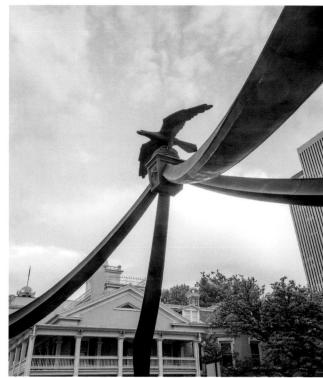

# STATUES & FOUNTAINS

## *Interesting Facts*

- The Nauvoo Bell monument houses the original bell from the Nauvoo, Illinois Temple. When the Mormon pioneers were forced out of Nauvoo in 1846, one of the wagon trains carried the bell with it across the plains. During the journey, the pioneers rang the bell every morning to signal departure and every evening to announce night sentries going on duty. In its home on Temple Square, it is struck hourly.[32]

- The seagull statue serves as a reminder of the miracle of the seagulls, which took place shortly after the first pioneers arrived in the Salt Lake Valley in July 1847. When a plague of crickets threatened to destroy one of their first harvests, the pioneers prayed for divine assistance. Their answer came through large flocks of seagulls that came in and devoured the insects.[33]

- Built in 1942, the Handcart Pioneer Monument pays tribute to the group of pioneers who crossed the plains with handcarts instead of wagons. Because it was built during World War II, special permission had to be obtained from the government to use so much bronze for a statue.[32]

- The Great Salt Lake Base and Meridian is the point from which all of Salt Lake City's original streets were named and numbered. It was fixed after Brigham Young chose the temple site in July 1847.[32]

- The Brigham Young statue was erected in memory not only of Brigham Young, who directed much of the settlement of the Utah territory, but to the pioneers who faithfully heeded his call.[32]

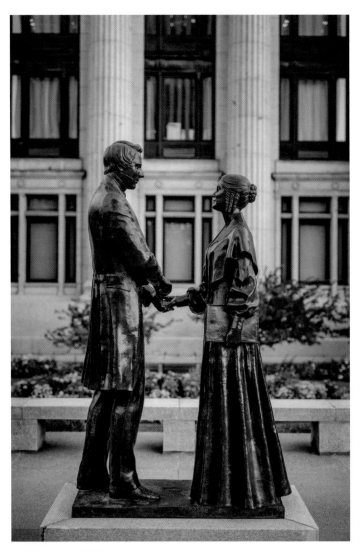

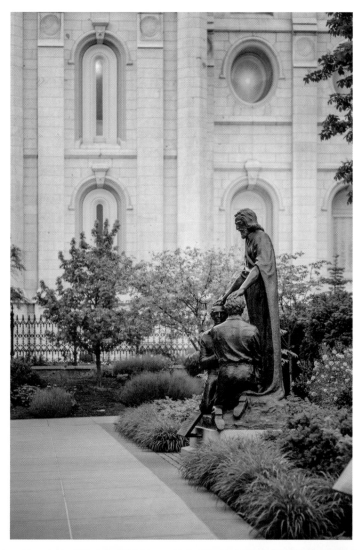

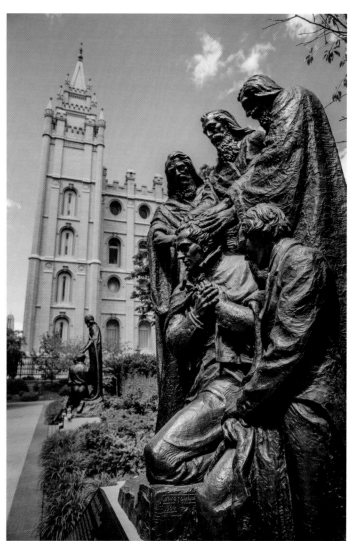

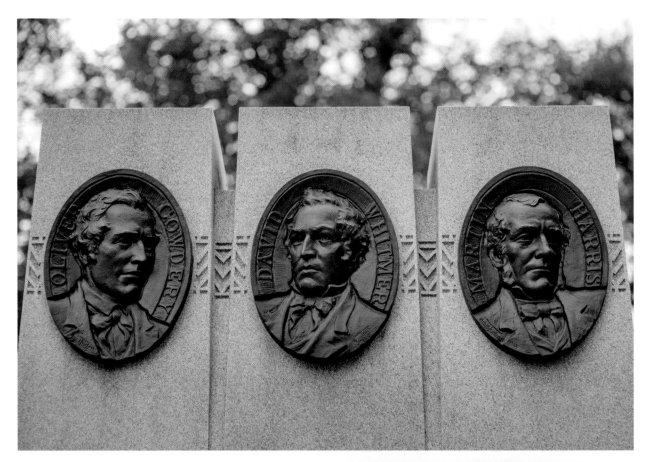

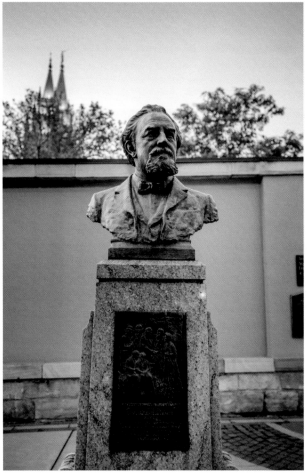

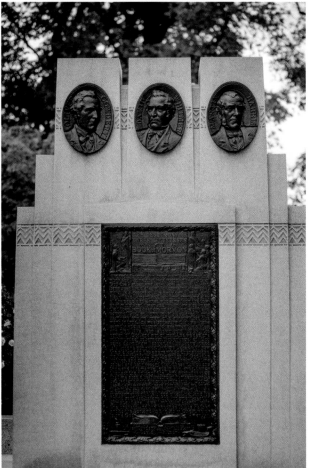

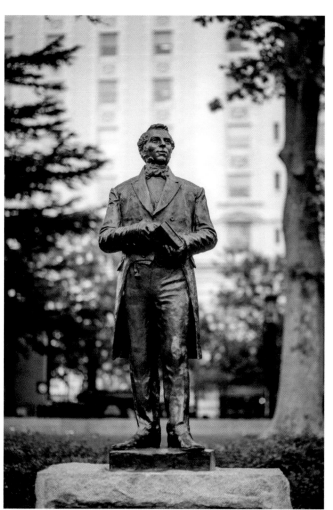

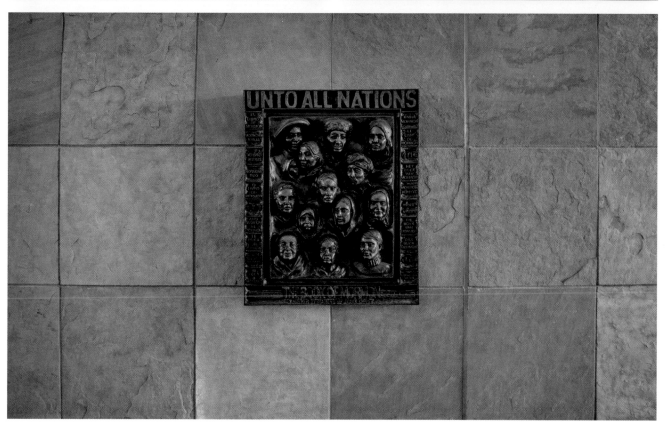

UNTO ALL NATIONS

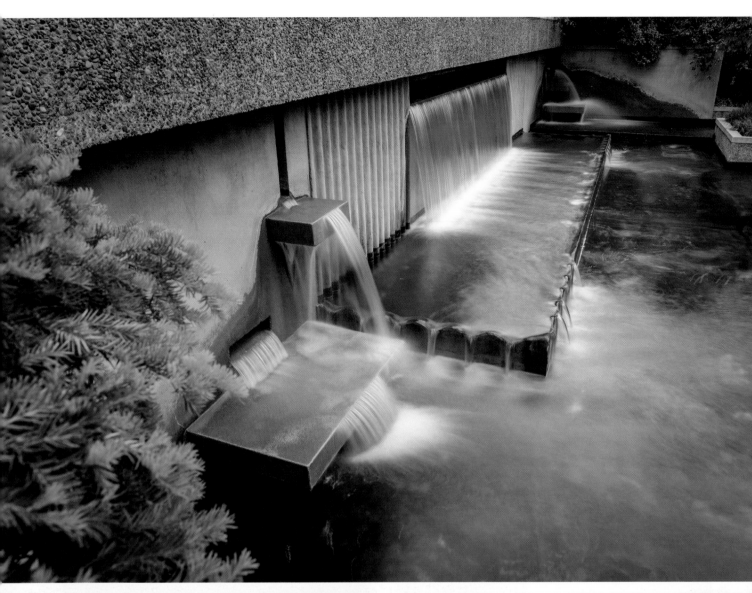

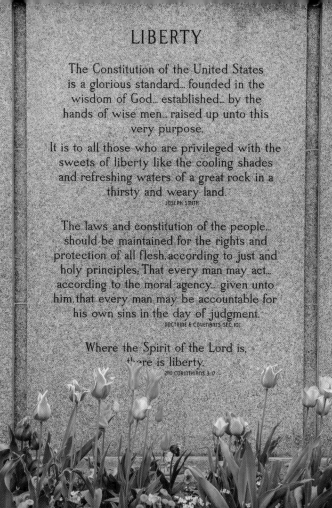

# LIBERTY

The Constitution of the United States is a glorious standard... founded in the wisdom of God... established... by the hands of wise men... raised up unto this very purpose.

It is to all those who are privileged with the sweets of liberty like the cooling shades and refreshing waters of a great rock in a thirsty and weary land.

JOSEPH SMITH

The laws and constitution of the people... should be maintained for the rights and protection of all flesh, according to just and holy principles, That every man may act... according to the moral agency... given unto him, that every man may be accountable for his own sins in the day of judgment.

DOCTRINE & COVENANTS SEC. 101

Where the Spirit of the Lord is, there is liberty.

2ND CORINTHIANS 3:17

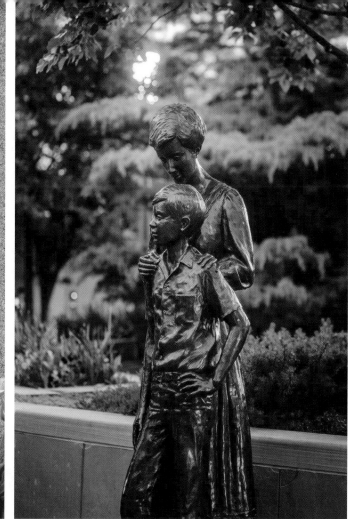

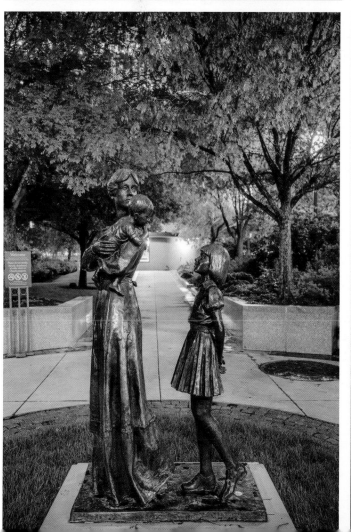

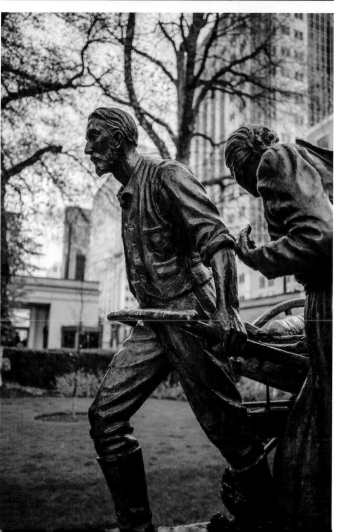

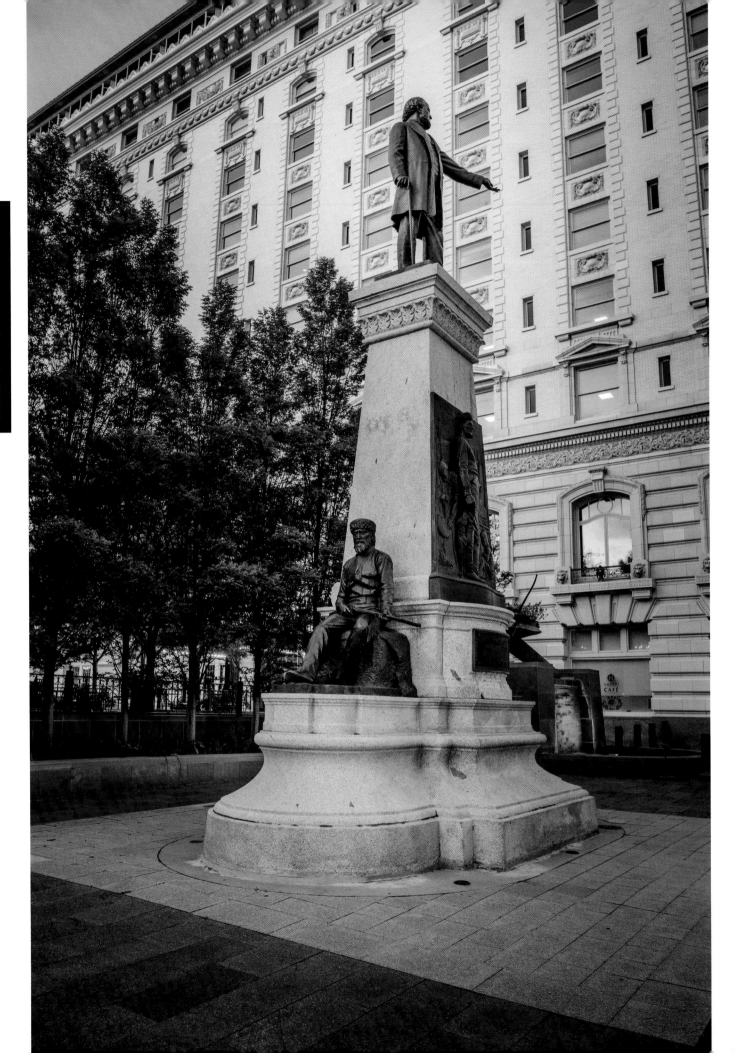

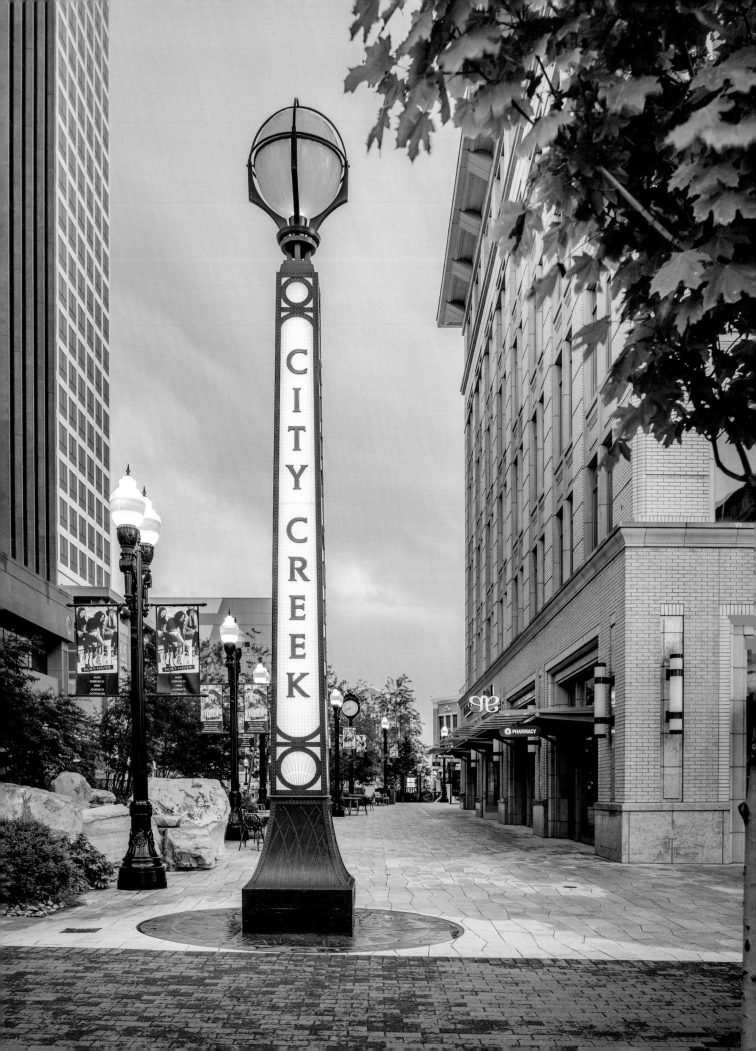

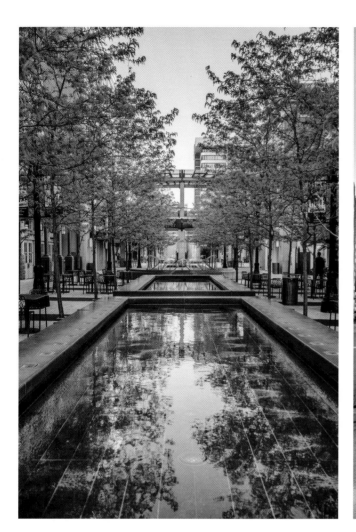

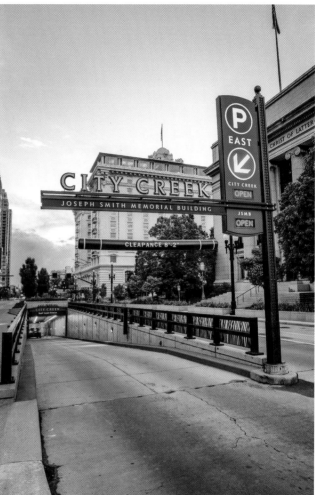

# SURROUNDING AREA OF CITY CREEK

## *Interesting Facts*

- City Creek Center takes its name from City Creek, which ran through Salt Lake City. At one point, water from the creek was diverted to a waterwheel in the basement of the Tabernacle and powered the organ for the Mormon Tabernacle Choir.[34]

- One of the largest downtown redevelopment projects in the US, City Creek Center opened in 2012. Its design centers around a creek. The building includes a retractable roof, pedestrian skybridge, and more than 100 stores and restaurants.[35]

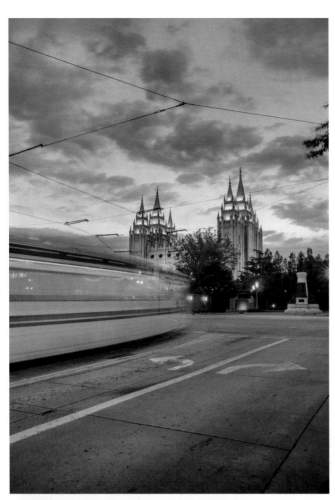

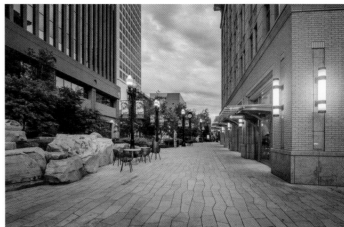

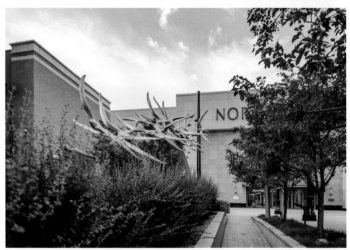

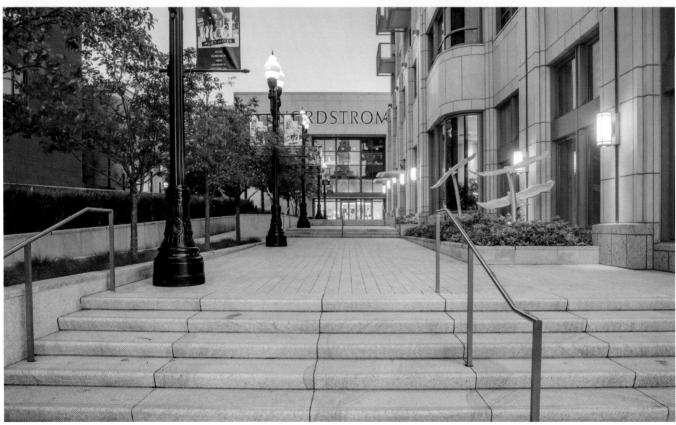

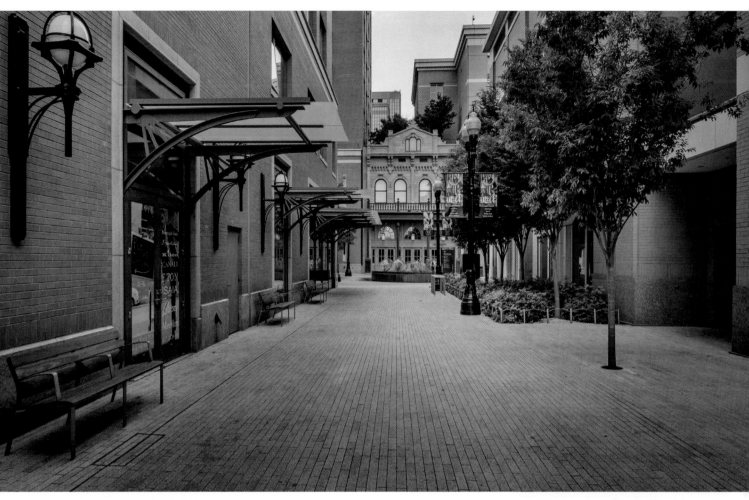

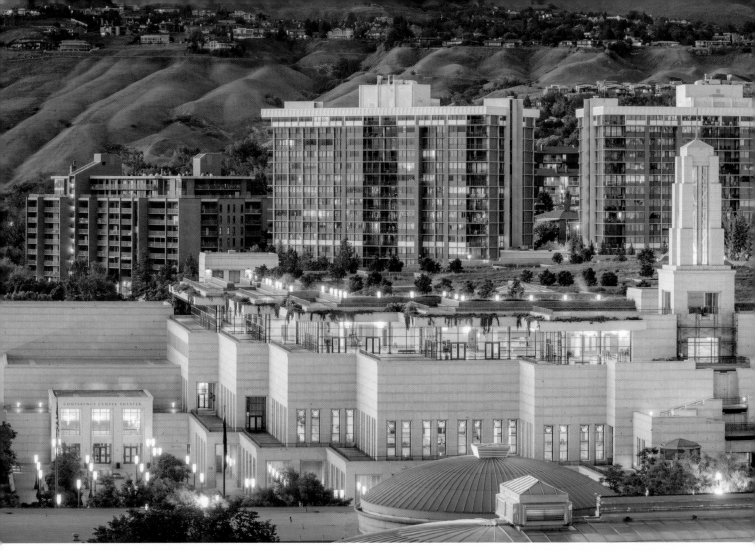

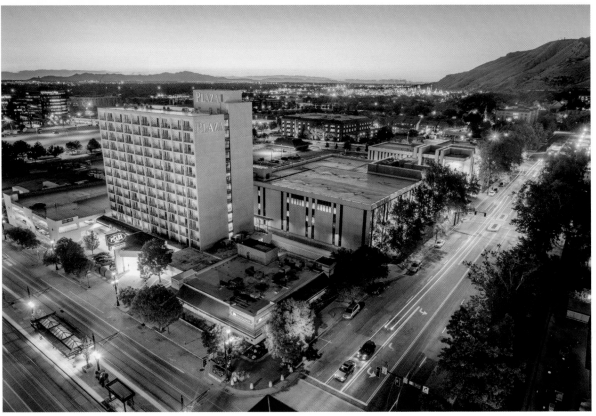

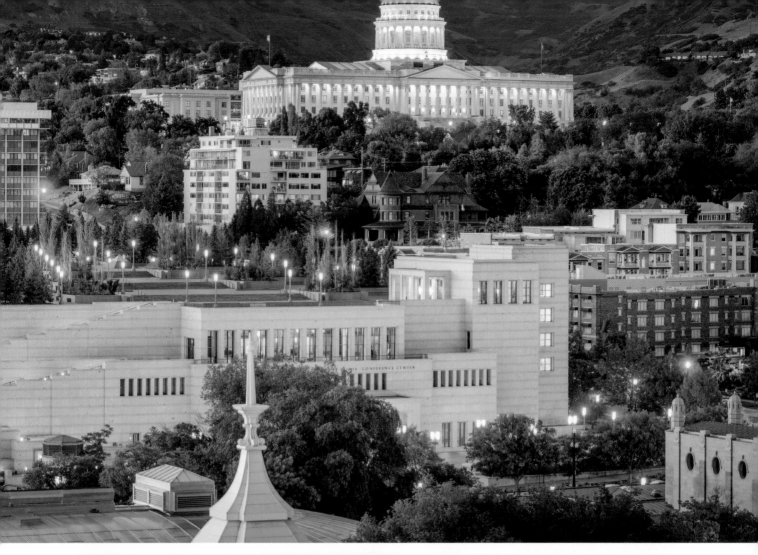

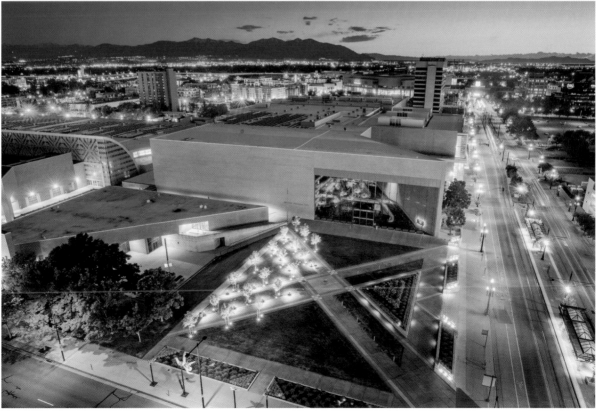

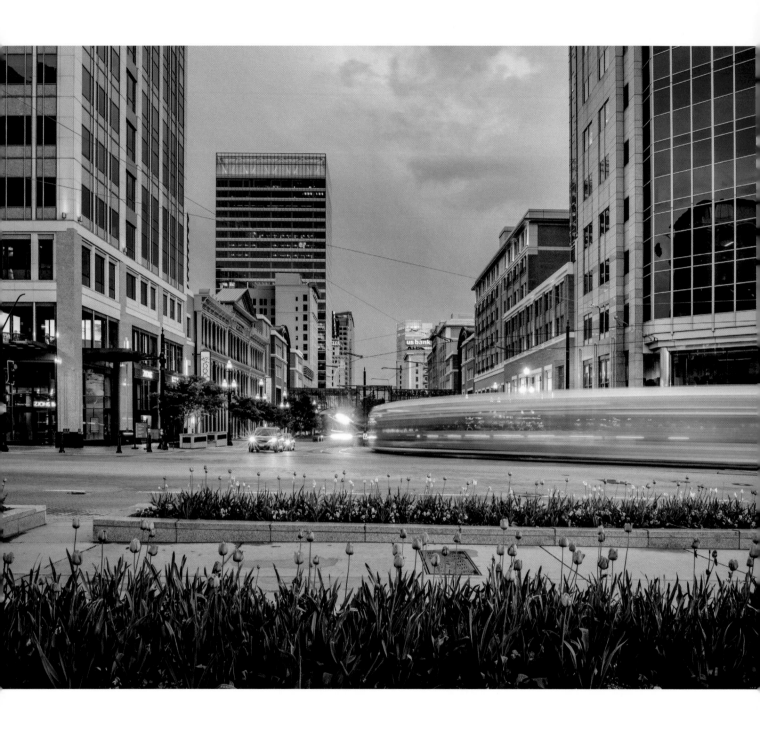

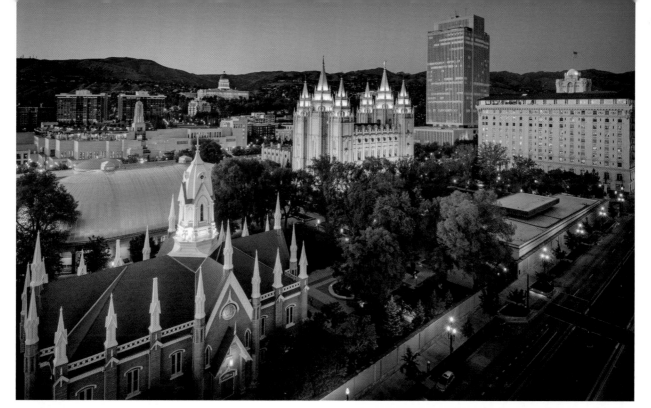

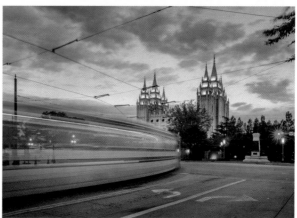

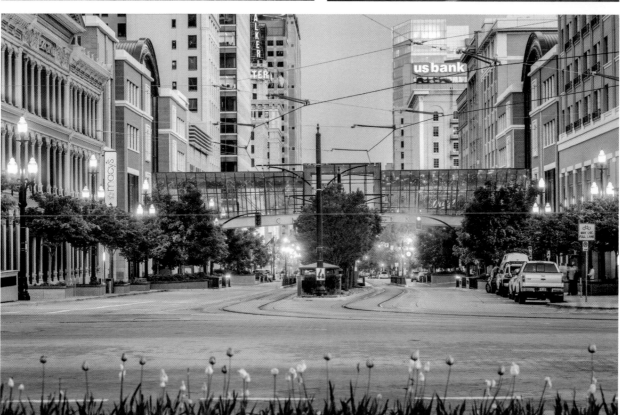

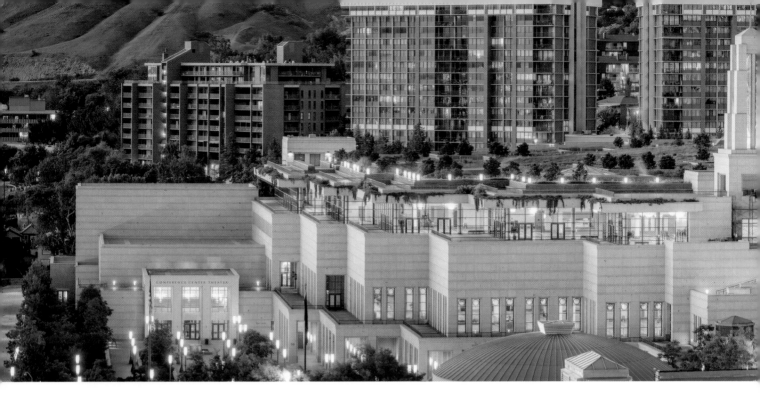

# ENDNOTES

1. Gordon B. Hinckley, "The Salt Lake Temple," Ensign, March 1993.

2. Jesse Weber, "The Architecture and Construction of Temple Square," https://www.templesquare.com/blog/architecture-construction-temple-square/, October 20, 2016.

3. Tammy Reque, "Interesting Facts You Didn't Know About the Salt Lake Temple," https://www.templesquare.com/blog/interesting-facts-you-didnt-know-about-the-salt-lake-temple/, May 26, 2015.

4. "Only a Stonecutter," LDS Media Library, https://www.lds.org/media-library/video/2010-07-140-only-a-stone-cutter?lang=eng#d.

5. Ryland Robinson, "Inside the LDS Conference Center," https://www.templesquare.com/blog/inside-the-conference-center/, June 23, 2015.

6. "LDS Conference Center," https://www.templesquare.com/explore/conference-center/.

7. Gordon B. Hinckley, "This Great Millennial Year," October 2000 General Conference, https://www.lds.org/general-conference/2000/10/this-great-millennial-year?lang=eng.

8. Tammy Reque, "How much do you know about the Tabernacle?" https://www.templesquare.com/blog/how-much-do-you-know-about-the-tabernacle/, November 13, 2014.

9. "The Tabernacle," https://www.templesquare.com/explore/tabernacle/.

10. "Mormon Tabernacle Choir," https://www.templesquare.com/explore/mormon-tabernacle-choir/.

11. Boyd K. Packer, "The Spirit of the Tabernacle," April 2007 General Conference, https://www.lds.org/general-conference/2007/04/the-spirit-of-the-tabernacle?lang=eng.

12. "Joseph Smith Memorial Building," https://www.templesquare.com/explore/jsmb/.

13. Ryland Robinson, "Hotel Utah: Grande Dame of Salt Lake," https://www.templesquare.com/blog/hotel-utah-grande-dame-of-salt-lake/, July 7, 2015.

14. "The Magnificent Hotel Utah Opens Its Doors," Deseret Evening News, 1911, qtd in "Hotel Utah: Grande Dame of Salt Lake," https://www.templesquare.com/blog/hotel-utah-grande-dame-of-salt-lake/, July 7, 2015.

15. JoAnn Jolley, "Century-Old Assembly Hall Is Renovated," Ensign, February 1983.

16. "Assembly Hall," https://www.templesquare.com/explore/assembly-hall/.

17. Daniel H. Ludlow, Brigham Young University, Encyclopedia of Mormonism (New York: MacMillan, 1992), 1466-1467.

18. Matthew O. Richardson, "5 Things You Never Knew About the Christus Statue," LDS Living, http://www.ldsliving.com/5-Things-You-Never-Knew-About-the-Christus-Statue/s/78222.

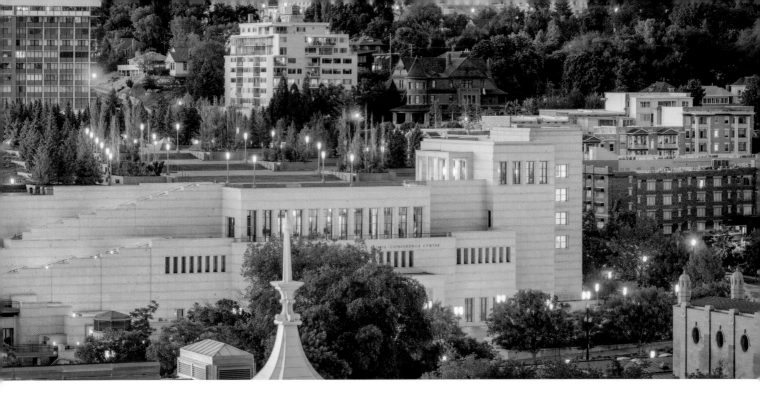

19. C. Mark Hamilton, "Temple Square," Utah History Encyclopedia, http://historytogo.utah.gov/places/historical_places/templesquare.html.

20. Breanna Olaveson, "5 things you didn't know about the Temple Square lights," Utah Valley 360, https://utahvalley360.com/2013/12/09/5-things-you-didnt-know-about-the-temple-square-lights/, December 9, 2013.

21. "Temple Square," https://utah.com/temple-square.

22. Tammy Reque, "#TempleSquare: Top 10 Instagrams of September," https://www.templesquare.com/blog/templesquare-top-10-instagrams-of-september/, October 9, 2015.

23. "Renovated Church History Museum Reopens on Temple Square," Mormon Newsroom, http://www.mormonnewsroom.org/article/renovated-church-history-museum-reopens-on-temple-square.

24. "Family History Library," Mormon Newsroom, http://www.mormonnewsroom.org/article/family-history-library.

25. "Church Office Building," https://www.templesquare.com/explore/church-office-building/.

26. "The New General Church Office Building," Ensign, January 1973.

27. "Relief Society Building," https://www.lds.org/locations/temple-square-relief-society-building?lang=eng&_r=1.

28. Tammy Reque, "Inside the Relief Society Building," https://www.templesquare.com/blog/inside-the-relief-society-building/, September 26, 2014.

29. Lynn Arave, "The history of the LDS Church Administration Building," Deseret News, https://www.deseretnews.com/article/705372791/The-history-of-the-LDS-Church-Administration-Building.html, May 17, 2011.

30. "The Beehive House," https://www.templesquare.com/explore/beehive-house/.

31. Aimee Pledger, "Oldest Buildings in the Salt Lake Valley," https://www.templesquare.com/blog/oldest-buildings-salt-lake-valley/, April 14, 2016.

32. Tammy Reque, "Temple Square Pioneer Walk," https://www.templesquare.com/blog/temple-square-pioneer-walk/, July 22, 2015.

33. Daniel H. Ludlow, Brigham Young University, Encyclopedia of Mormonism (New York: MacMillan, 1992), 1287.

34. Scott C. Esplin, "The Organ," in The Tabernacle: "An Old and Wonderful Friend" (Provo, UT: Religious Studies Center, Brigham Young University, 2007), 201–15, https://rsc.byu.edu/archived/tabernacle-old-and-wonderful-friend/thesis-historical-study-construction-salt-lake-7.

35. "City Creek Center: A shopping experience like no other," http://www.shopcitycreekcenter.com/m/about_us.

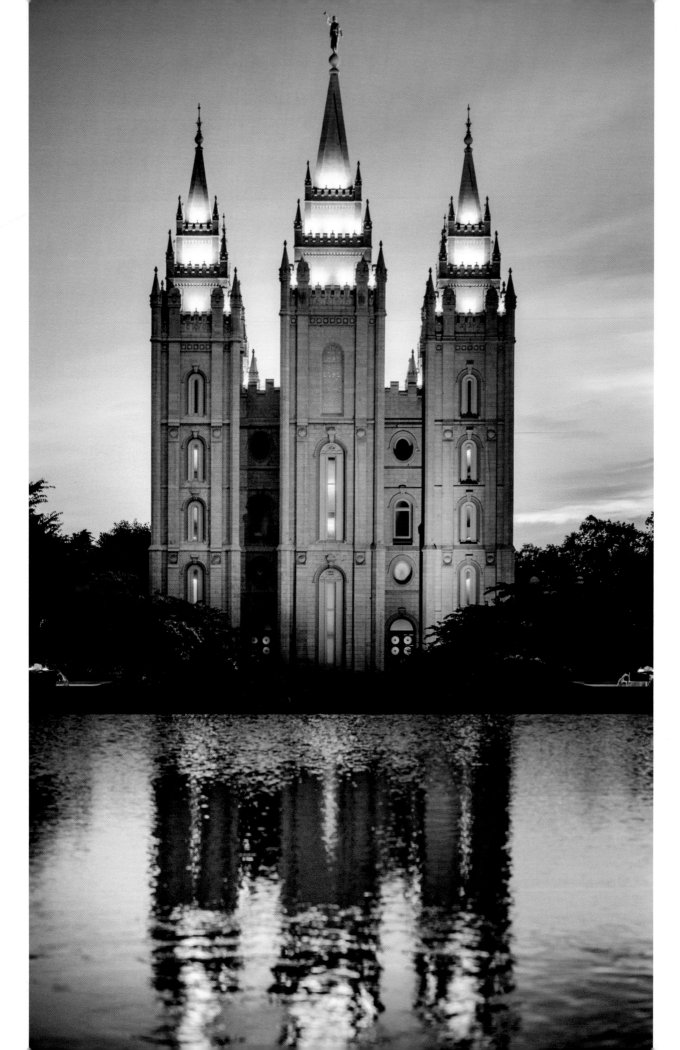

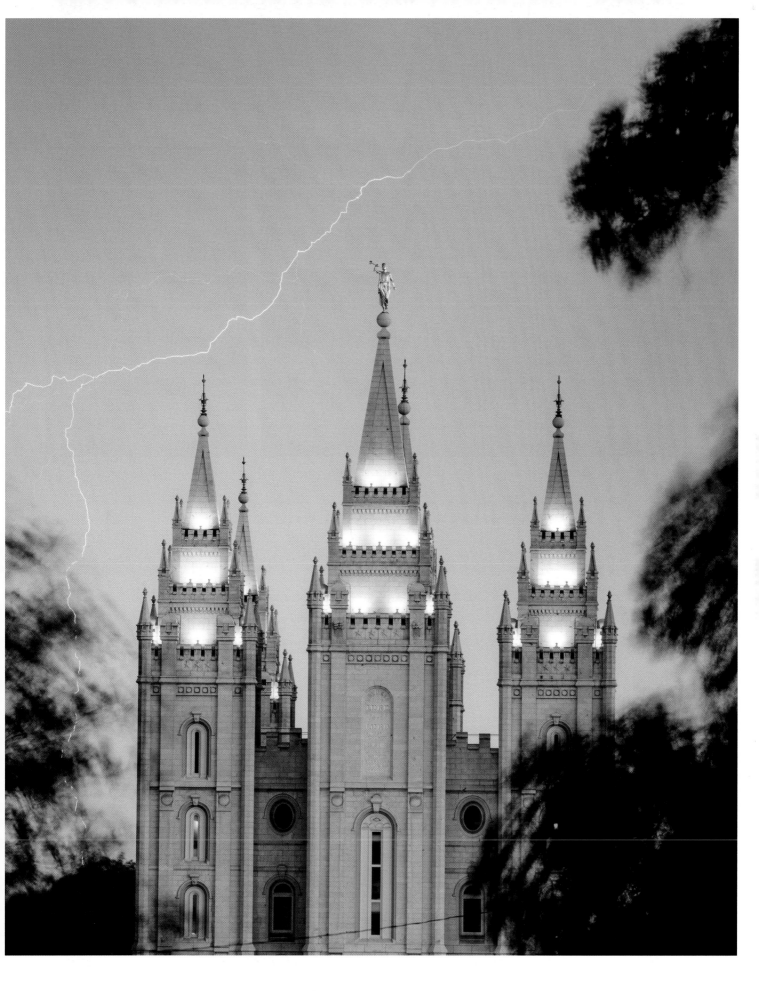

# SCOTT JARVIE, PHOTOGRAPHER

Scott studied languages at BYU, and while traveling in Europe he discovered his love for photography. He has spent the last decade and tens of thousands of hours fervently honing his craft. Scott is a full-time photographer, earning a living primarily as a wedding photographer, while still getting plenty of opportunities to travel the world.

Check out Scott's website to see more temple images, including new temples that are being built. You can view the images, share them on social media, and buy artwork for your home at www.jarviedigital.com.

SCAN to visit

www.jarviedigital.com